To My Friend Bud
The "MERMAID" → D.7
BMcCay
8·10·2019

Bill —
with great appreciation for all
that you do!

Dave

ART of the BUCKLE

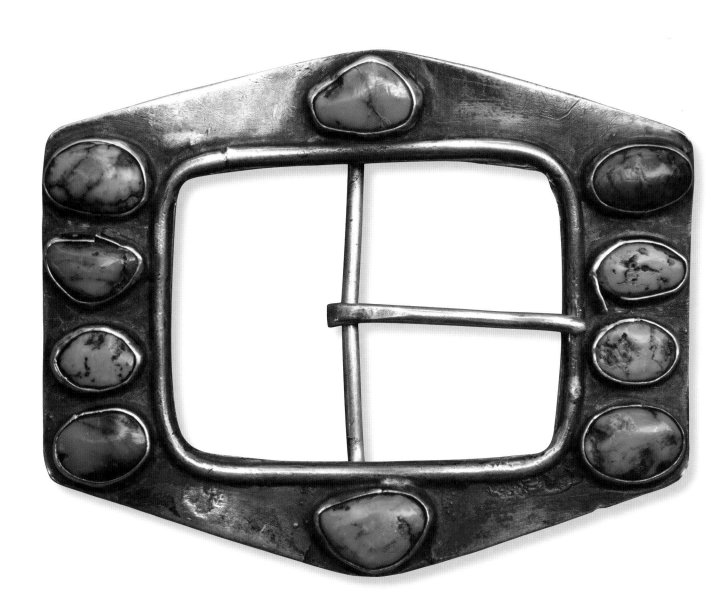

ART of the BUCKLE

JIM ARNDT & MARY EMMERLING

GIBBS SMITH
TO ENRICH AND INSPIRE HUMANKIND

To Nathalie, the Queen of the Buckles, and also my number one supporter, biggest fan, and best friend. She makes every good day better, and every bad day good. It is inconceivable that this could get done with out her.

Merci beaucoup!

—JA

To my wonderful family, Samantha and Jonathan, who I have tried to make into cowboys and cowgirls, though they are truly NYC kids!

To Reg Jackson, who has made the last sixteen years truly Western.

—ME

17 16 15 14 13 5 4 3 2 1

Text © 2013 Jim Arndt and Mary Emmerling
Photographs © 2013 Jim Arndt

Published by
Gibbs Smith
P.O. Box 667
Layton, Utah 84041

1.800.835.4993 orders
www.gibbs-smith.com

Cover designed by Blackeye Design
Interiors designed by Renee Bond
Printed and bound in China

Gibbs Smith books are printed on either recycled, 100% post-consumer waste, FSC-certified papers or on paper produced from sustainable PEFC-certified forest/controlled wood source. Learn more at www.pefc.org.

Library of Congress Cataloging-in-Publication Data

Arndt, Jim.
 Art of the buckle / Jim Arndt & Mary Emmerling. — First Edition.
 pages cm
 ISBN 978-1-4236-3218-4
 1. Belt buckles—Collectibles—West (U.S.) I. Emmerling, Mary Ellisor. II. Title.
 NK4890.B4A76 2013
 739.27'8—dc23
 2013006452

(Overleaf credits, left to right: Mona Van Riper, Sherwood collection, Richard Stump, Doug Magnus, vintage, and unknown.)

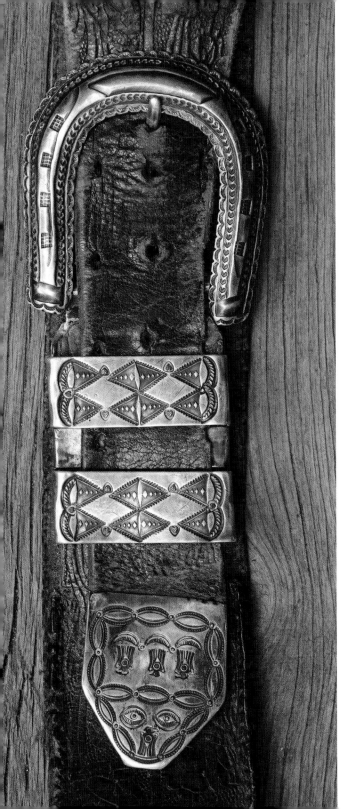

CONTENTS

INTRODUCTION

THROUGHOUT THE CENTURIES, MEN HAVE usually needed an accessory of some type to hold up their trousers. In the cowboy culture, suspenders were practical for vigorous outdoor work, while belts were not.

However, styles began to change in the 1920s with the advent of the rodeo trophy buckle. These were costly to make, so being awarded a championship or commemorative buckle was like winning a pot of gold! This was the beginning of the buckle as a statement of pride among working cowboys, an icon that said, "Here I am. I'm a winner, a force to be reckoned with!" Such big, flashy buckles weren't for everyday; they were for best dress, for wearing to the Saturday-night dance in town.

Buckles entered the mainstream popular culture via Hollywood film star cowboys of the 1930s and '40s, and pretty soon wannabe cowboy kids could buy a ranger set with a holster and cap gun at the five and dime. Big boys were attracted to big buckles, too. Here was another accessory that one could give a man besides a tie or belt. Silversmiths and jewelry makers put artistry into one-of-a-kind and custom buckles, spinning out a fabulous genre of gentlemen's jewelry.

The buckles we see today are the creations of numerous extremely talented artists, jewelers, silversmiths, bead workers and leather workers. If you can think of a buckle that would be just your style or bear icons that show people who *you* are, there is a buckle artist who can create your dream and bring your message forward. Although there are tens of thousands of buckles out there, some of my favorites are from when my love for the art of the buckle began.

When I met my cowboy, Reg Jackson, who grew up in the West, he showed me his rodeo buckles,

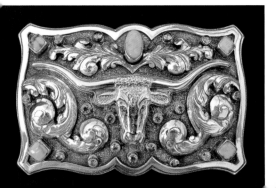
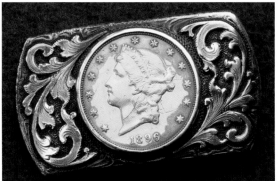
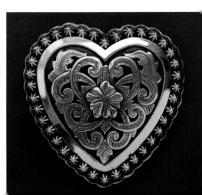

western fringe jackets, bandanas, cowboy belts, and Navajo silver jewelry. I was hooked! I started looking for and collecting rodeo buckles and belts. I loved the trophy buckles that had bucking horses, bulls, ropers, and barrel racers—all of which were highly engraved or inlaid with gems or from towns that I loved visiting.

I had spent a lot of time going to Cheyenne Frontier Days in Wyoming, shooting my *American Country West* book. On the other end of the spectrum, I even attended the Rodeo Days in Montauk, Long Island, New York. In every magazine—from *Vogue, English Vogue,* and *Côté Sud* to *House and Garden*—I would look for fabulous layouts on western clothes and settings.

Then I met my favorite French cowgirl, Nathalie Kent, and was also introduced to Jim Arndt, who had shot a lot of the western commercials and ads. Nathalie and Jim were both fabulously well dressed in Santa Fe western style, and Nathalie had a namesake store in Santa Fe, where she sold a lot of clothing and jewelry of the type they wore. I started shopping there, as well. I would wear my turquoise jewelry everywhere I went, but in New York, people would ask, "Have you been out West?" When I flew on airlines and had my rodeo buckle on, I would be asked, "What's your best time?"

I love all of my collections now, starting with rodeo buckles, ranger sets, conchos, trophy buckles, denim, Chimayo weavings, cowboy boots, Levi's, bandanas, cowboy hats, turquoise jewelry, coats, and RRL and RL clothes that I have worn since Ralph Lauren's first western collection entered the market in 1978. I look for buckles at all the antique shows, flea markets and antique malls. What do I look for? Definitely I look for buckles that commemorate cities, ranches, or other places; that have people's names or initials; and I look for buckles with stones. I like the buckles BIG!

Now that you know all the details, which style of buckle do you want to start looking for? Western style is *my* style. I can't imagine being without my favorite pieces of jewelry—including my buckles!

As Gene always said, "Happy Trails!"

—*Mary Emmerling*

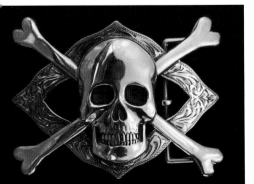
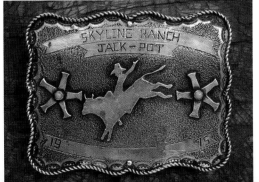

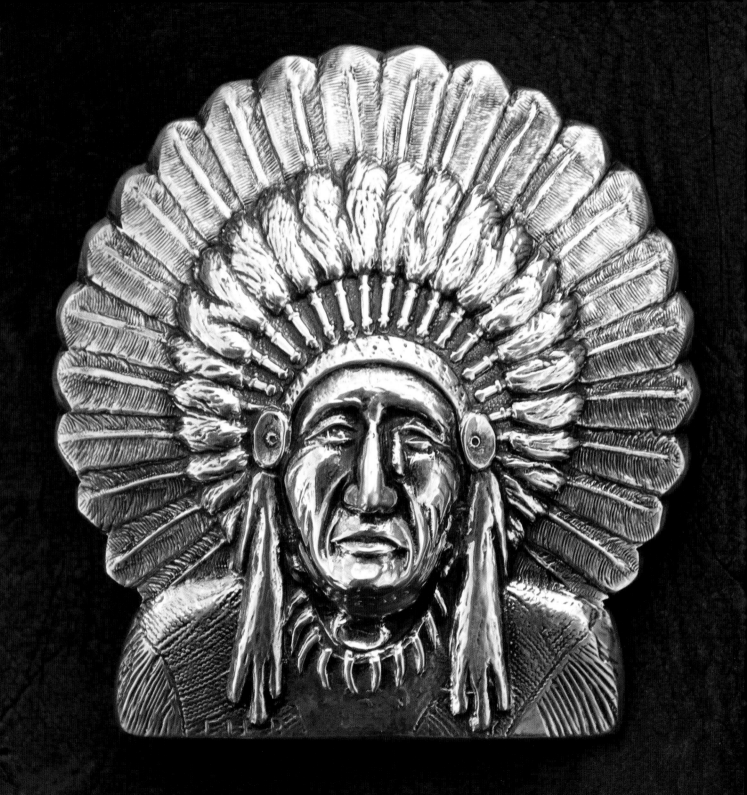

COWBOYS & INDIANS

WHAT EPITOMIZES THE HISTORY OF THE
West more than Cowboys and Indians?

Indian imagery represents our true original Americans, who we look to particularly for their value of living in harmony with Mother Earth. Whether in profile or full face with headdress, the image of the Indian reflects strength and pride in one's heritage. Many of the incredible buckles I love have been made by the Diné, or Navajo.

The cowboy image is a favorite for buckle collectors. He represents independence, among other things. I've loved the cowboy and Indian in film, from classic models like Hopalong Cassidy (I have seen every movie!), Roy Rogers, the Lone Ranger and Tonto, and Gene Autry, The Singing Cowboy, to the latest Lone Ranger and Tonto played by Armie Hammer and Johnny Depp. Tremendous fun!

My first buckle was on my two-gun cap pistol holsters—
shiny tin with a horse head design and some horseshoes at the corners.
From that time till now, that first buckle has welcomed many more to my collection.
They're Western History and I love history.

—Reg Jackson

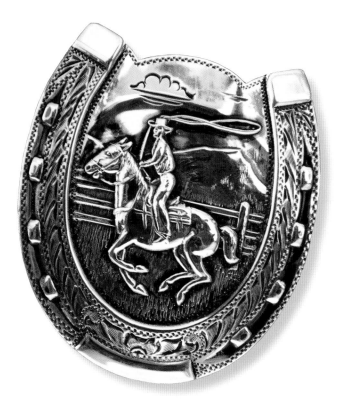

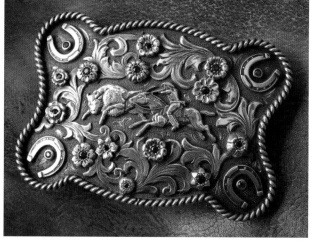

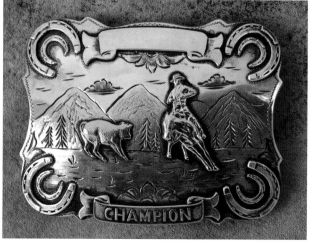

Cowboys go riding! A selection encircled
in horseshoes, or roping and hunting.
(Clockwise from left: Comstock, Clint Orms,
Comstock. Facing: Western Vintage Revival.)

PREVIOUS OVERLEAF: Bohlin sterling silver
Indian head.

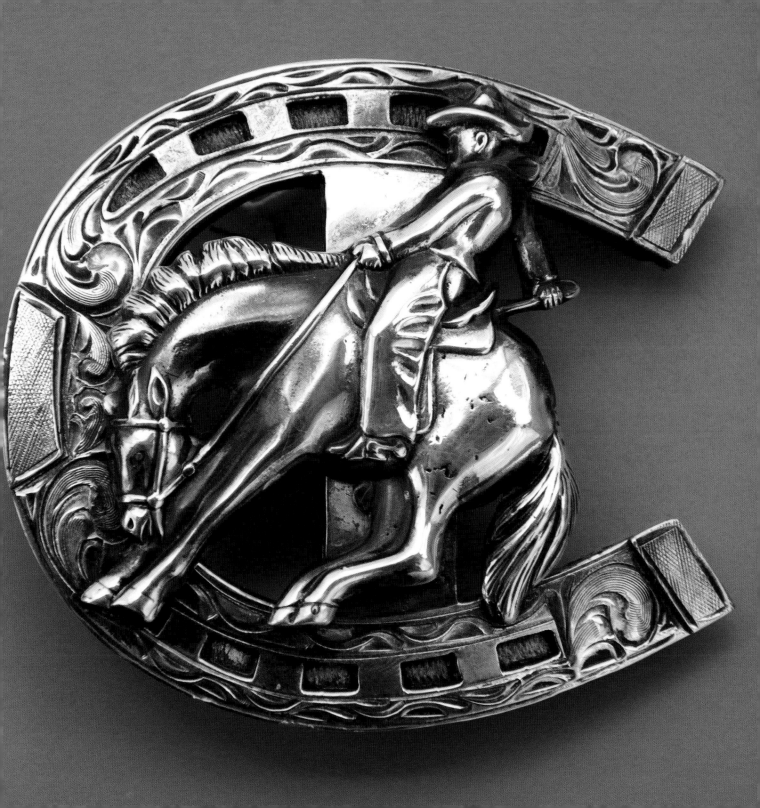

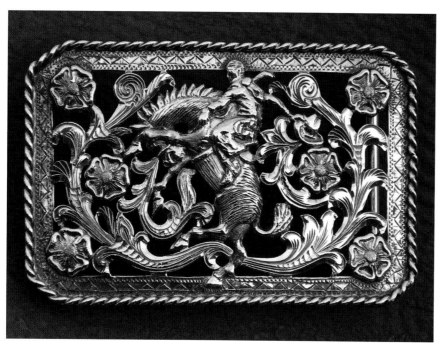

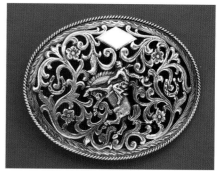

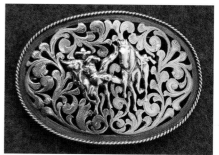

Filigree cowboy buckles in multicolor gold and silver. (Clockwise from top left: Bohlin, Bohlin, Bohlin, Comstock.)

OPPOSITE: Cast-brass western-themed buckles.

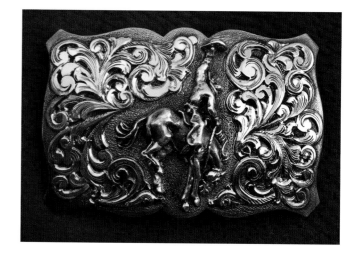

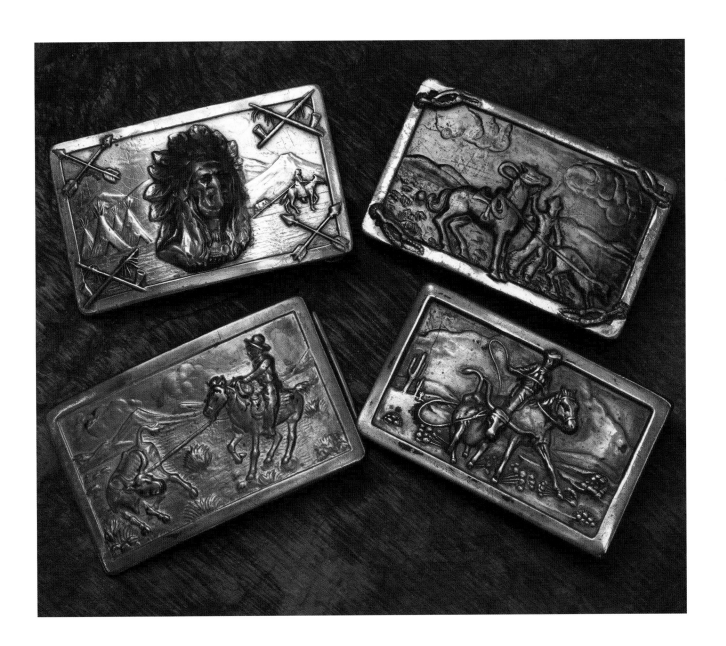

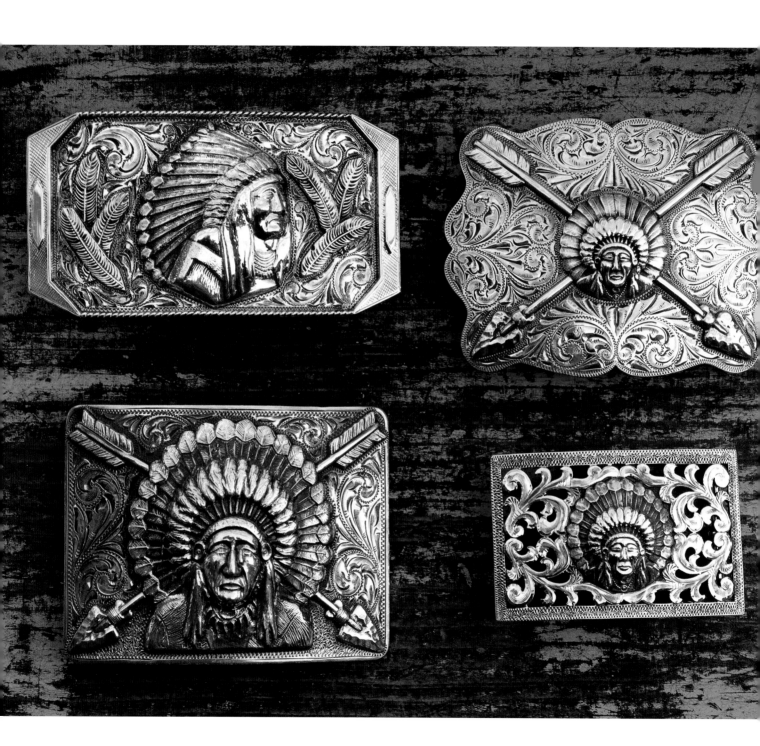

"Why I do stay up late, insist on the best of everything? I care so much if the buckles are lined up correctly in the showcase, fingerprint free, organized and ready to do their job the next time they meet a stranger. We put them on stage every day, give them a chance to dance, sing and perform. It is not only my responsibility to create them but to care for them and give them the best homes, homes they can thrive in, and inspire the inspirers.

"If each piece we create doesn't have its own life that will touch and encourage its owner and viewers, we did not do our job.

"As fate would have it, I was introduced to Michael Redshirt, and he told me of the American Indian traditions and how they always put themselves into their creations, giving life that would be felt by many, long after they were gone. I planned many years ago to create, to teach, to share and to make sure the wonderful creations we make would be touched and felt.

"If a blind man can be inspired from our works, they have feeling, love and a special spirit."

—*Clint Orms*

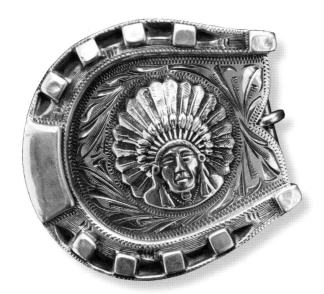

Bohlin Indian head buckles. (Sandroni collection.)

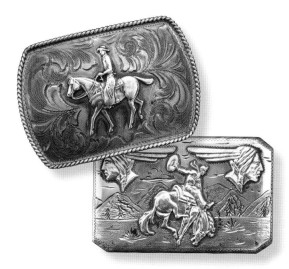

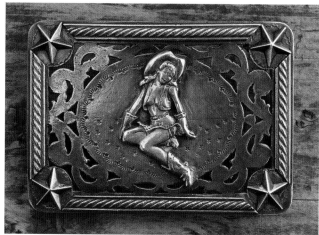

ABOVE: A couple of cowboys ridin' and buckin', and a sweetheart cowgirl. (Left to right: Clint Orms, Comstock, Susan Adams.)

RIGHT: Three-color gold raised, engraved buckin' bronc with piercing arrow and filigree. (Clint Orms.)

OPPOSITE: Three examples of classic bucking cowboys. (Clockwise from top left: Clint Orms, Comstock, Bohlin.)

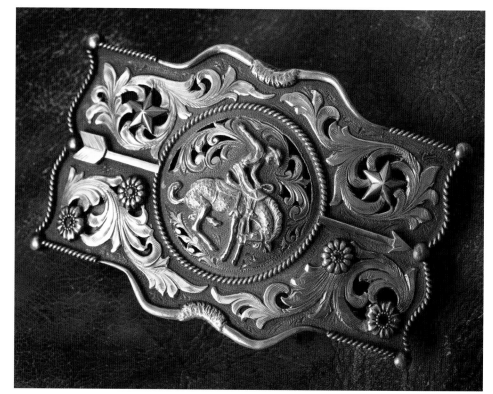

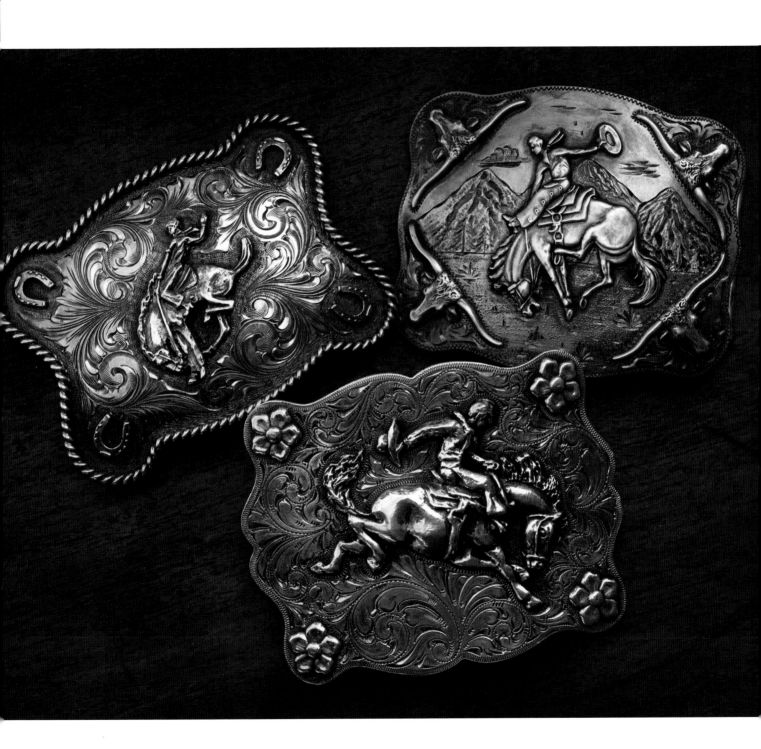

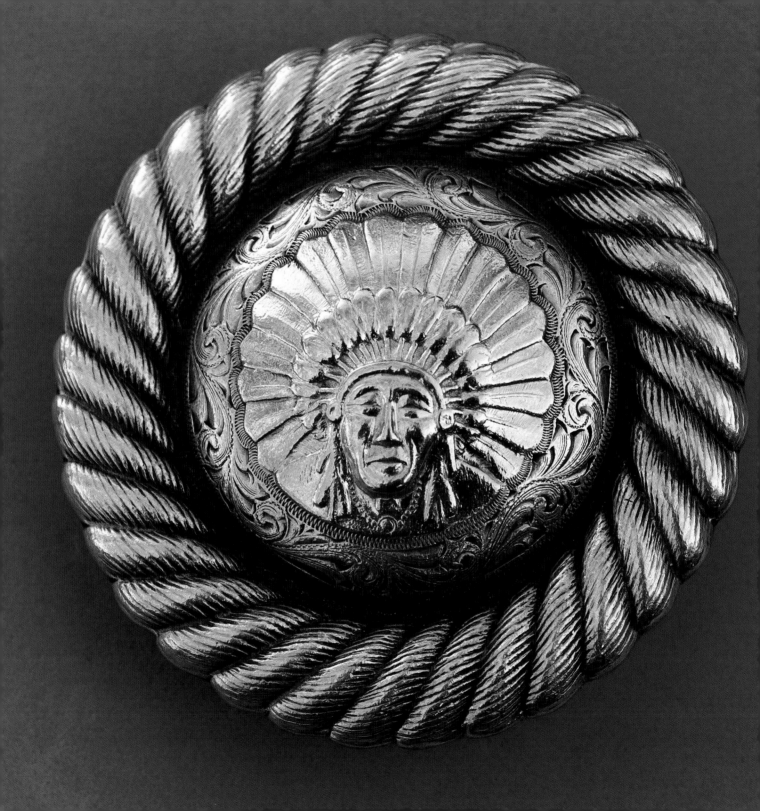

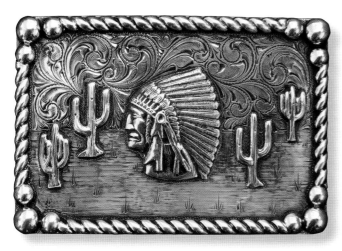

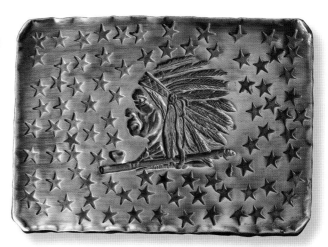

OPPOSITE: Indian head in large rope-style frame. (Bohlin.)

Profiles in overlay, stamped with stars, and a cast cutout. (Clockwise from top left: Bohlin, Clint Orms, Arnold Goldstein.)

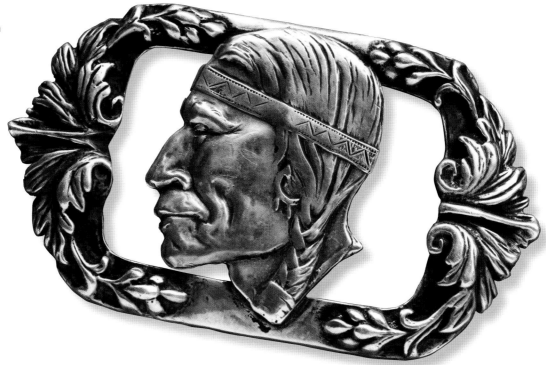

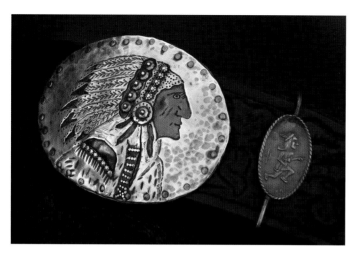

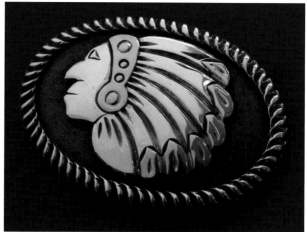

"Traveling the world inspires me and my work. Carved scrolls and floral motifs, architectural and decorative details of Southeast Asian temples and buildings, traditional western engraving on guns and rifles, the carved wood mantels and moldings in the Victorian-era house I grew up in—all these elements fascinate and have definitely informed my design style. They feel like the parts of a larger visual story.

"Making buckles is like practicing the art of alchemy: melting and pouring molten metal, raising surfaces, drawing wire. It's all about transformation, recombination, creation. The jeweler gets to be the sorcerer, the mad scientist, the tinkerer. It's the practice of an ancient art in a modern time."

—Samantha Silver

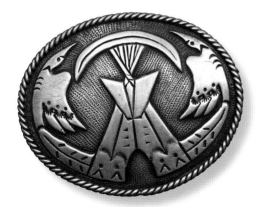

Copper and hand stamping for a different feel, a sleek and modern take on a classic image, and a sliver tipi. (Clockwise from top left: Margaret Sullivan, James Reid, unknown.)

OPPOSITE: A 1960s-era collection of turquoise, coral, buffalo nickels, and an Indian, all on one buckle. (Scott Corey collection.)

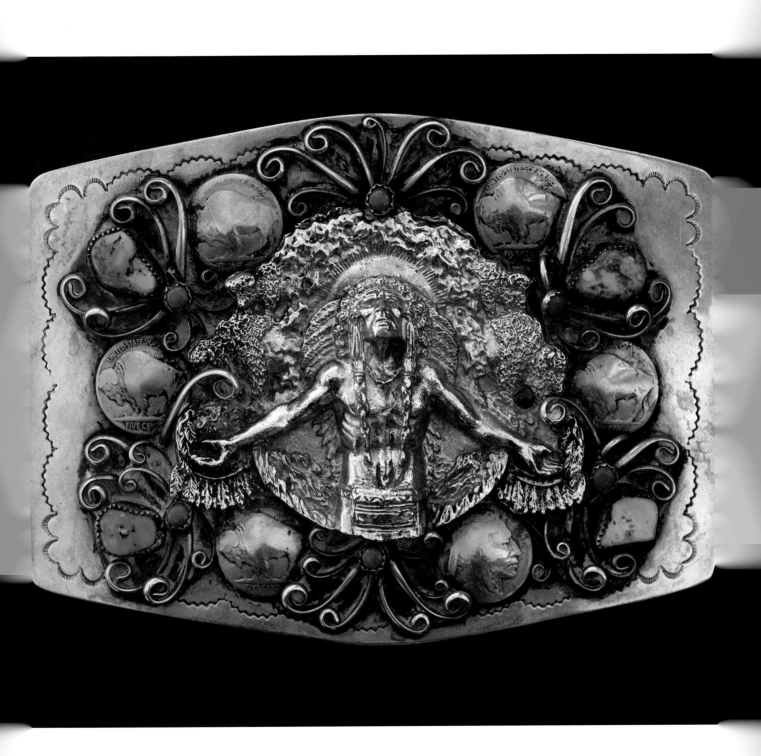

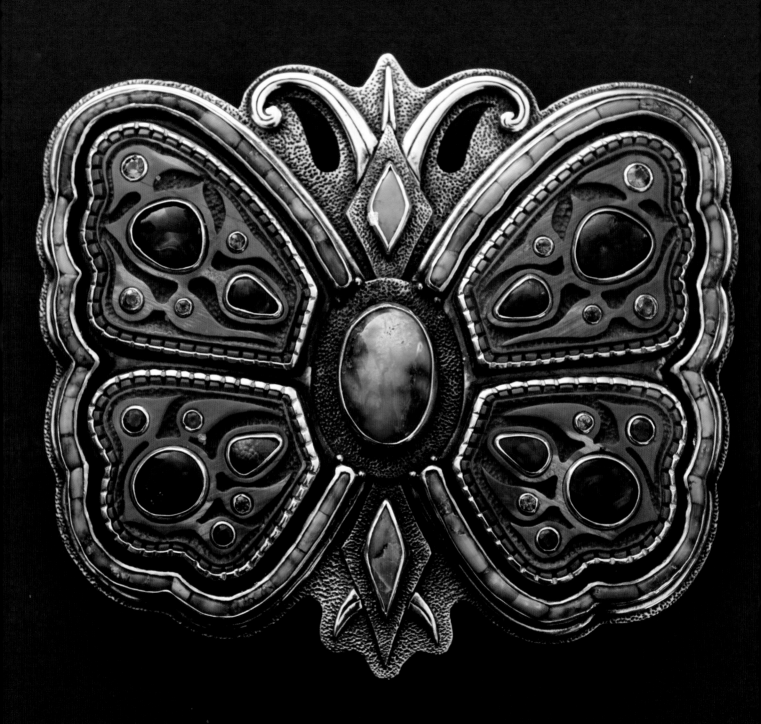

CONTEMPORARY HIGH STYLE

TODAY'S ARTISTS PUSH THE BOUNDARIES of materials, processes and forms to create belt buckles as beautiful as any necklace pendant or chunky bracelet. Unique design, totally unexpected and unusual, is the hallmark of contemporary buckle art.

From delicate filigree on one hand, to organic swooshes executed in shiny silver, the creative limits seem unbounded. If butterflies are your thing, or fishing, horses, hearts, or arrows, there is no shortage of exquisite silverwork to appease your appetite for a unique piece of waistline jewelry.

These are buckles we would love to have in our wardrobes—wearable art. I can't imagine not having dozens of buckles to choose from.

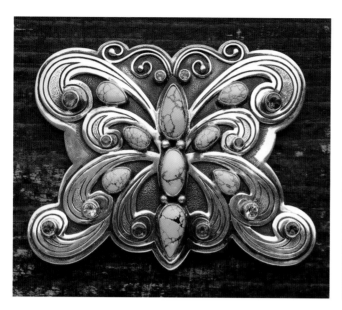

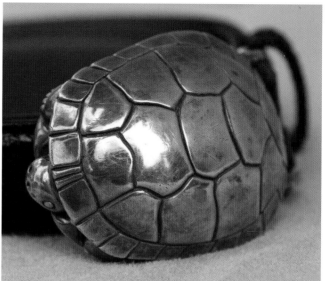

A butterfly, turtle, and trout. What's your favorite animal? (Clockwise from top left: Mona Van Riper, Barry Kisselstein, James Reid.)

OPPOSITE: How about a sleek horse head, an owl, an elk, or even pelicans? (Clockwise from top: James Reid, Barry Kisselstein, Lee Downey, Lee Downey.)

PREVIOUS OVERLEAF: Inlaid butterfly with mammoth ivory, opals, and Carico Lake turquoise. (Lee Downey.)

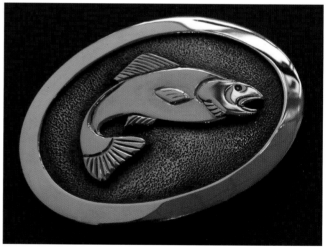

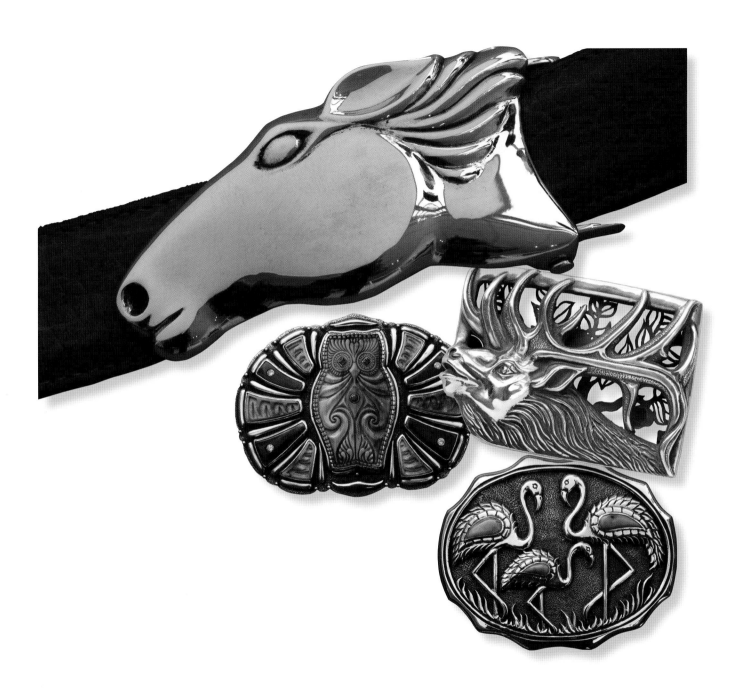

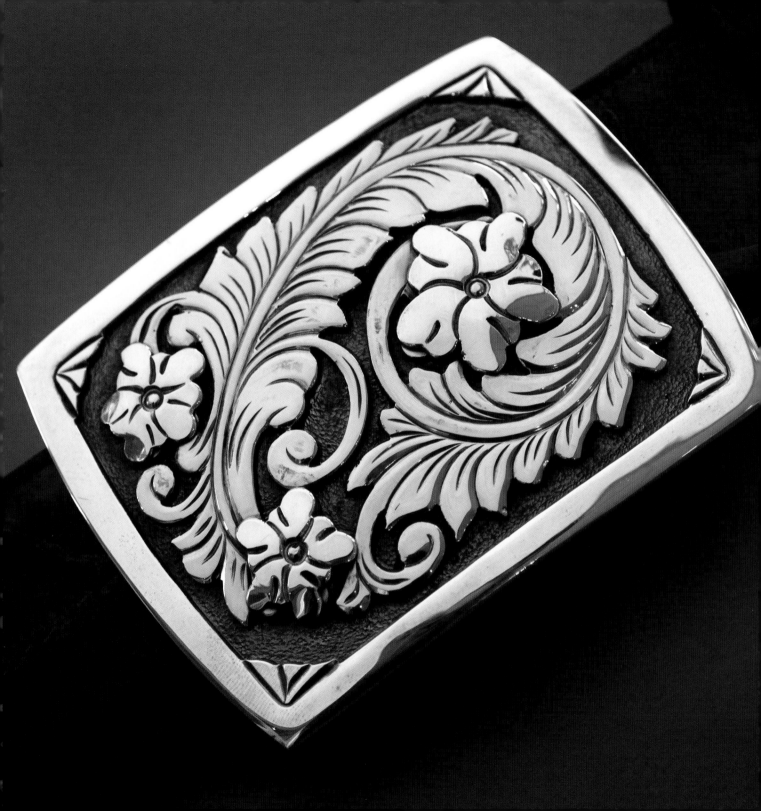

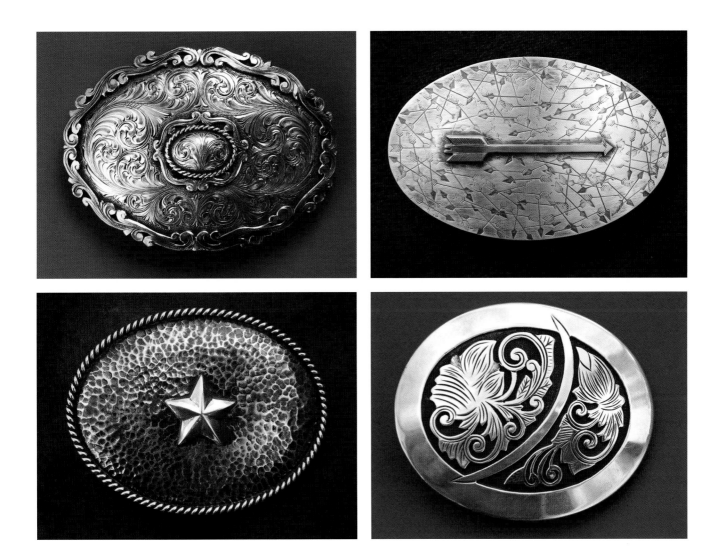

Creative techniques pushed by contemporary artisans. (Opposite: James Reid. This page top and bottom left, Clint Orms; bottom right, Richard Stump.)

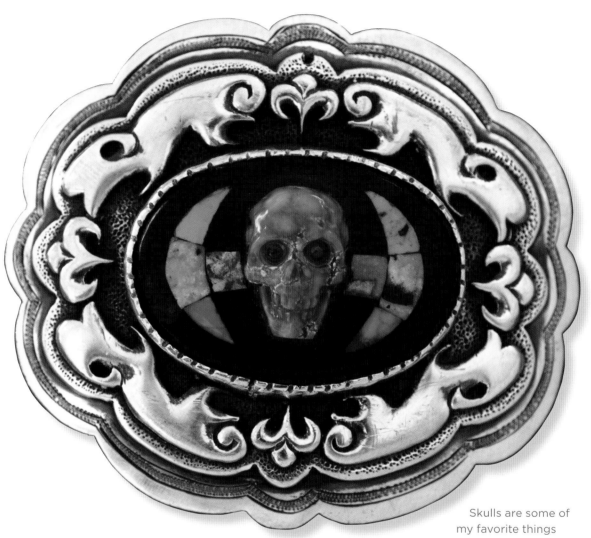

Skulls are some of
my favorite things
on contemporary buckles,
surrounded with great borders—even a
snake! (Samantha Silver and Lee Downey. Opposite,
clockwise from top left: Chet Vogt, Lee Downey, Jeff
Deegan, Mona Van Riper.)

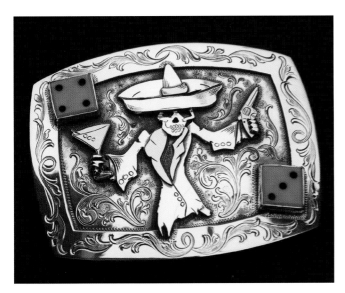

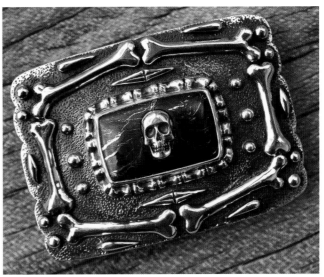

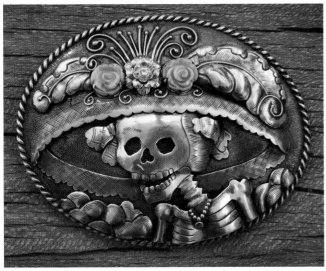

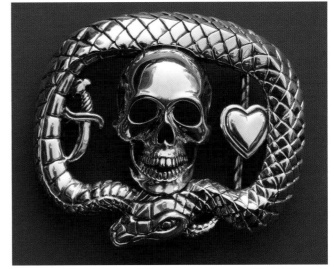

A modern take on older symbols, the Zia sign of New Mexico graces three. Right is a contemporary concho. (Clockwise from top left: Walt Doran, Jean Harris and Jean Taylor, Walt Doran, James Reid.)

OPPOSITE: Two very contemporary buckles, one of hammered sterling and the other unusual titanium with Bisbee turquoise. (Left to right: Cliff Doran, Pat Pruitt.)

"The artist: Having people respond to stimulus expressed through a piece of mine is the payoff. Always inspiring to register enthusiasm, good or bad . . . but hopefully never neutral.

"The pitch: Investing in a quality piece of art is always a good feeling, and if it's a buckle you'll never have to get caught with your pants down.

"The jeweler: This stuff is really driven by the beauty of the natural materials and how they fit into the whole human experience. . . . the instinct we all have to adorn ourselves and each other . . . it's one of the most basic of motivations. I see it as being talismanic— a wedding ring, a rodeo buckle, a diamond tiara—all contain messages, signals. We broadcast ourselves and our connection to the elements and mostly, the mystery.

"And really: Having the most amount of fun with your clothes on requires style, panache and just a bit of innuendo . . . admiring someone's buckle parts can cover all that ground."

—Lee Downey

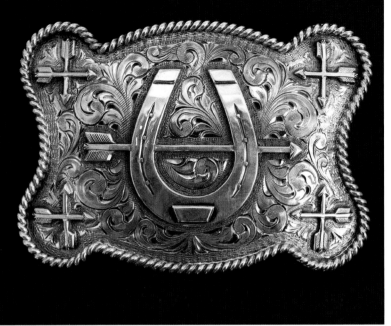

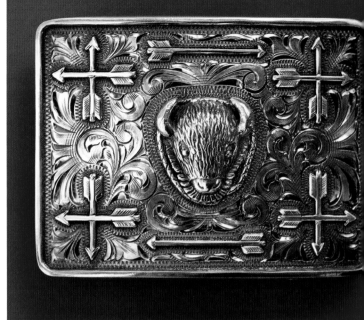

Combining symbols creates visual impact. Crossed arrows, a gold buffalo, and a streamlined longhorn "Rodeo or Die." (Clockwise from top left: Clint Orms, Clint Orms, Doug Magnus.)

OPPOSITE: A fleur-de-lis, a Carico Lake turquoise cross, a Guadalupe Madonna in mother-of-pearl, and a sacred heart. (Clockwise from top left: Doug Magnus, Mona Van Riper, Samantha Silver and Lee Downey, Jeff Deegan.)

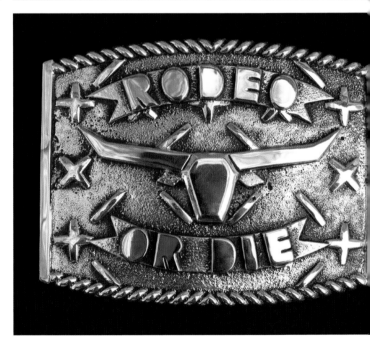

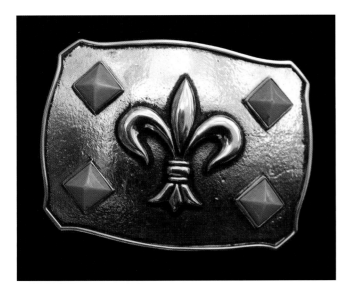
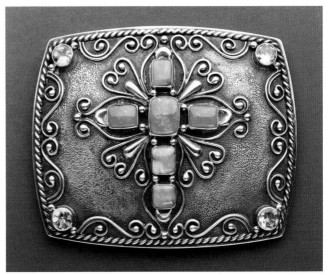
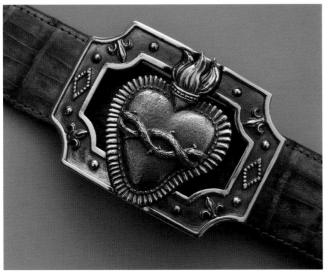
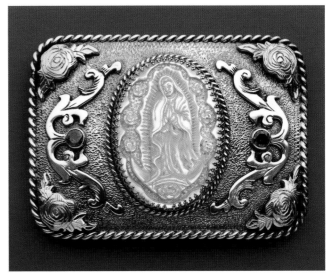

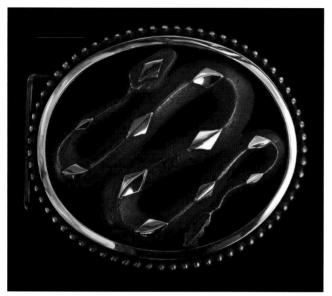
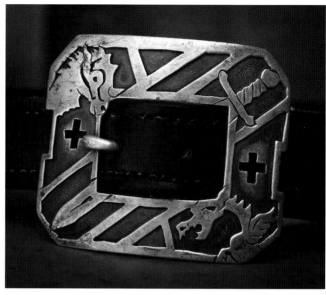
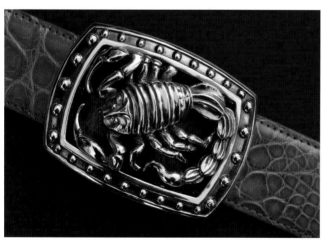
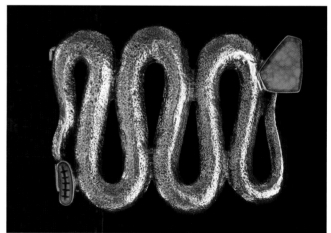

Snakes, dragons and scorpions define these buckles. (Clockwise from top left: Doug Magnus, Clint Mortenson, Doug Magnus, Barry Kisselstein.)

OPPOSITE: Jet, turquoise, and coral inlay create a stunning work of art. (Lee Downey.)

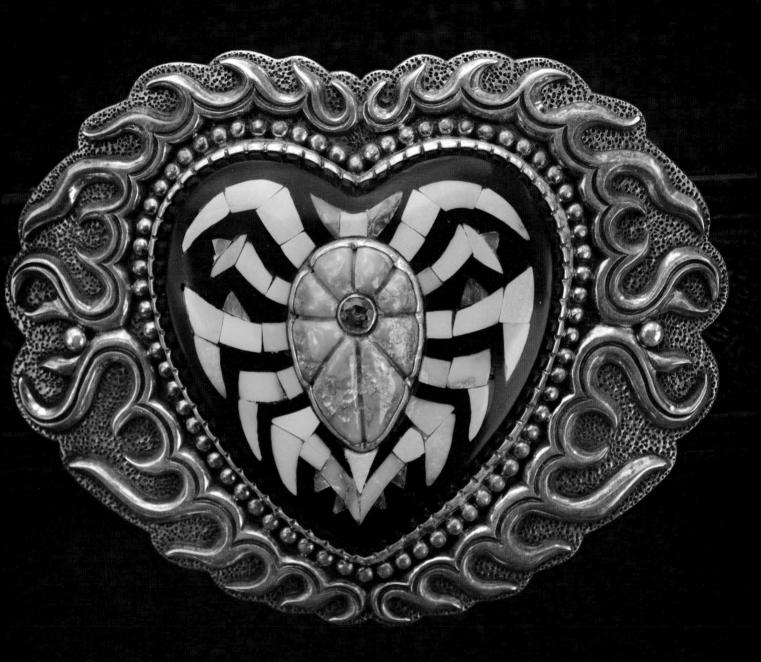

Carved stone, fossilized mammoth and lapis lazuli inlays. (Clockwise from top left: Lee Downey, Samantha Silver, Mona Van Riper.)

OPPOSITE: Turquoise is set in all shapes & sizes. (Clockwise from top left: Walt Doran, Walt Doran, Doug Magnus.)

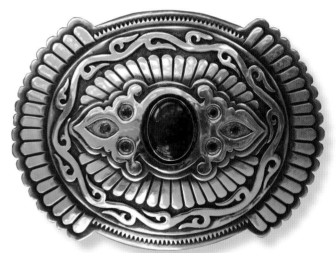

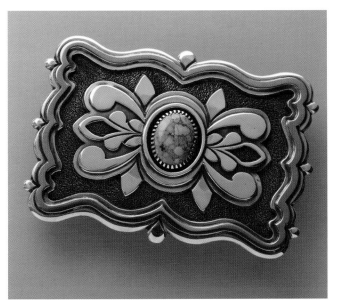

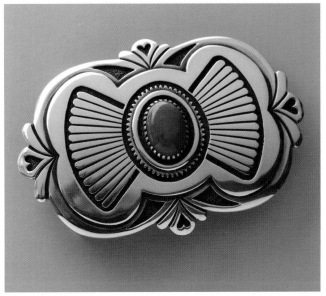

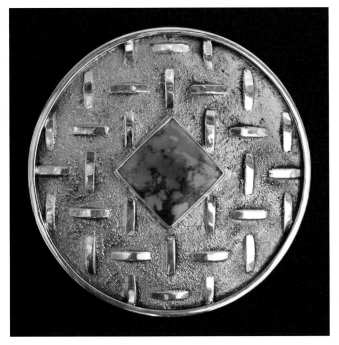

"I am very fortunate to be in a position of going to the shop each day and deciding what I'd like to make. I take this responsibility very seriously, and appreciate the opportunity to interpret buckle ideas into something that lasts a lifetime.

"Working on many of our buckles is like trying to put together a hot, moving puzzle. Between the angles of the silver and gold, the intense heat, and the catalyst used in soldering, you really need your wits about you."

—James Stegman

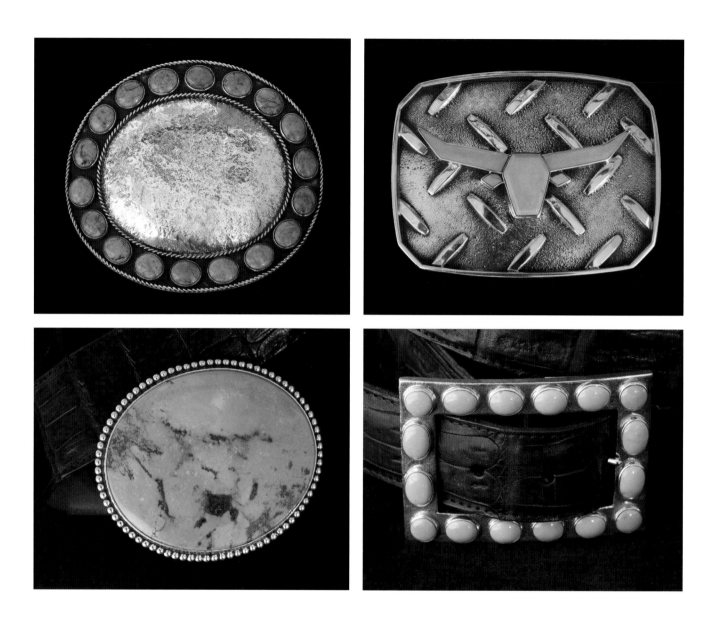

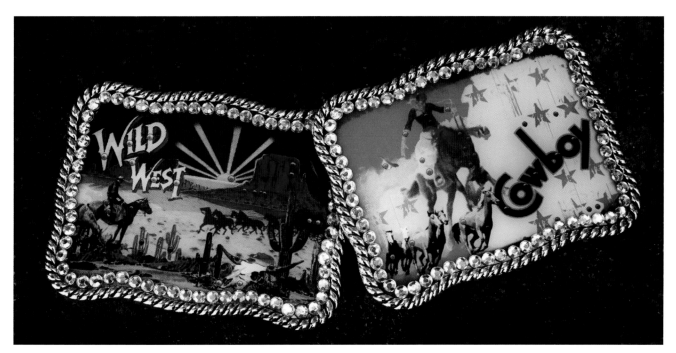

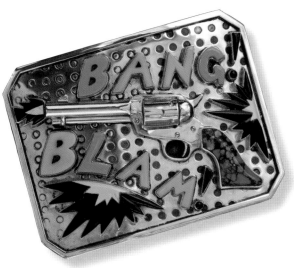

OPPOSITE: Turquoise used as borders, as a slab to make a whole buckle, and to shape a longhorn. (All Doug Magnus.)

All for fun! Kitschy western scenes for the kids buckles and "Bang Blam" to make a statement. (Bottom, Doug Magnus.)

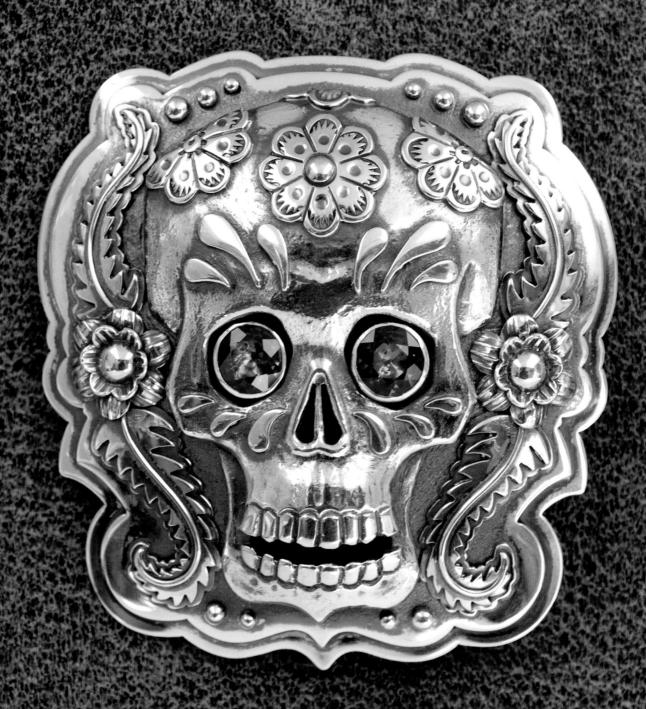

FAVORITE
WESTERN ICONS

I GUESS I WAS A western girl before I knew it. In Minot, North Dakota, I remember going to the rodeo on Saturday mornings. That's where I got my first tourist western buckle. I recently found a photo of my brother, Terry Ellisor, and me at Christmas when we had moved to Rehoboth Beach, Delaware; I had on my big western belt.

Some buckle companies took center stage as early as the 1920s, with Bohlin taking an early lead in saddles, buckles, spurs, you name it—the major cowboy accoutrements. Other companies joined the ranks of high-class buckle makers, one being John McCabe in 1923, which would later be acquired by Sunset Trails in the 1960s. Their work, along with Bohlin's, set the standard of excellence in western silver and gold creations.

I started collecting buckles with stones and to remember places I had been. Some of my favorites have icons like stars, cowboy boots, arrows, horseshoes, hearts, crosses, skulls, and my favorite—crowns.

"One of the challenges a buckle purchaser faces is understanding materials and production methods used. Materials normally fall into three categories: 1) high-end—made of solid sterling silver (a world standard of 92.5% silver and 7.5% copper) and gold (normally in karat from 10 kt. [42% gold] to 18 kt [75% gold]; 2) mid-range—sterling front whose gold counterpart is gold fill; 3) lower-priced pieces—plated silver and bronze-like materials. Each has its place, but the price and quality vary accordingly.

"Likewise in the building of a buckle, they may be totally handcrafted, cast from a mold, or machine stamped. Again, each has its place and price point.

"When shopping for a buckle, these are important points to remember."

—Chet Vogt

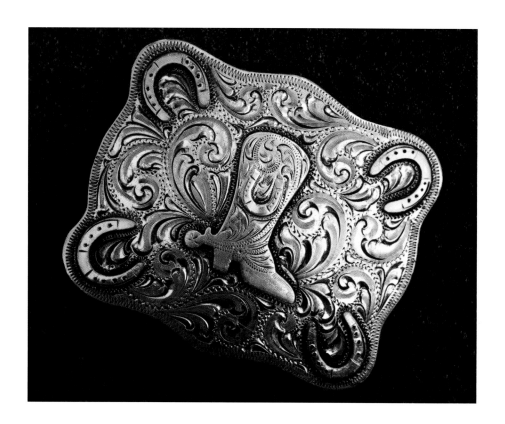

Vintage cowboy boot pin incorporated onto a trophy-style buckle. (Clint Mortenson.)

OPPOSITE: Cowboy boots and stars—two recurring buckle icons. Top Left is the "Golden Spur" buckle. (Clockwise from top left: Bohlin, Vogt, Silver King, Clint Orms.)

PREVIOUS OVERLEAF: Intricate flowered skull with green faceted eyes. (Annelise Williamson.)

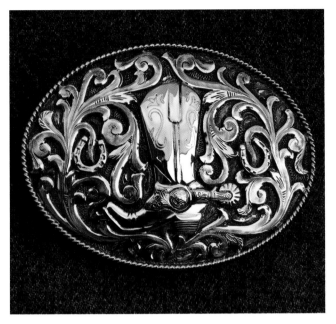
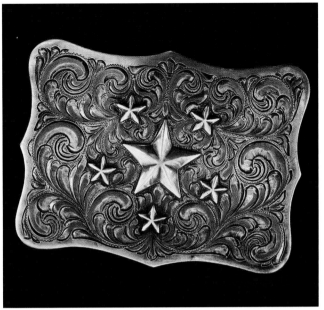
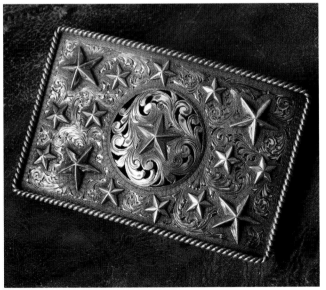
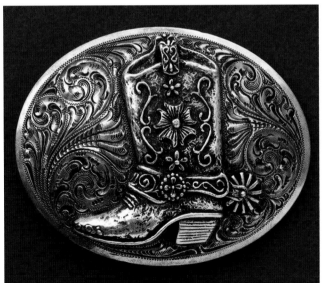

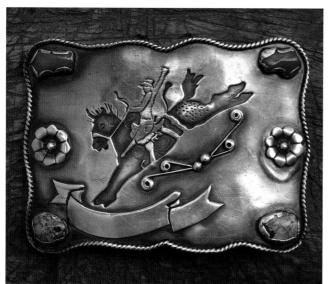

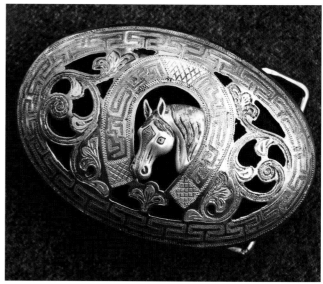

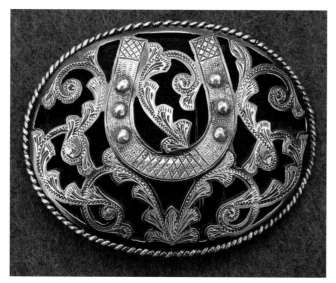

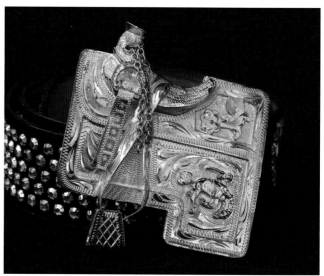

CLOCKWISE FROM TOP LEFT: Chunks of turquoise and coral surround a bronc rider on this vintage buckle. The Mexican silver inlay mimics piteado inlay. Horseshoe up, so the good luck doesn't fall out. Hank Snow's saddle buckle (courtesy of Marty Stuart).

OPPOSITE: Gold-nail horseshoe with diamonds. (Ann Lawrence collection.)

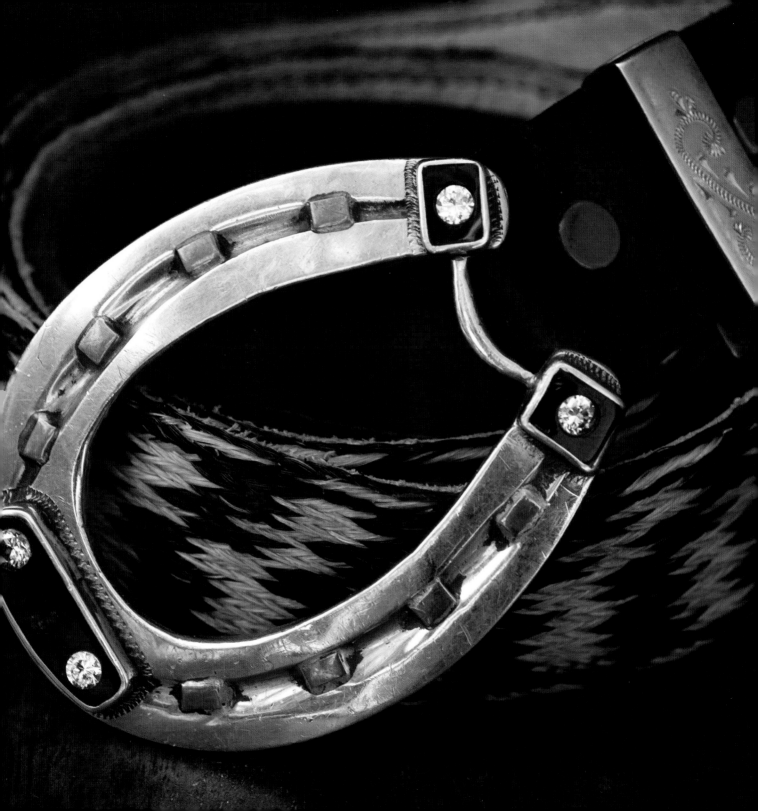

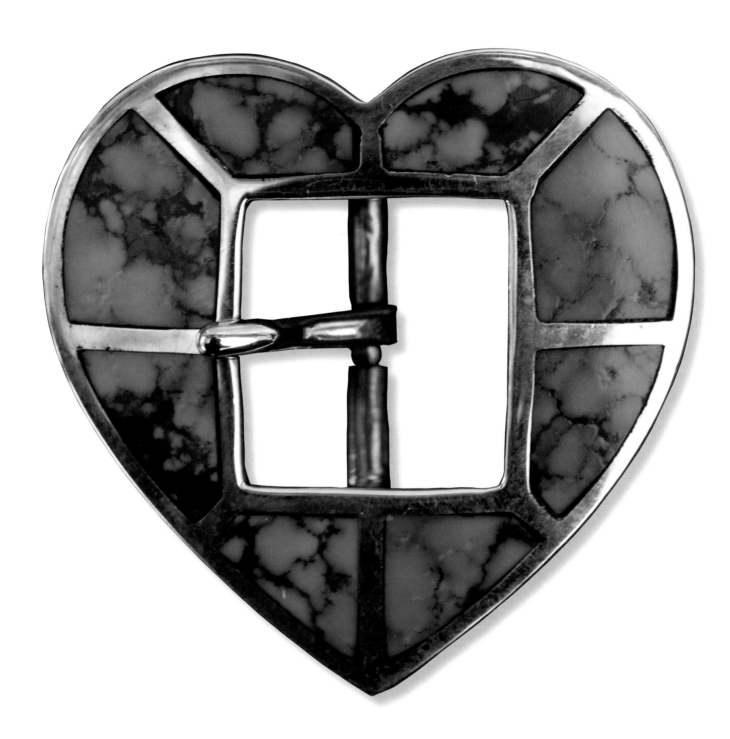

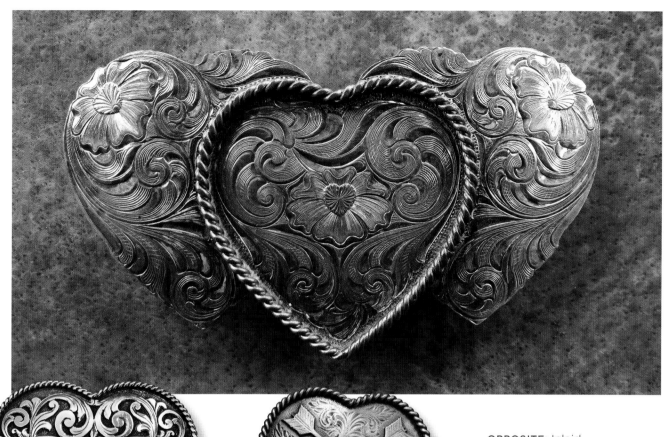

OPPOSITE: Inlaid turquoise heart buckle. (Doug Magnus.)

Triple silver heart with rope-outline overlaid heart; crossed arrows; an inlaid design featuring mother-of-pearl and colorful jewels; overlaid filigree corralled by a silver rope outline. (Clockwise from top: unknown, Clint Orms, Lee Downey, Comstock.)

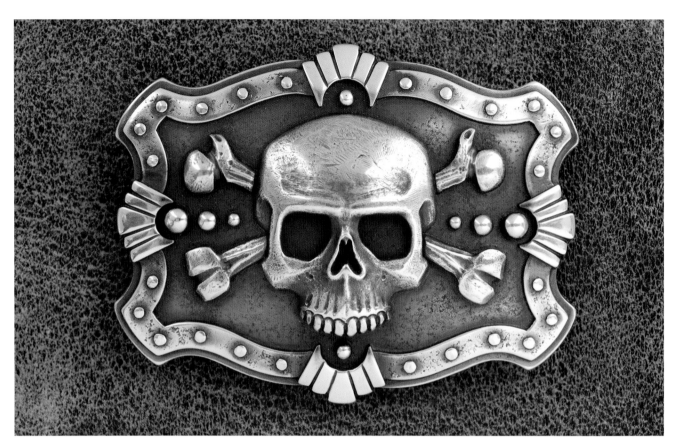

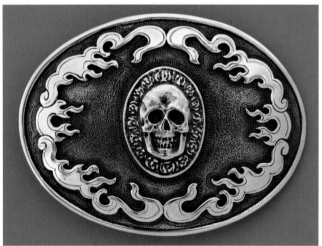

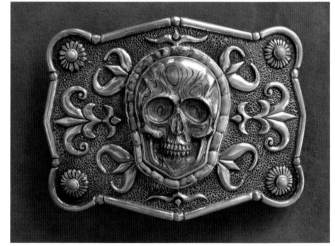

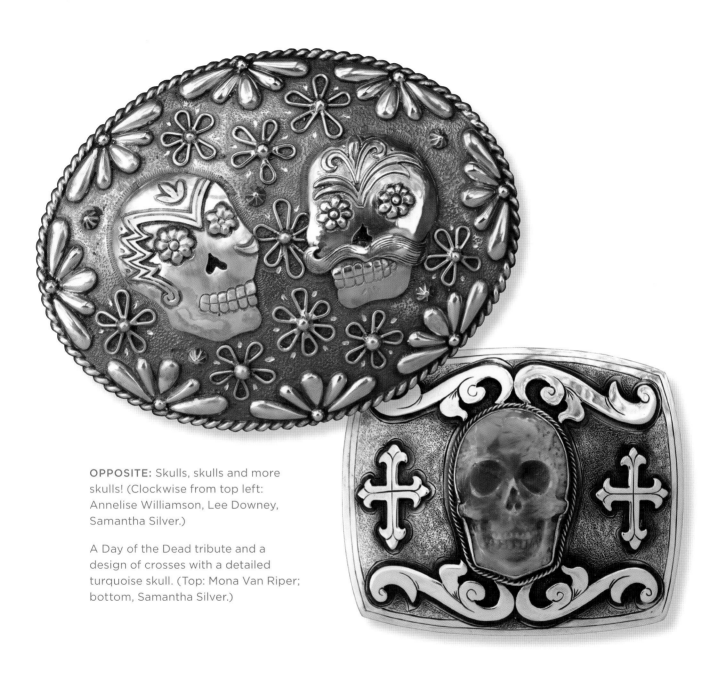

OPPOSITE: Skulls, skulls and more skulls! (Clockwise from top left: Annelise Williamson, Lee Downey, Samantha Silver.)

A Day of the Dead tribute and a design of crosses with a detailed turquoise skull. (Top: Mona Van Riper; bottom, Samantha Silver.)

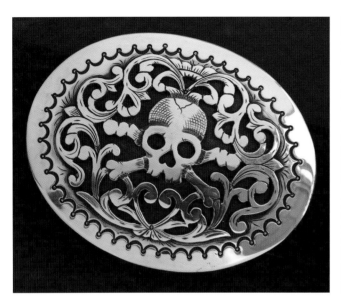 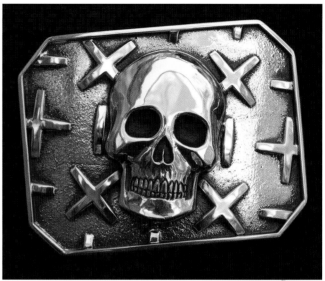

"My first buckle was a small antique Indian one I found in Paris in 1970.
The next ones were bigger, bigger, bigger, and bigger!

"In the beginning, it was more important to me for them to be vintage, but now, with all the great Native and Anglo artists, I've enlarged my mind and vision to include more diversity in my collection. They must be classic, elegant and flashy, combined with taste and technique — the soul of a buckle.

"And in today's world, it is more fun to invest in buckles than the stock market. When I get dressed in the morning, I decide my outfit starting with my buckle."

—Nathalie Kent

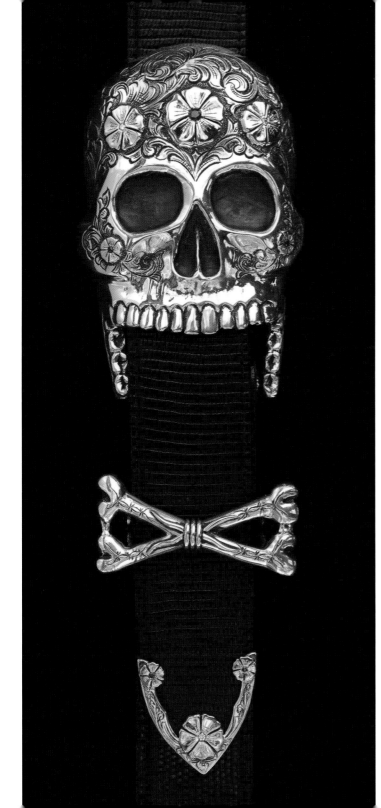

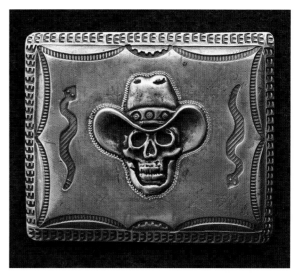

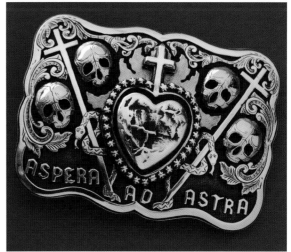

How many ways can you skull up a buckle? Filigree, overlaid on crosses, flowers on his head and a cool bow tie, wearing a cowboy hat, and in multiples. (Opposite left to right: Walt Doran, Doug Magnus. This page, clockwise from left: Doug Magnus, Tom Dewitt, Richard Stump.)

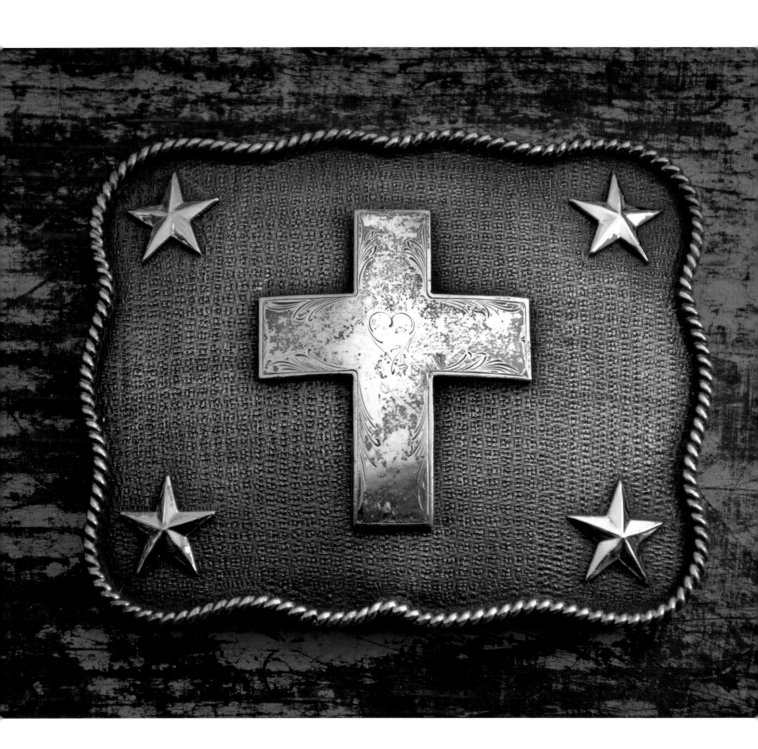

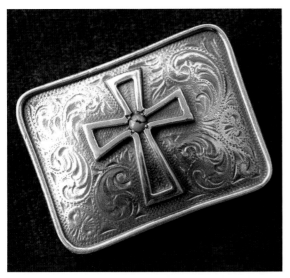

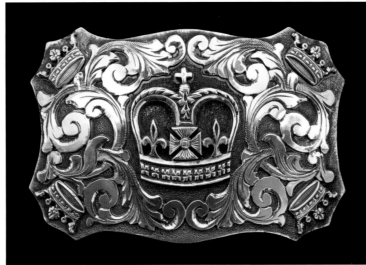

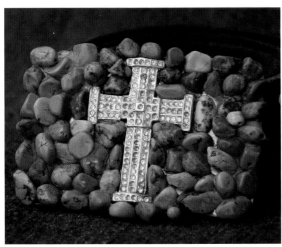

OPPOSITE: A classy design incorporates three popular icons—the cross, stars, and an engraved heart. (Clint Orms.)

Artistic interpretations of crosses. (Clockwise from top left: Clint Orms, Silver King, Silver King, Clint Mortenson, Mary's bling.)

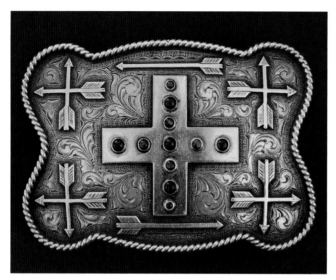
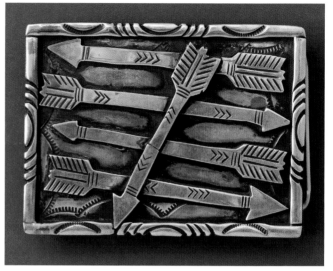
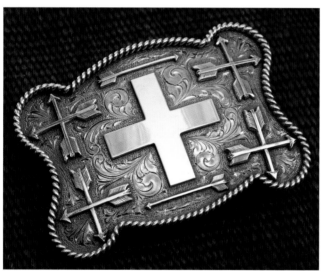
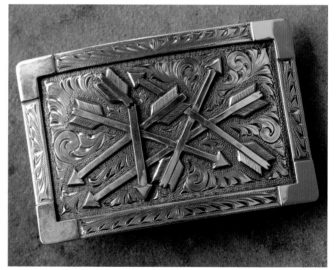

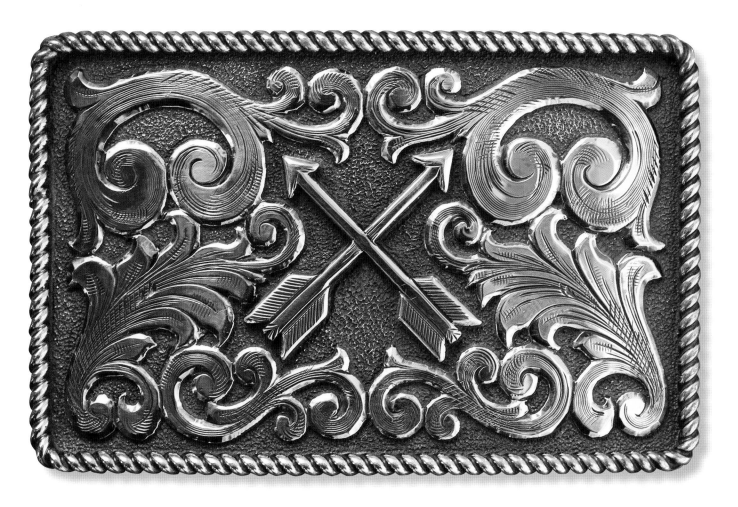

Arrows—crossed, jumbled, or broken. (Opposite, clockwise from top left: Clint Orms, vintage, Clint Orms, Clint Orms. This page, Clint Orms.)

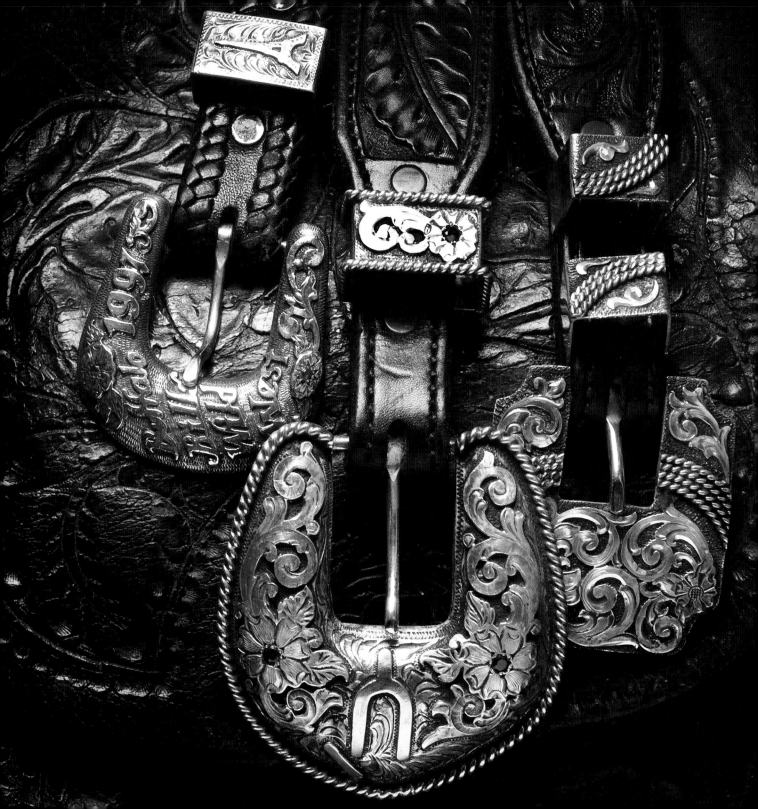

RANGER SETS

IN A RANGER SET, YOU have the buckle and one or two keepers and also a tip at the end. The tongue of the buckle goes through the keepers.

Ranger sets, generally in sterling silver and gold, are worn more for dressing up—in the boardroom as well as at the ball, for a night on the town with friends or a special charity event. Both women and men wear ranger sets.

The backgrounds are usually beautifully hand-engraved, adding raised figures to the buckle design such as initials, a horse, a cross, or roses.

Part of the cache of ranger sets is their sophisticated style; but part is a subtle message that although he may be a banker now, in his dreams he is western—maybe even a cowboy.

"My world is full of three-piece silver buckle sets. I can't imagine life without them. I have them on my watchband, briefcase, guitar straps, money holder, gun holsters, suits, coats, hatbands, belts, boots and sheaths. I'm convinced, on more than one occasion, a buckle set is the only thing that has held me together and kept me from blowing away to Pluto. A man needs a good silver buckle set."

—*Marty Stuart*

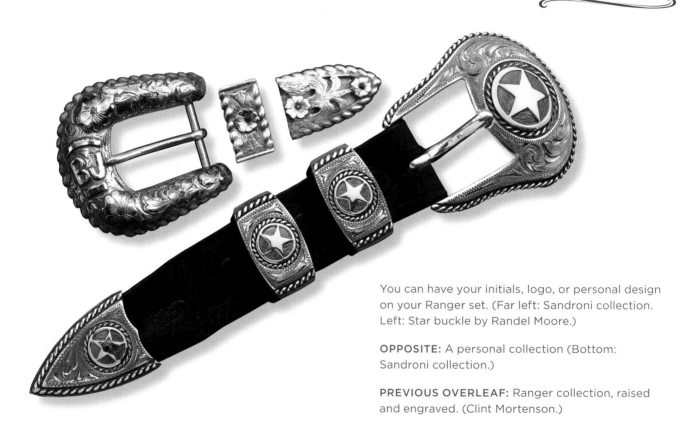

You can have your initials, logo, or personal design on your Ranger set. (Far left: Sandroni collection. Left: Star buckle by Randel Moore.)

OPPOSITE: A personal collection (Bottom: Sandroni collection.)

PREVIOUS OVERLEAF: Ranger collection, raised and engraved. (Clint Mortenson.)

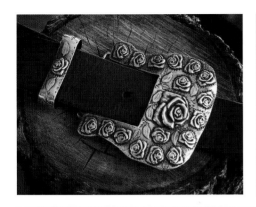

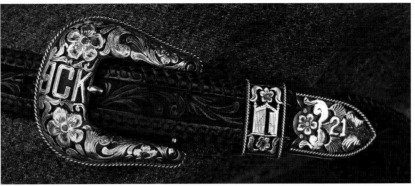

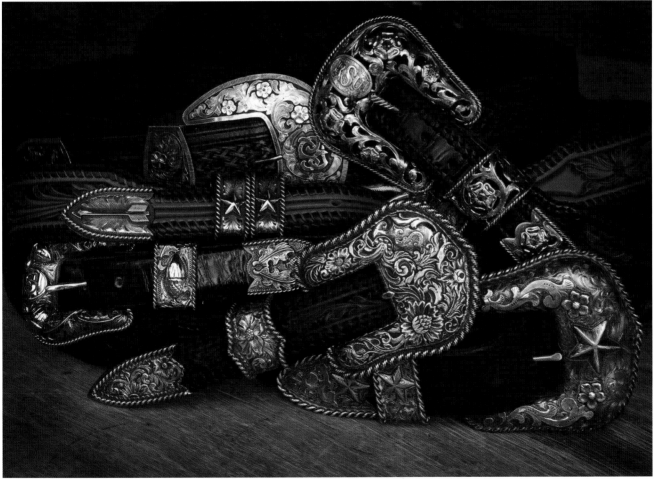

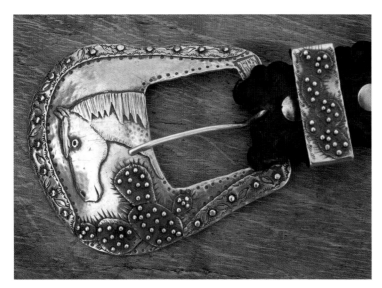

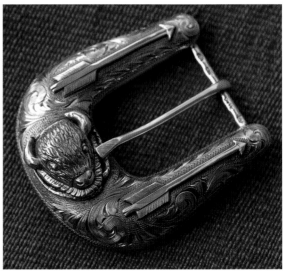

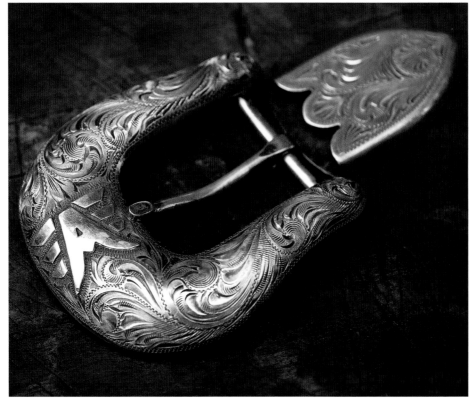

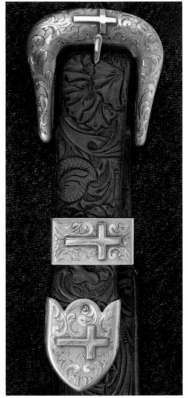

OPPOSITE: Add a horse head, a bison, a flying A, or the cross to personalize. (Top left, Margaret Sullivan; top right and bottom left and right, Clint Orms; bottom right courtesy Reg Jackson.)

Classic but contemporary variations of the ranger buckle. (Top to bottom: James Reid, John Rippel, James Reid.)

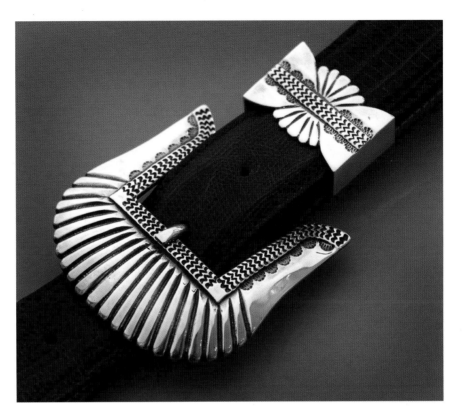

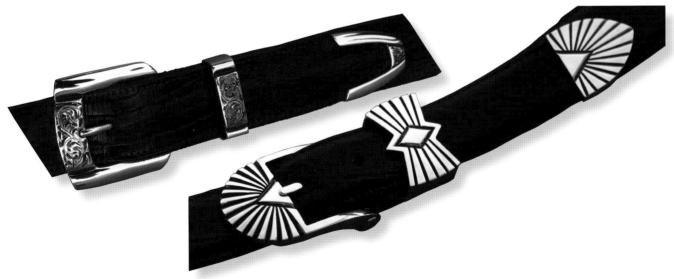

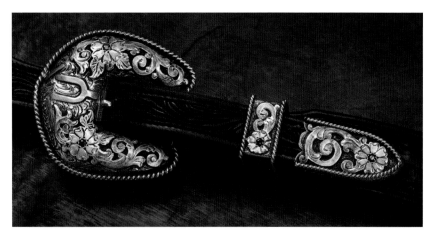

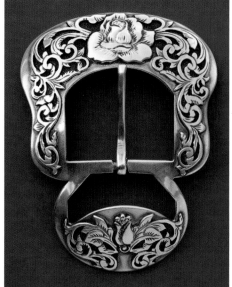

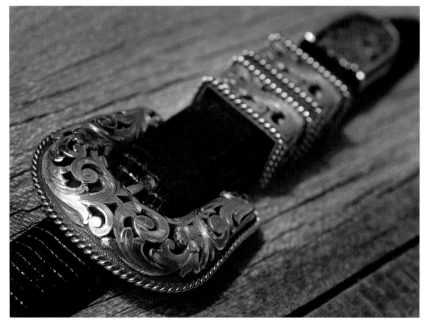

Gold in three colors creates style all its own. (Clockwise from top left: Clint Mortenson, John Rippel, Clint Mortenson, Clint Orms.)

OPPOSITE: Three elegant gentlemen's buckle sets crafted for Wilson Franklin. (Left to right: Harry Hudson, Chet Vogt, Ahmed Kahn.)

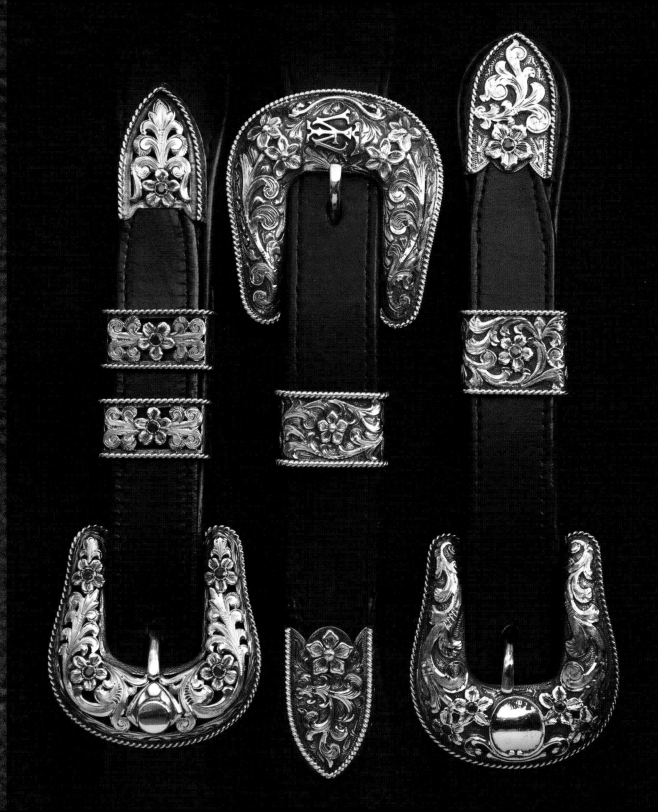

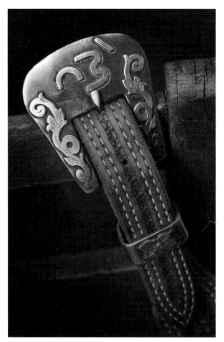

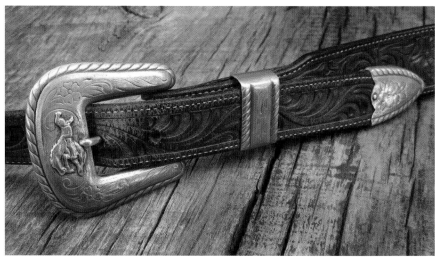

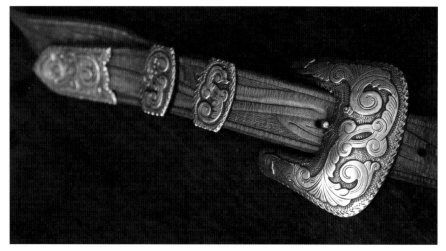

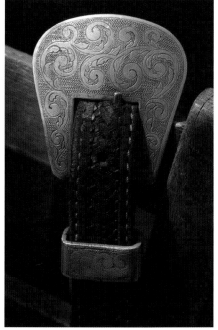

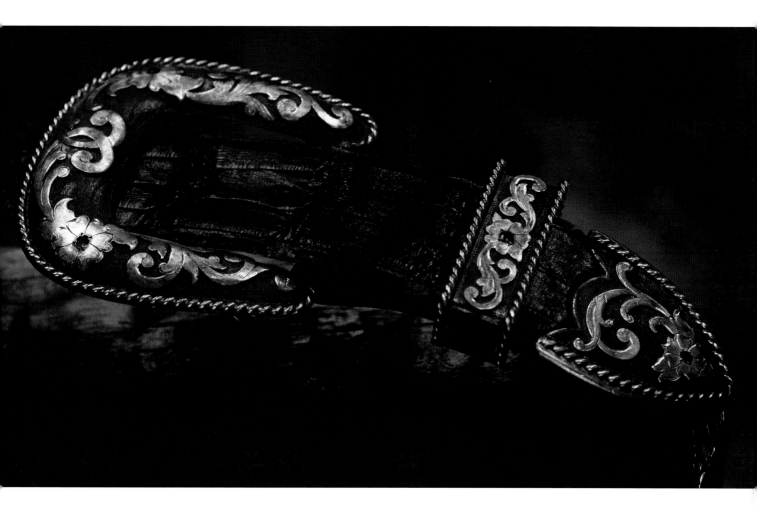

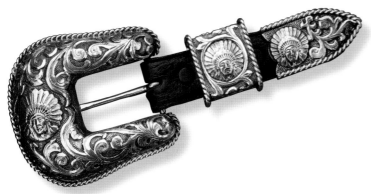

OPPOSITE: More unusual are buckles made of brass. (Clockwise from top left: Matt McClure, vintage, Matt McClure, vintage.)

ABOVE: Johnny Cash's personal buckle. (Courtesy Marty Stuart collection.)

LEFT: Overlaid silver on black background pops the design. (Chet Vogt.)

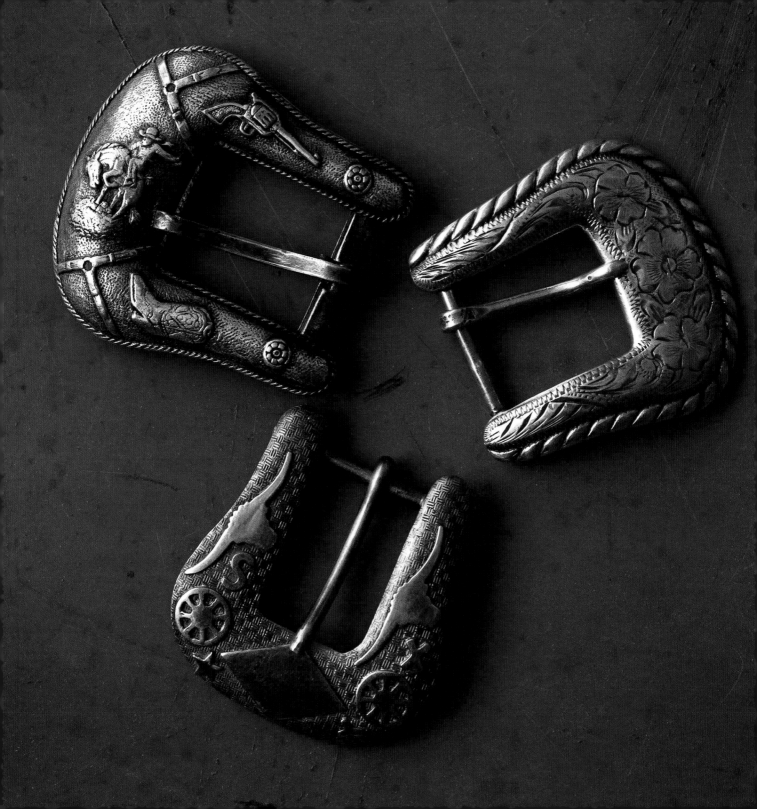

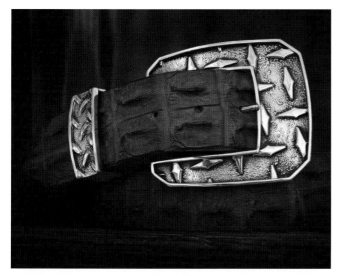

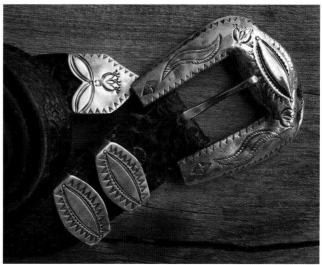

OPPOSITE: Vintage classic cowboy styles. (Mortenson collection.)

A diamond plate look, gold overlay, and stamping suit individual tastes. (Clockwise from top left: Doug Magnus, vintage, Tom Dewitt, Arnold Goldstein.)

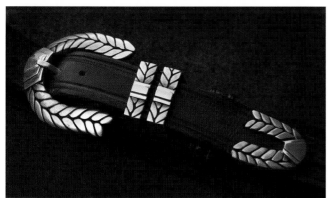

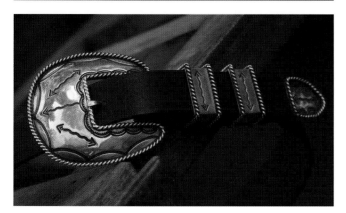

"The greatest challenge for me building a custom one-of-a-kind buckle is not in its actual production, but in its design. When I design the piece, it is very important to try to 'read the mind' of the person who will be wearing it. I feel that a buckle reflects the personality of the wearer—some want big and bold while others want small and conservative. Some want a buckle set; some want a buckle only. Some want a great amount of detail (ranch name, their name, etc.), while others want only a simple monogram. It is my job to understand the unique desires of that customer so that when the final product is delivered, I hear, 'Wow, this is perfect.' Mission accomplished."

—*Chet Vogt*

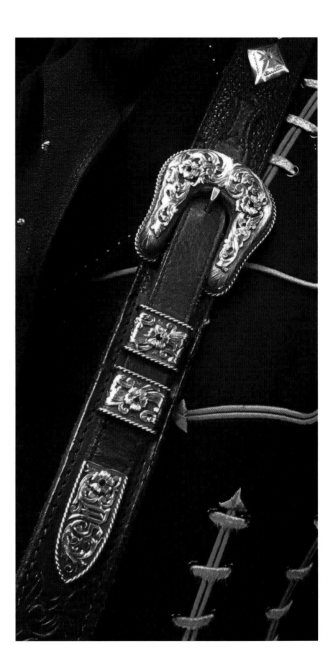

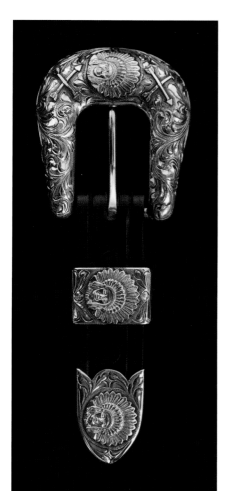

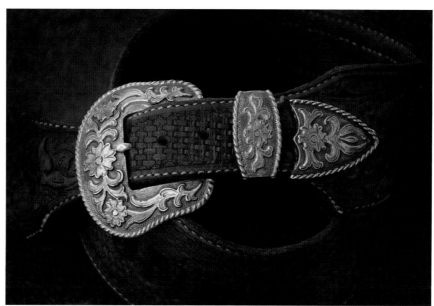

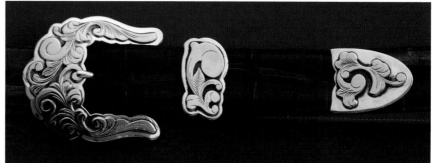

OPPOSITE: A four-piece gold ranger set with overlay jazzes up Marty Stuart's guitar strap.

THIS PAGE: An exquisite Indian head detail and two floral designs in gold decorate silver buckles. (Clockwise from top left: Bohlin, unknown, James Reid.)

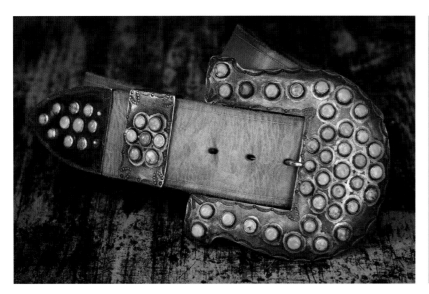

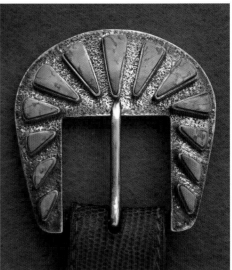

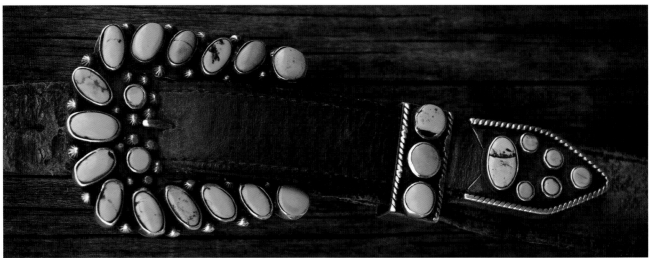

Turquoise embellishes all of these vintage Native American–made buckles.

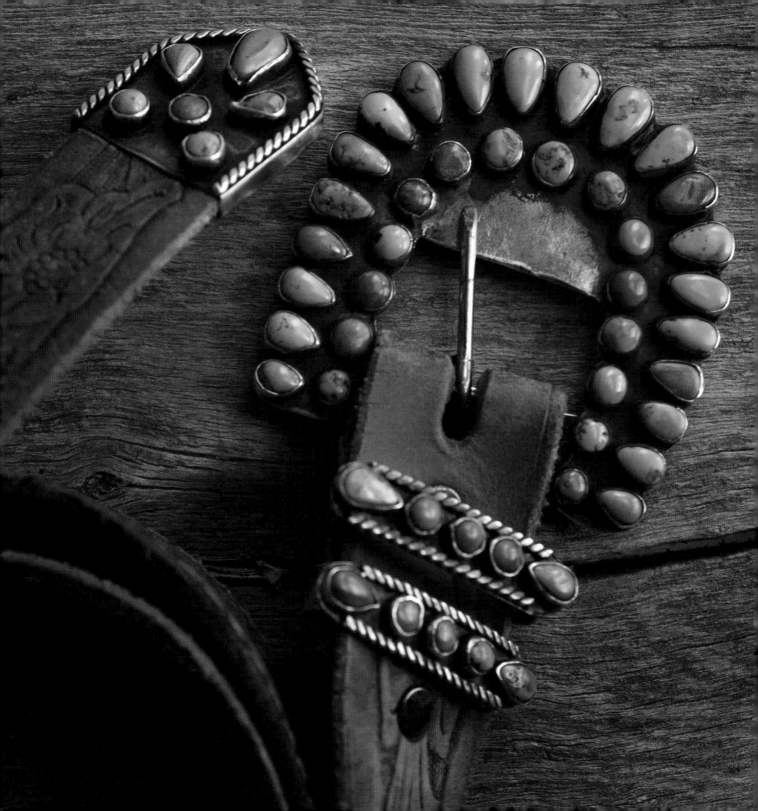

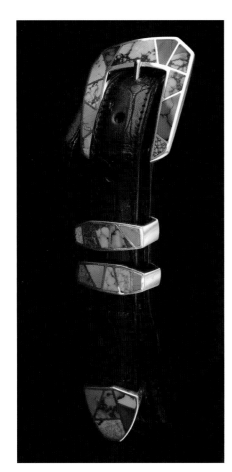

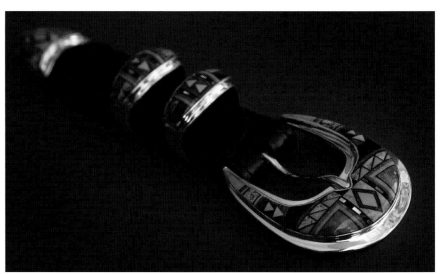

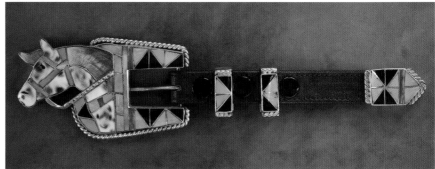

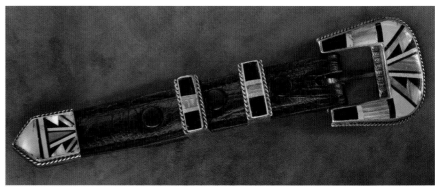

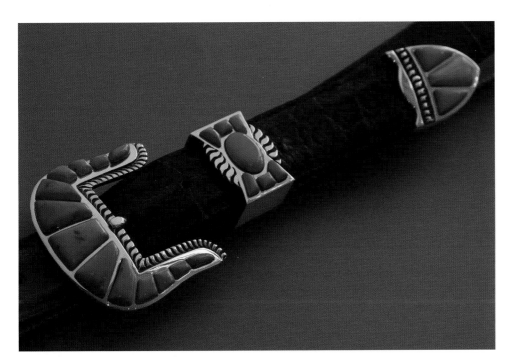

OPPOSITE: Stunning examples of craftsmanship and inlay techniques with turquoise, coral, jet, spiny oyster, and lapis. (Top left: B. G. Mudd, others unknown.)

Domed inlaid turquoise in two different looks. (Both James Reid.)

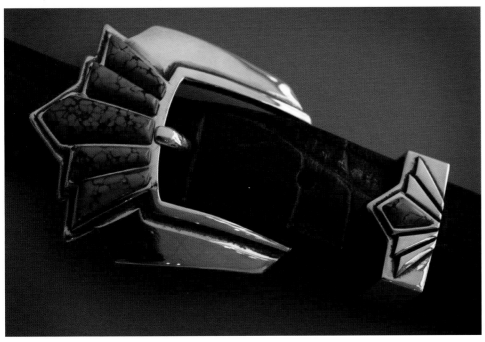

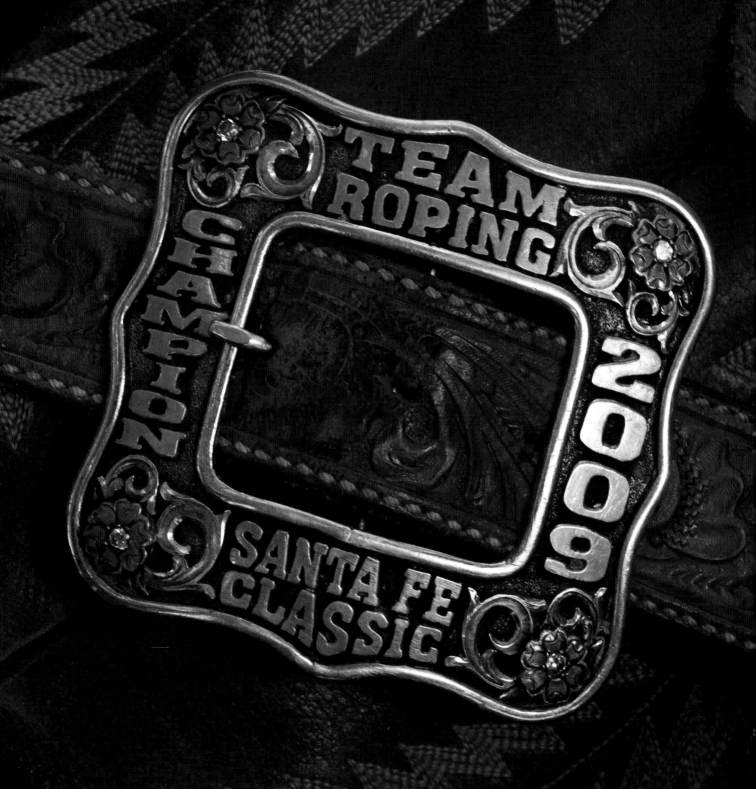

TROPHY

TWENTY-TWO MILLION FANS SUPPORT rodeo each year, and talented riders, ropers, clowns, and even announcers have been awarded trophy buckles over the decades. Riders can win buckles for roping, barrel racing, riding, and all other skill events—and for all-around cowboy.

There are many different regional and national rodeo associations in North America, for all ages and skill levels—from little britches, junior, high school, and college to ranch, professional women's, cowboy's, all-Indian and more. At all of the rodeos organized by these groups, trophy buckles are awarded to the winners. A trophy buckle is a real point of pride for these athletes, as it identifies their accomplishments to people who see them win or wearing the buckle.

Very large buckles are also called "trophy" for their size, even if they weren't awarded as rodeo prizes.

While the ultimate way to have a trophy buckle is to win it, the rest of us can enjoy collecting trophy buckles from pawnshops and antique shows. I am known for my western rodeo buckles and love wearing them.

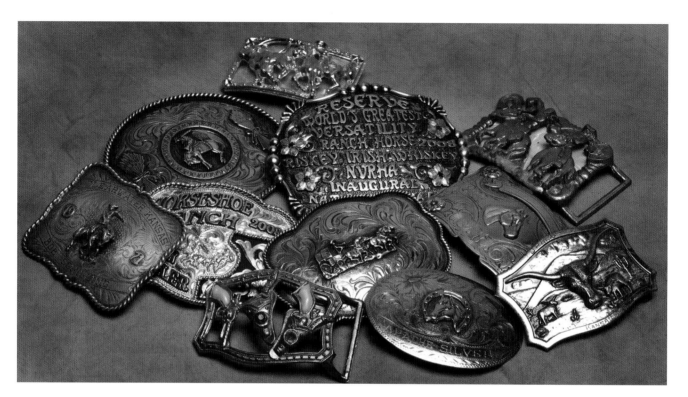

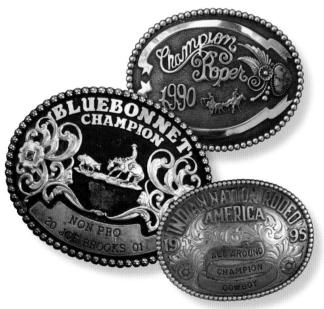

"When I design a trophy buckle, I really consider what event it is for or who will win it. New designs with a vintage look are my favorites. One of my biggest compliments is seeing a top cowboy or cowgirl that I know has won a lot of buckles through the years wearing one of mine as their favorite. I feel lucky to do what I do. I like the mix of creativity and working with Western heritage stuff."

—Clint Mortenson

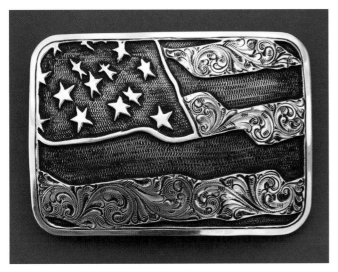

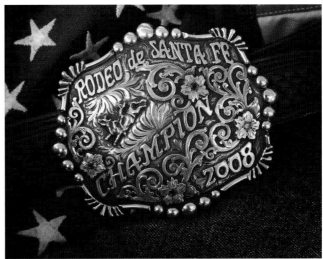

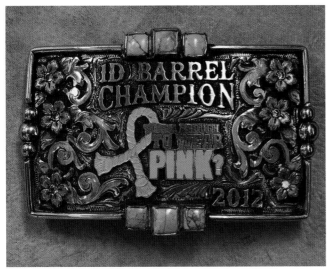

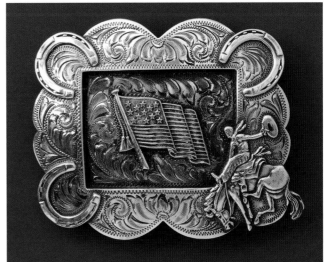

OPPOSITE: Fun collection of vintage event buckles in all shapes and sizes.

Tributes to the American flag, breast cancer awareness, and the Santa Fe Rodeo champion.

(Clockwise from top left: Silver King, Clint Mortenson, Comstock, Clint Mortenson.)

PREVIOUS OVERLEAF: Unique open-center champion buckle. (Clint Mortenson.)

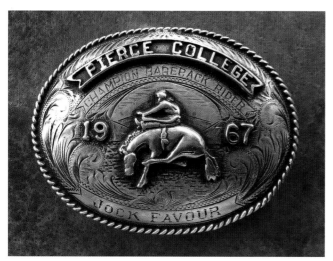

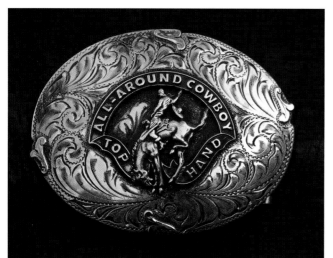

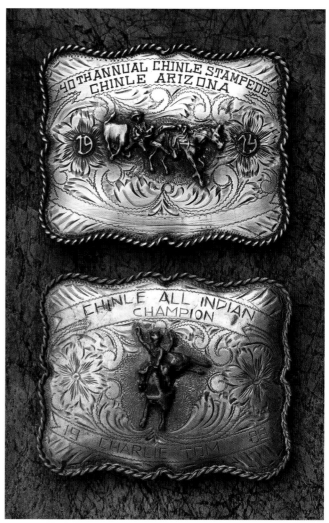

College champion bronc rider Jock Favor became a silversmith himself. Two award buckles from Chinle. All-around cowboy buckle. (Comstock.)

OPPOSITE: Most of these trophies came from small-town rodeos. (Courtesy Jock Favor collection.)

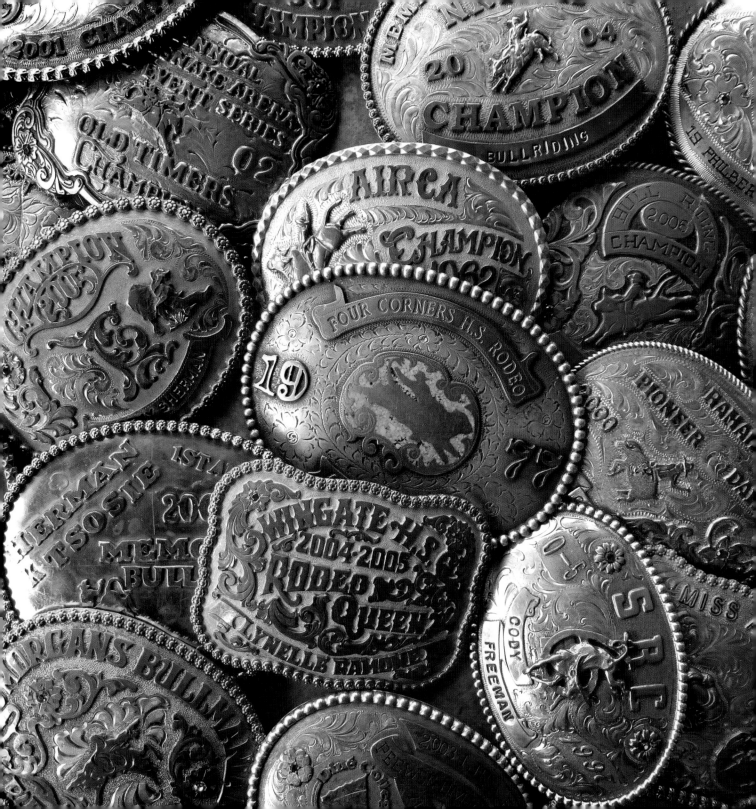

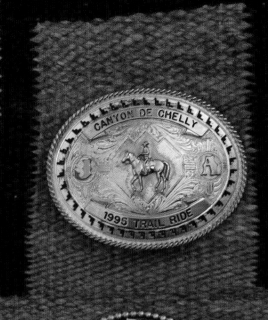

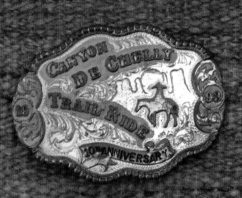

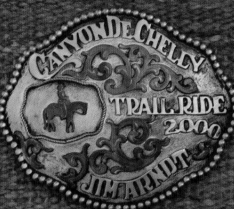

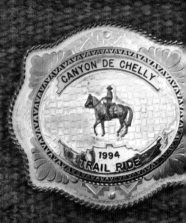

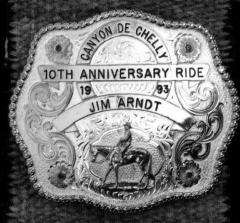

COMMEMORATIVE & PERSONAL

WHETHER YOU HAVE RIDDEN A horse a hundred miles in one day, starred in a Wild West show, set a land speed record at the Bonneville salt flats, or want a reminder of your ranch, an event, or even your initials, a treasured commemorative buckle becomes part of your heritage, to be worn proudly and handed down to generations that follow.

You can go to a silversmith and have them make a special buckle that you and your significant other design together. This is a very personal way to make a special gift and a great memory.

"I was in the country music duo Brooks and Dunn for almost twenty years. We played countless rodeos. Each time we did, we were given buckles. As a result, I have hundreds of them. Prize buckles are the ultimate cowboy 'atta boy.'

"Each event, and consequently each buckle, has a story of its own.

"Cheyenne is the grand Daddy of 'Em All. It has an old-school, Wild West organic vibe. I wore the buckles from Cheyenne for years. They were fashioned more like buckles that were made to be worn and not displayed, so I wore them. I remember playing the 100th anniversary of the Daddy of 'Em All. I don't know if I was more excited about getting the commemorative buckle or playing the show. I would've played just to get that buckle."

—*Ronnie Dunn*

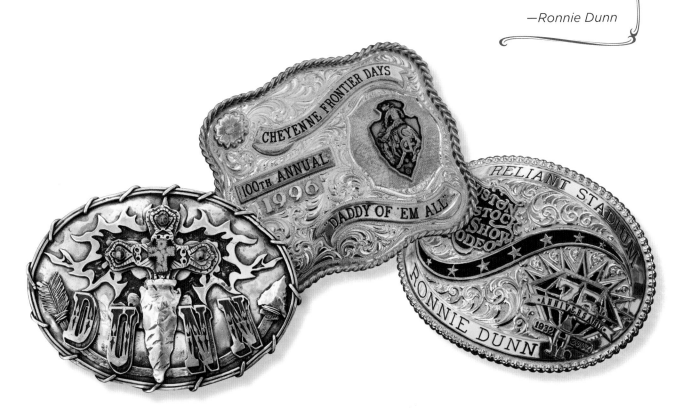

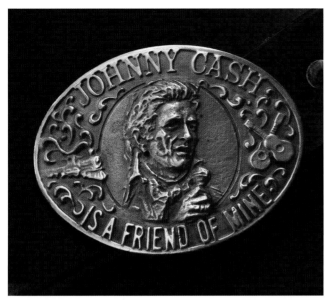

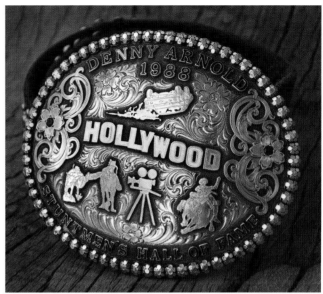

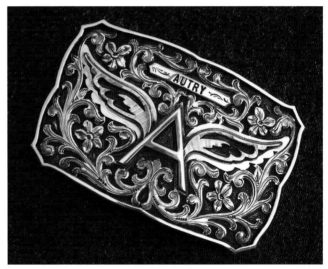

OPPOSITE: Ronnie Dunn's personal buckles include "Dunn" buckle. (Nancy Anderson.)

Buckles commemorating Johnny Cash, Hollywood, and two flying A's—one of Jim Arndt's and one for Gene Autry. (Clockwise from top left: courtesy Marty Stuart, Gist, Bohlin, Holland.)

PREVIOUS OVERLEAF: Commemorative Canyon de Chelly trail ride buckles. (Designed by Amado Pena, Jr.)

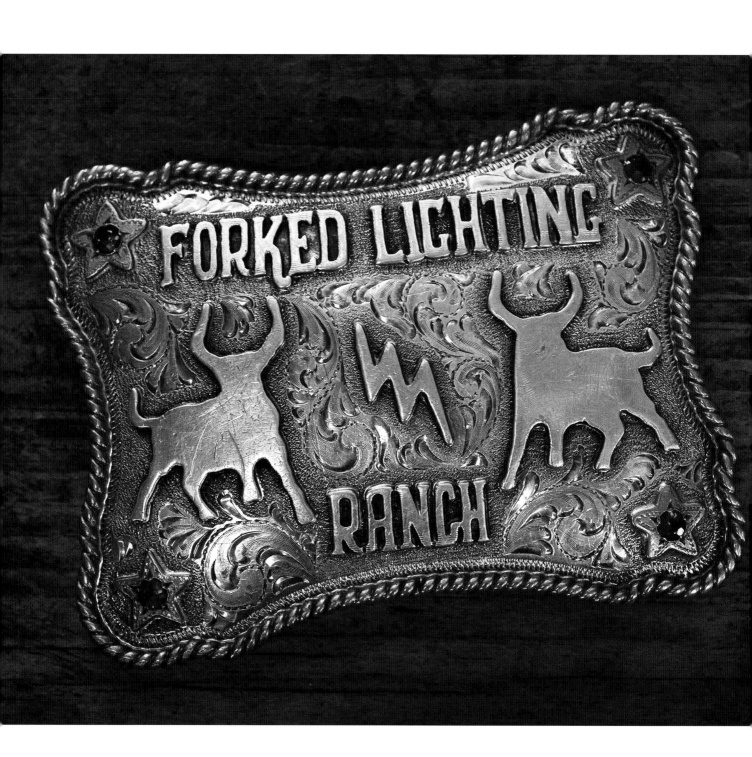

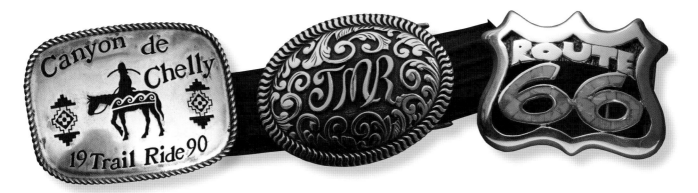

Anything and everything can be commemorated on a buckle—ranches, trail rides, favorite initials, Route 66, or a movie. (Clockwise from top left: unknown, James Reid, Harvey Kaplan, Clint Mortenson.)

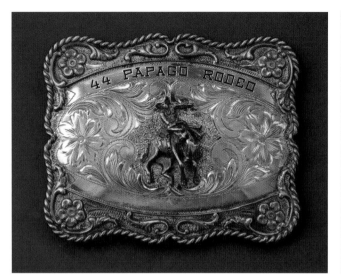

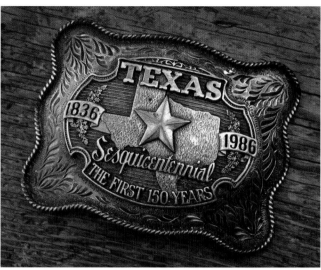

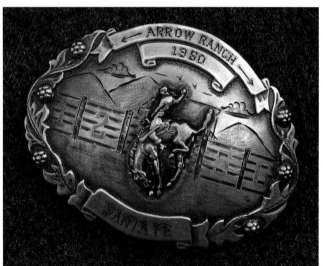

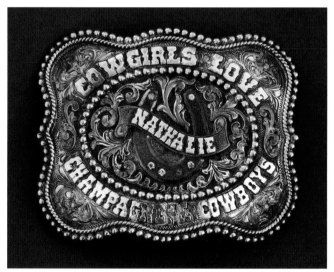

Commemorating events, ranches, and cowgirl-cowboy love. Collecting a variety of buckles makes it fun! (Clockwise from top left: unknown, unknown, Clint Mortenson, Comstock.)

OPPOSITE, TOP: Custom Johnny Hallyday ranch buckles. (Clint Mortenson.)

OPPOSITE, BELOW: Boots and Boogie and M. L. Leddy commemoratives. (Clockwise from top: Clint Mortenson, M. L. Leddy, Clint Mortenson.)

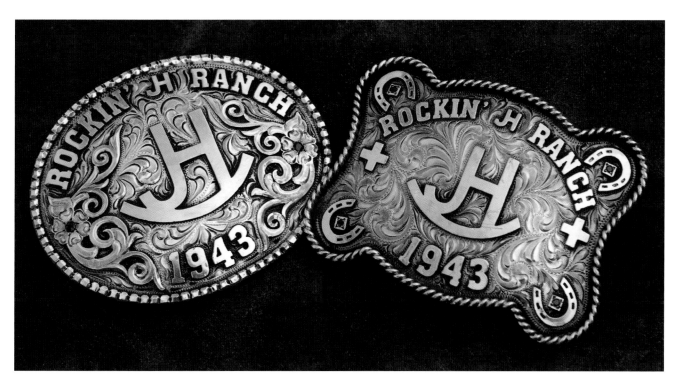

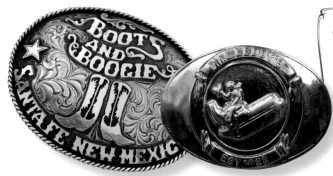

"I'm French, but when I put on my trophy buckle and hat, I am a Cowboy!"

—*Johnny Hallyday*

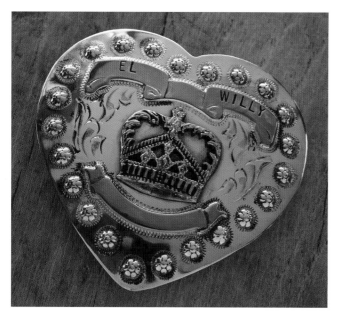

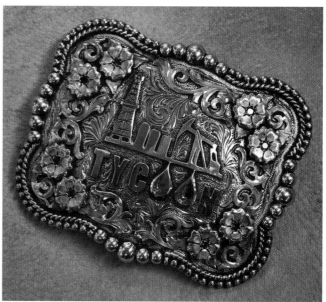

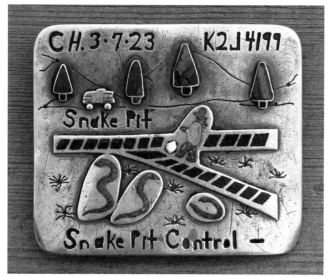

Marty Stuart's "El Willy" gift from Billy Gibbons. An oil tycoon needs a buckle. Snake pit control . . . who knows? Four sixes — the story goes that the ranch was won in a card game with four 6s, and thus its name. (Top right: Clint Mortenson; others unknown.)

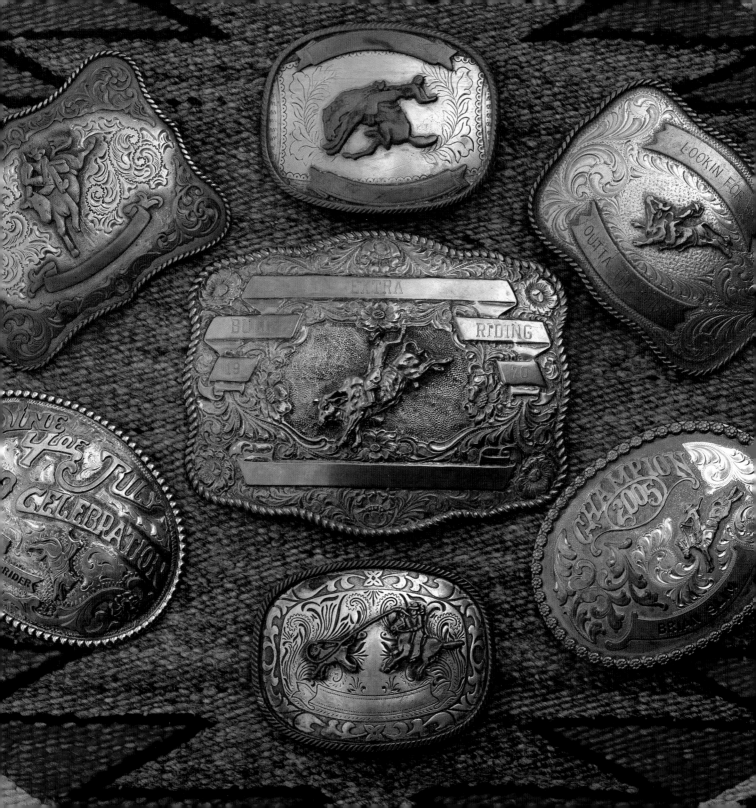

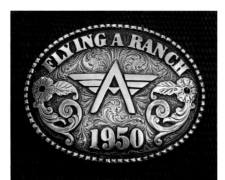

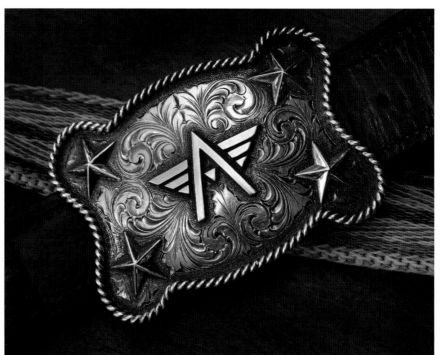

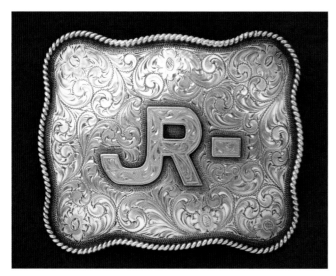

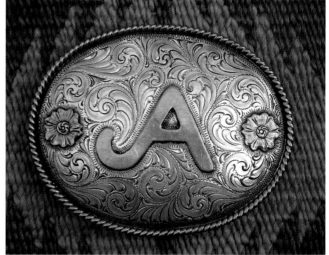

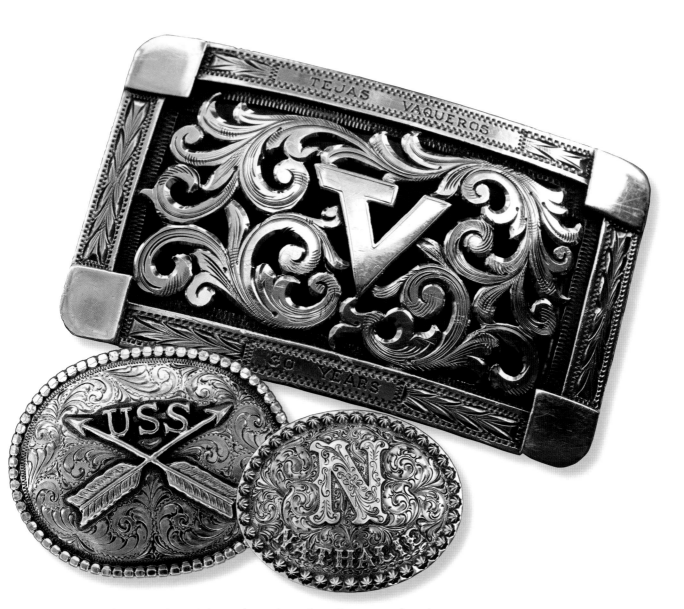

OPPOSITE: Logos or brands have always been favorites on cowboys' buckles. (Clockwise from top left, Hopi-made, Clint Orms, Clint Mortenson, Clint Orms, Clint Mortenson.)

A tribute to the thirtieth anniversary of Teas vaqueros. A USS pin re-used on a contemporary trophy buckle. Nathalie's big N engraved buckle. (Clockwise from top: Clint Orms, Silver King, Clint Mortenson.)

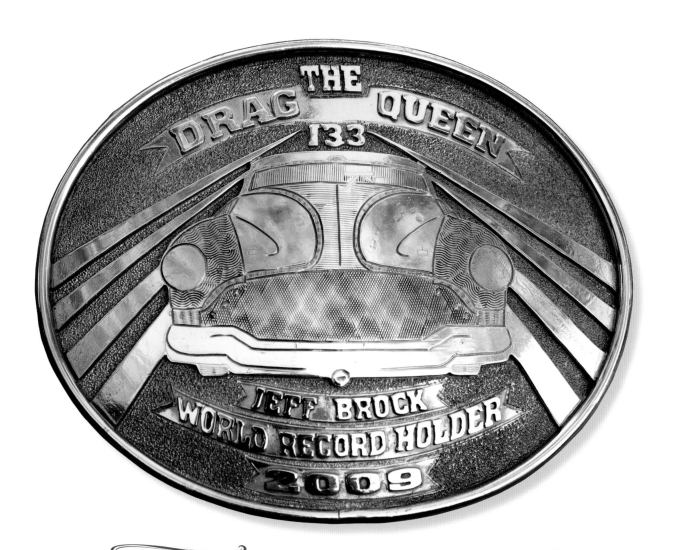

"Nothing is quite as exciting for me as actually being on the salt at Bonneville racing, but my buckle reminds me of my first time there, setting the World Land Speed record."

—Jeff Brock

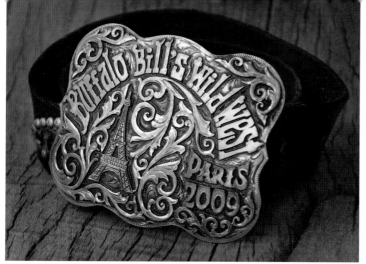
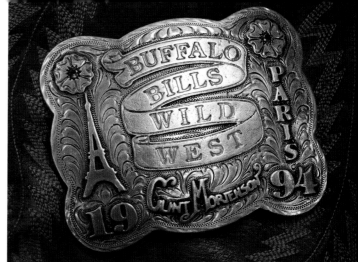
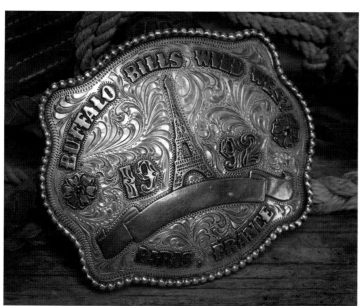
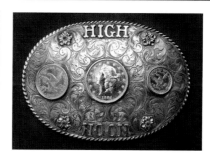
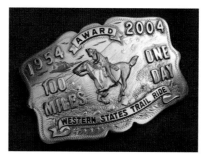

OPPOSITE: Buckles need not necessarily be western themed. Brock's Bonneville Bombshell 1952 Buick buckle. (Clint Mortenson.)

Remembered: the West in Paris France in three variations on Buffalo Bill's Wild West show; High Noon; a hundred-mile race. (Clockwise from top left: Clint Mortenson, Clint Mortenson, unknown, Comstock, Clint Mortenson.)

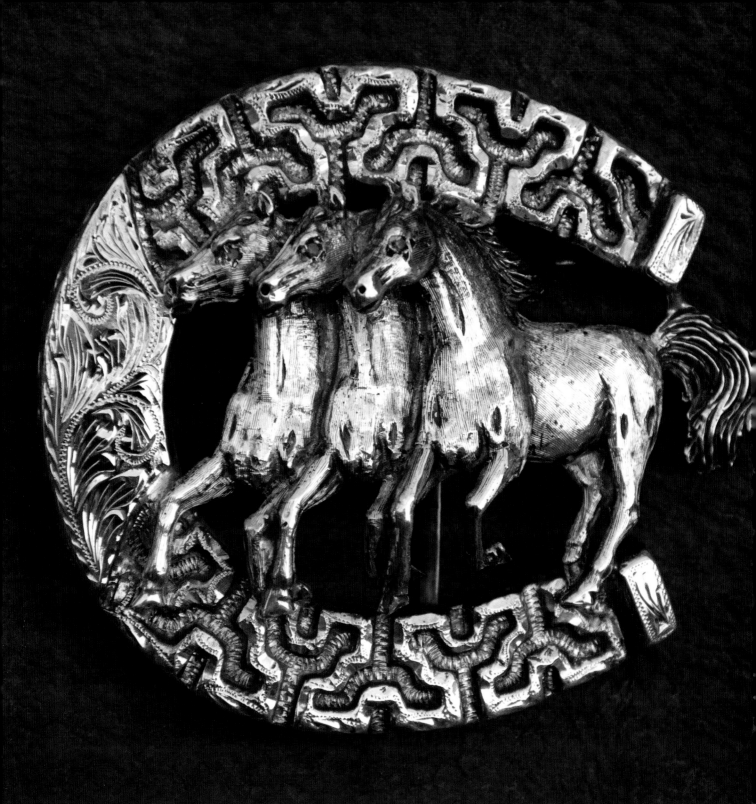

EQUINES, BOVINES & SIDEWINDERS

WITH OVER NINE MILLION HORSES in America and a whole bunch of longhorns, it is no wonder that they end up on so many buckles. Horse people, western or not, have a love affair with their horses and all things horsey. Antique or contemporary, a buckle with a horse will be special to them. Buckle artists use the image of a rearing horse, a prancing one, or just a horse head to adorn all shapes and styles of buckles.

It's the same if you are connected with a cattle ranch, are a Texas girl, or just like longhorns—you will look for those buckles with cattle imagery.

Other animals are ensconced on buckles too—such as buffalo, bear, birds, and sidewinders—even if one does not like snakes, they still look great in designs of gold or silver on those unique buckles.

"William Faulkner once said, 'The aim of every artist is to arrest motion, which is life, by artificial means and hold it fixed so that a hundred years later, when a stranger looks at it, it moves again . . .' These are wonderful, wise words. It is my goal to make sure our buckles sing, dance and have a never-ending life of their own."

—Clint Orms

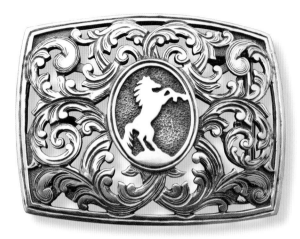

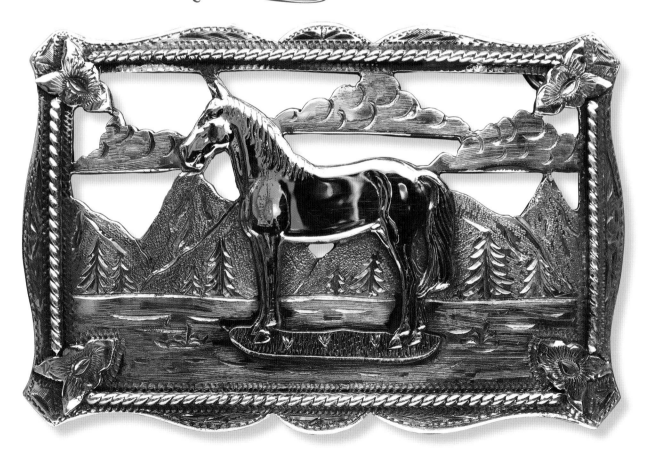

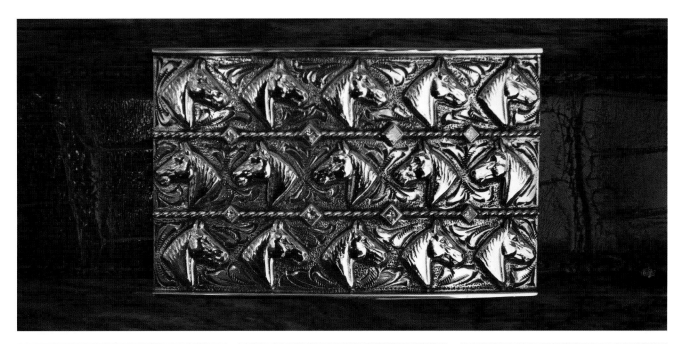

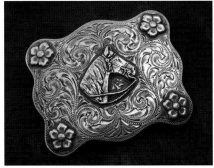 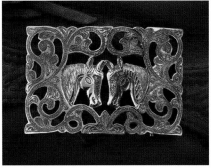 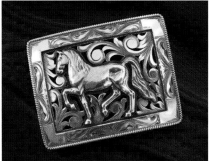

A rearing stallion, a horse head, standing in a landscape, or in multiples—the horse probably shows up on more buckles than any other animal. (Opposite top: Mona Van Riper. Opposite bottom: Comstock. This page, clockwise from top: Doug Magnus, Clint Orms, unknown, Bohlin.)

PREVIOUS OVERLEAF: Three-horse buckle. (Sandroni collection.)

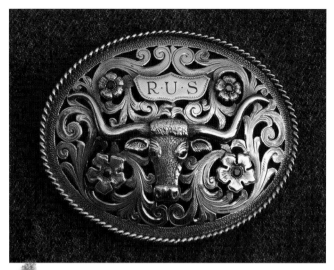

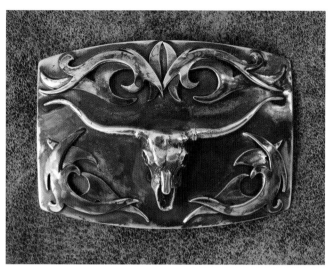

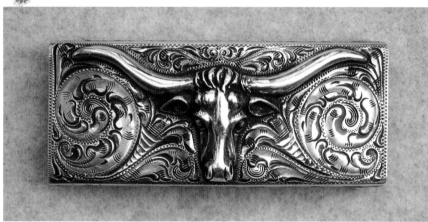

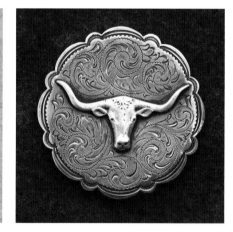

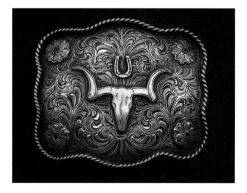

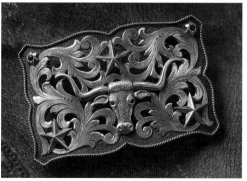

The image of the longhorn is a buckle staple. (Clockwise from top left: Clint Orms, Comstock, Tom Dewitt, Clint Orms, Clint Mortenson, Silver King. Opposite: Tom Dewitt.)

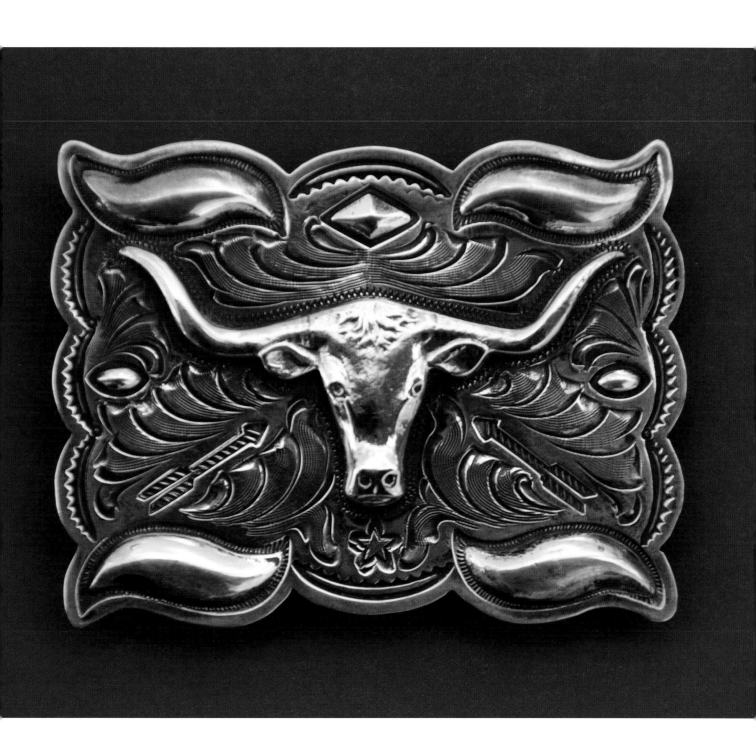

"In my designs the one consistent thread has been a fascination with the physicality of form. For me, I love jewelry that has a certain voluptuousness and a seamless consistency of sensory experience between the seeing and the actual feel of the piece in your hands. The tactile reinforces the visual. Shape and volume on my favorite designs are strong and graphic; "bold will hold," as the saying goes. I have employed any number of techniques over the years, including carving direct into metal, repoussé and raising. And while I still may employ these skills from time to time, sculpting in wax affords me the best and most expressive technique to achieve my vision.

"The major part of my body of work is based on the exploration of the power and attraction of iconic motifs. I look for motifs that have resonated down through the ages and across cultures, similar to what Jung referred to as the "collective unconscious." Animals, crosses and skulls, to name but a few, are some of the most potent symbols appearing in artwork from primitive time to the present. Building a design with any one of these taps into a strong and ancient narrative, enhancing the physical form I seek to sculpt.

"So for me the strongest designs have always been about sculptural form together with content and the dynamic they communicate. The sculpting and execution of the piece is a series of decisions based on shape and proportion, between polished and matte, smooth and detail-worked surfaces."

—*Jeff Deegan*

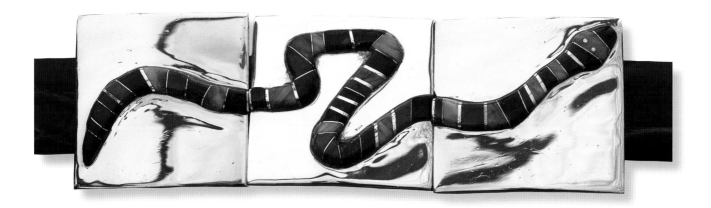

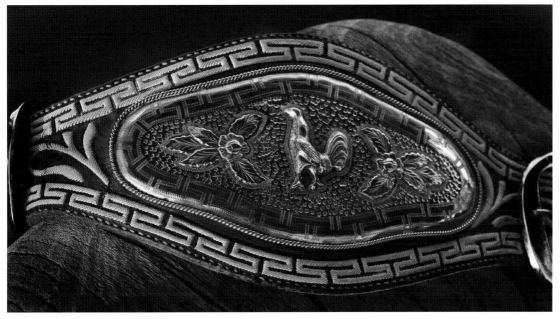

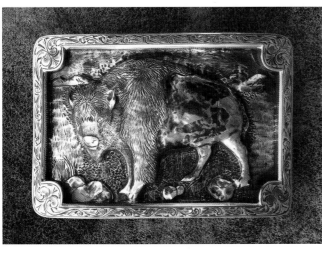

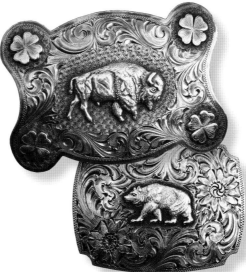

OPPOSITE: A snake slithers across a three-piece buckle. (Brett Bastian.)

A rooster buckle is set on a piteado belt. Repoussé buffalo are lifelike if not life-size. A golden bear speaks of someone's affinity for wildlife. (Clockwise from top left: Ann Lawrence collection, Clint Orms, Schaezlein, Bohlin.)

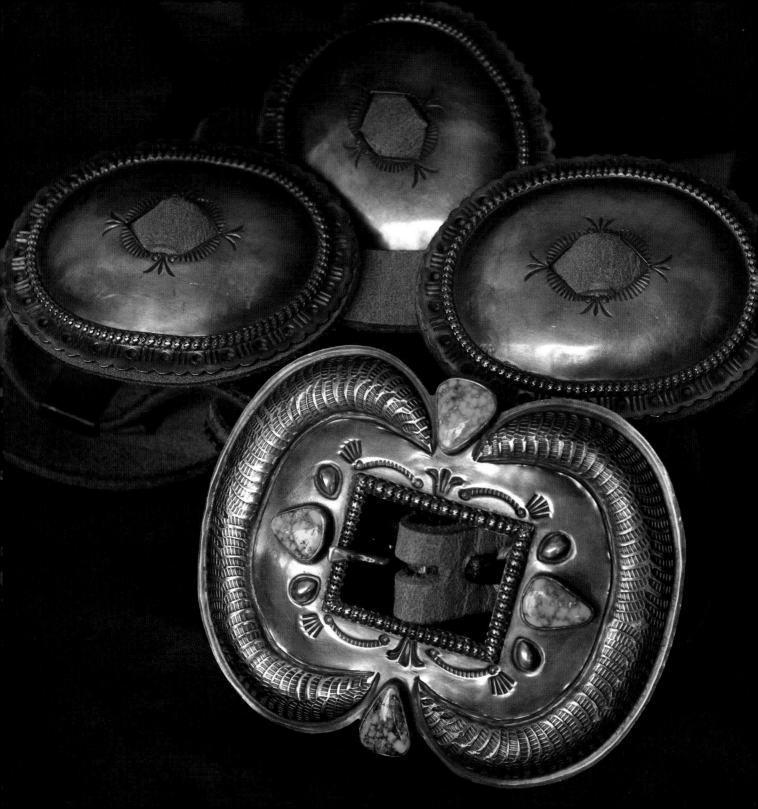

CONCHOS

"CONCHO" COMES FROM THE SPANISH word *concha,* meaning "shell." Originally, Navajo, Zuni, or Pueblo made silver conchos as a sign of status or wealth.

Concho belts traditionally have multiple round or oval buckle-size medallions and sometimes butterfly-shaped spacers in between on the belt, with a buckle of a different shape or size. Many contemporary concho belts follow the same style and look and are worn by both women and men.

When I first discovered concho belts as fashion items, I loved the big conchos. Some were silver and some had turquoise along with the silver. I loved wearing an all-silver concho belt with a black suit. So smart! A concho belt with turquoise paired with denim jeans and a white tee under a plaid cowgirl shirt makes a pretty classy statement as well.

"Our mom says that each piece takes a little bit of us with it since all of our pieces are made with love.

"Our designs are unique and designed with attention to function as well as aesthetics. From the initial design to the final polish, we give each piece meticulous care and personal attention. We have fun here!

"We have a bell in our showroom we ring when customers/friends leave happy. I'm not gonna lie and say it rings every day, but it sure as hell rings at least a few times a month!"

—*Malila & Miguel Davalos*

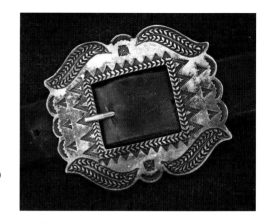

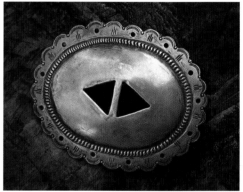

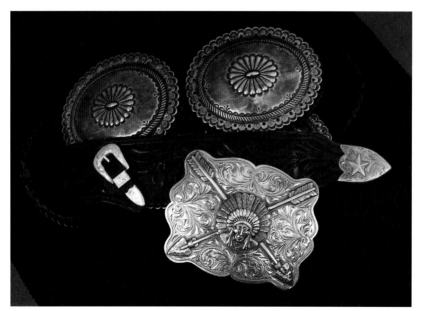

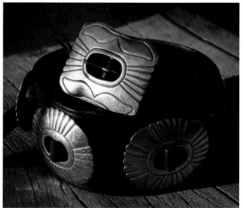

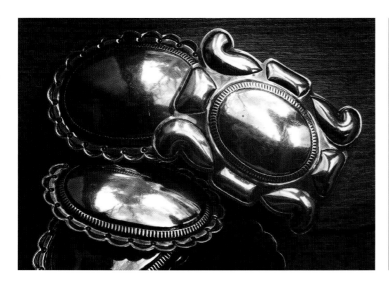

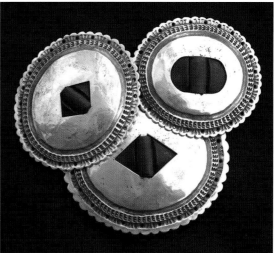

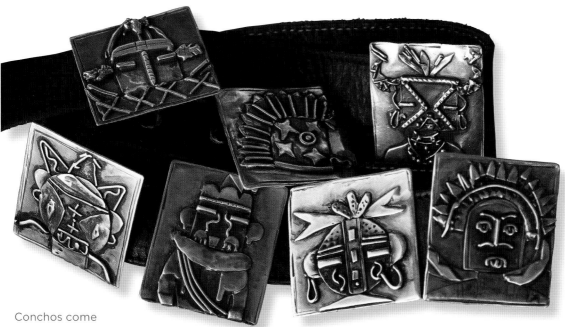

Conchos come
in all shapes and sizes.
Marty Stuart's Indian head buckle, far
left, fronts his Navajo stamped concho belt. A unique square concho belt inspired by Pueblo
designs. (Opposite, clockwise from top left: Adrian Teegarden, vintage, unknown, Bohlin. This
page, clockwise from top left: Fran Patania, Tom Dewitt, Catherine Mazierre.)

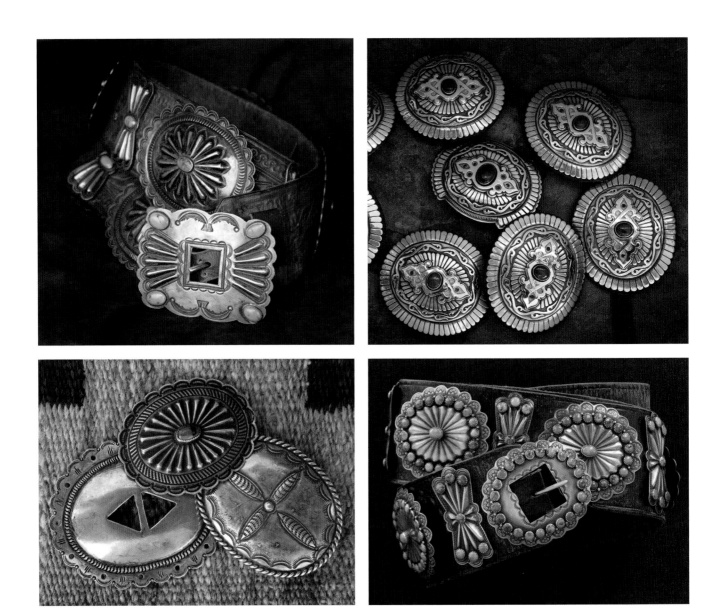

Stamped conchos might be inlaid with turquoise
as a single piece or in multipiece settings.
(Clockwise from top left: vintage, Mona Van Riper,
vintage, unknown.)

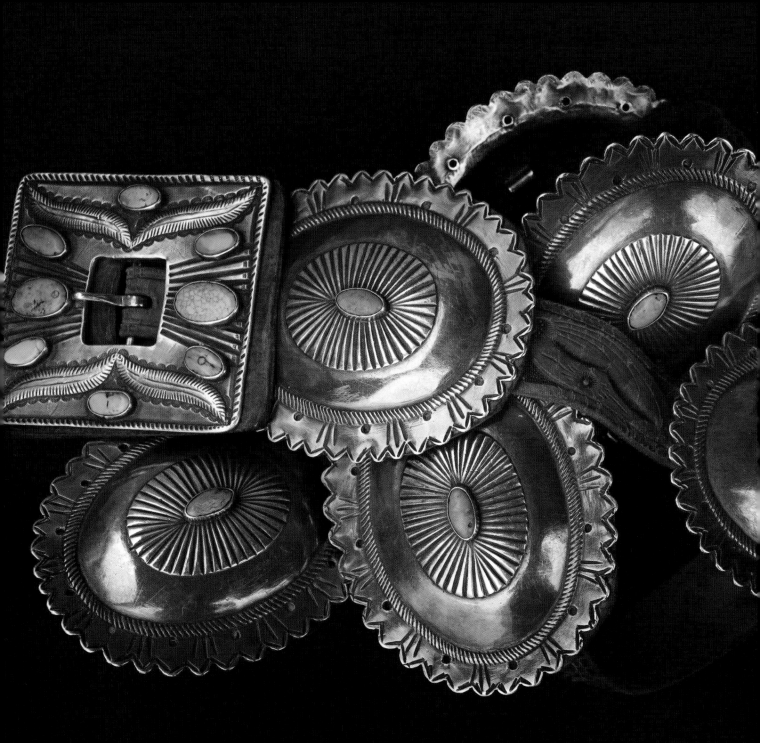

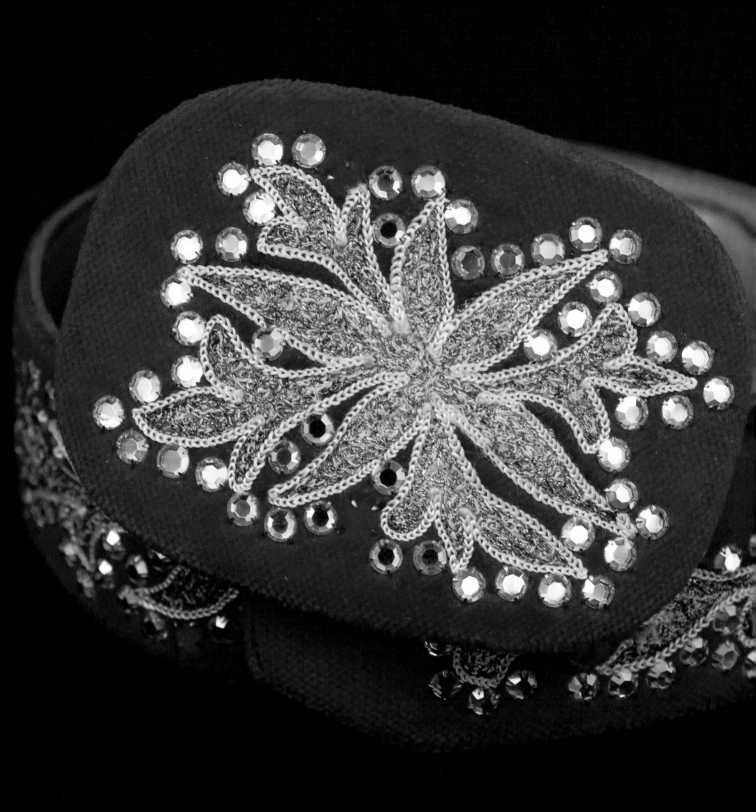

BEADS, LEATHER & STITCHING

IF YOU LOVE NATIVE AMERICAN beadwork and like to collect regional independent artists, you will love beaded buckles. The designs are intricate and colorful, with imagery ranging from flowers, animals, and horses to Native American Indian portraits and eagles.

The beading style uses bright colors and can range from simple to complex designs. Sewing beads on one at a time allows the artist a unique control of the palette that loom beading does not.

On leather, Mexican-style piteado stitching is a very intricate craft. In some families it was a tradition passed from generation to generation. Piteado work employs pita fiber from the agave, or maguey, plant spun into thread. Artisan-embroidered designs take many different patterns, from geometrics to horses.

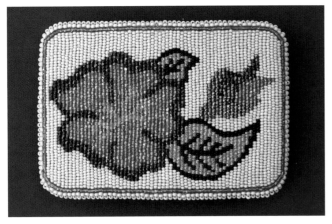
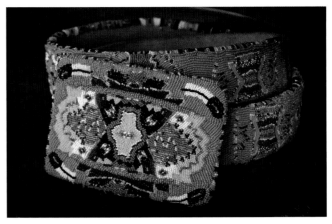
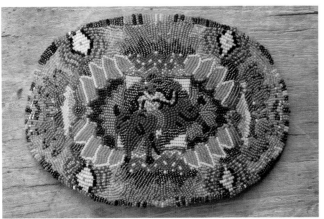
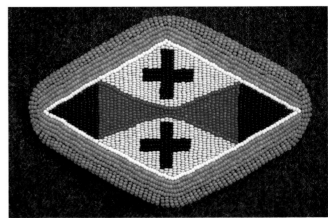
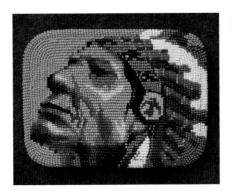
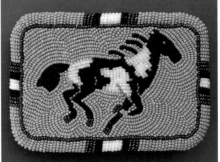

Hand-beaded buckles are sewn one bead at a time—from flowers to portraits, symbolism, and eye-dazzling patterns. (Clockwise from top left: unknown, John Willie, Marcus Ammerman, Teri Greeves, Marcus Ammerman, John Willie.)

PREVIOUS OVERLEAF: Red velvet Nudie embroidered and rhinestoned stage buckle for Miss Judy Lynn. (Courtesy of Marty Stuart.)

"The appeal of the belt buckle is closely associated with the appreciation of well-made things of utilitarian function. For a buckle the utilitarian aspect is a starting point; functionality is justification for sculptural expression.

"When designing a buckle I am mindful of several parameters: physical characteristics of the metal that suggest or limit expression within the medium; the history of the genre — what has been done and what could be done better, new and different, or in tribute to a classic tradition; and especially of the relationship between creation and consumption.

"The buckle we choose to make or to wear is unavoidably a statement that we offer about ourselves, our esthetic values, and clues as to who we wish others to think we are. In our minds we all wear each other's clothes, try them on for size, and especially in things relating to fashion there is forever a mixing up and piling on of layers of identity-related paraphernalia. Truth is, when making a buckle I am not really sure who it's for."

—*James Reid*

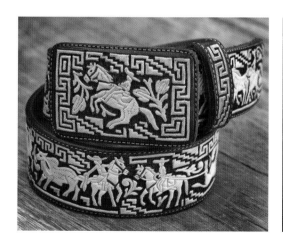
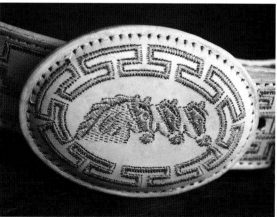

Piteado artisan designs are embroidered onto leather with fiber from the maguey plant or with cotton thread—a classic look.

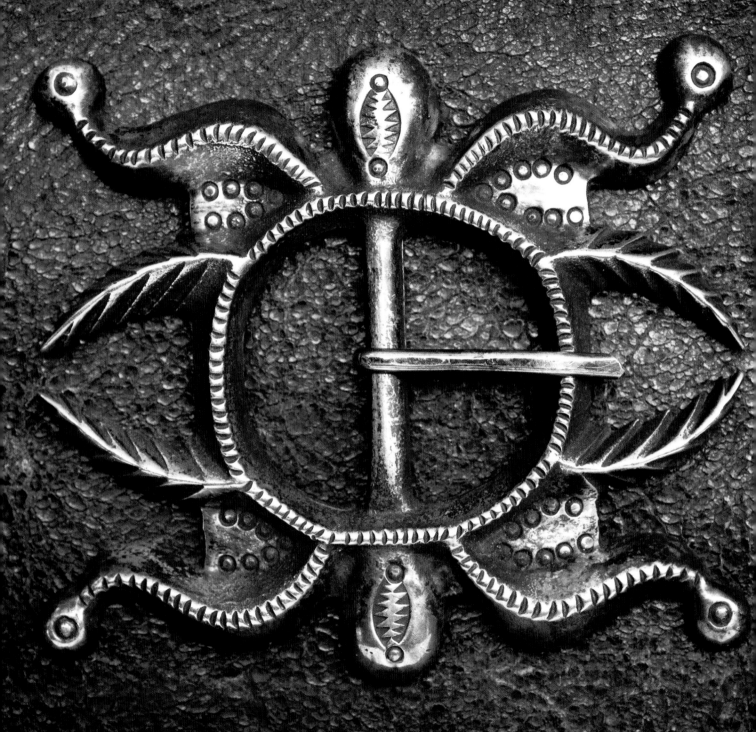

VINTAGE COLLECTABLES

ANTIQUE AND VINTAGE BUCKLES ARE so appealing. If you find a buckle you love, buy it! Don't go back for it; it will be gone. They are usually made of silver, sterling silver, gold, gold and silver, brass, and copper. Some vintage buckles also are made with stones—turquoise, coral, and inlays with jet black and turquoise.

Early Native American buckles are some of the most highly collectable and difficult to find, as are vintage rodeo buckles. They represent a mystic time so important to collectors who want to own such a classic piece of history. The Native designs and patterns—hammered, stamped, filed, engraved, inlaid, overlaid—were crafted by hand using handmade stamps and tools, or sometimes using silver dollars and ingot silver pounded on a piece of old railroad track.

When collecting, keep the ones that speak to you, the ones with soul. And when you collect—very soon, possibly—too many, you become a trader.

Vines, fish, elk, moose, antelope, and deer—how many animals can share one buckle? And it works beautifully! Edward Bohlin's personal buckle in all colors of gold, circa 1950. (Clockwise from top left: Mexican, Bohlin, vintage, unknown.)

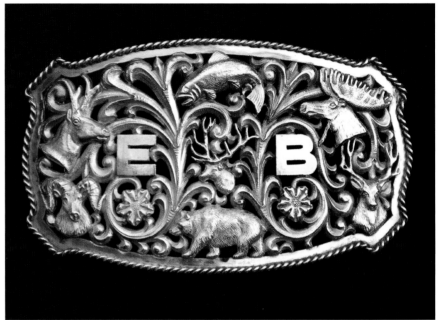

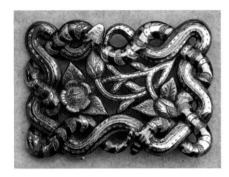

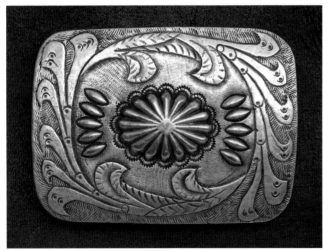

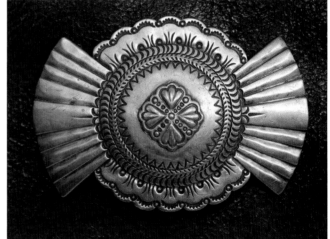

"Art comes in all sizes: large sculptures, big saddles, bits and spurs. But there are tiny jewels that are collected and worn every single day: belt buckles.

"You cannot own too many because they come in such varied sizes, materials and 'looks,' like sterling silver, gold, with diamonds and rubies. Or they are made from nickel silver with the names of rodeo winners from the 1930s or contemporary celebrities. Dress up and wear them on crocodile and alligator and wear 'em every day on a plain leather strap. Trophy buckles are one-piece oval, round or square-shaped that make a bold statement. Three- or four-piece ranger sets make their own kind of statement with a more linear art form.

"Big, small, fancy or plain, you can wear the one that best suits your mood or outfit! Keep your art close and enjoy!"

—Linda Kohn Sherwood

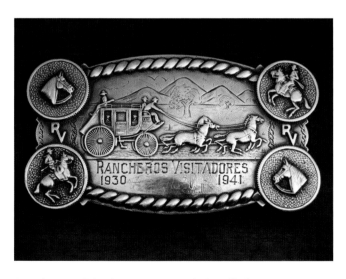 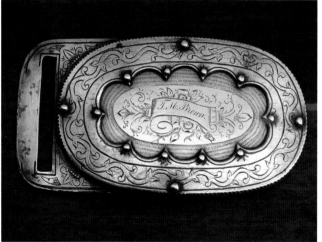

Rancheros Visitadores, 1941, and Sheriff Thomas Brown, 1829–1907. (Bob Sandroni collection.)

PREVIOUS OVERLEAF: Tufa-cast Navajo.

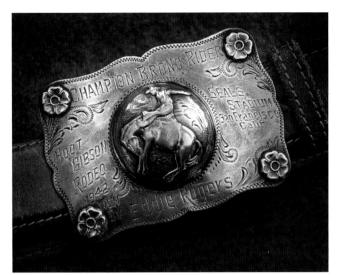

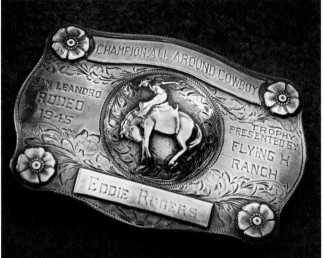

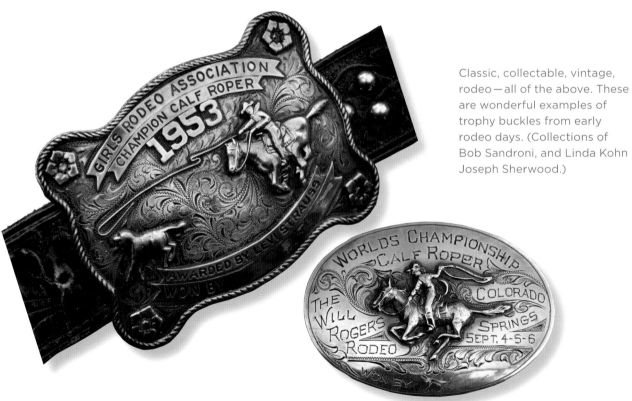

Classic, collectable, vintage, rodeo—all of the above. These are wonderful examples of trophy buckles from early rodeo days. (Collections of Bob Sandroni, and Linda Kohn Joseph Sherwood.)

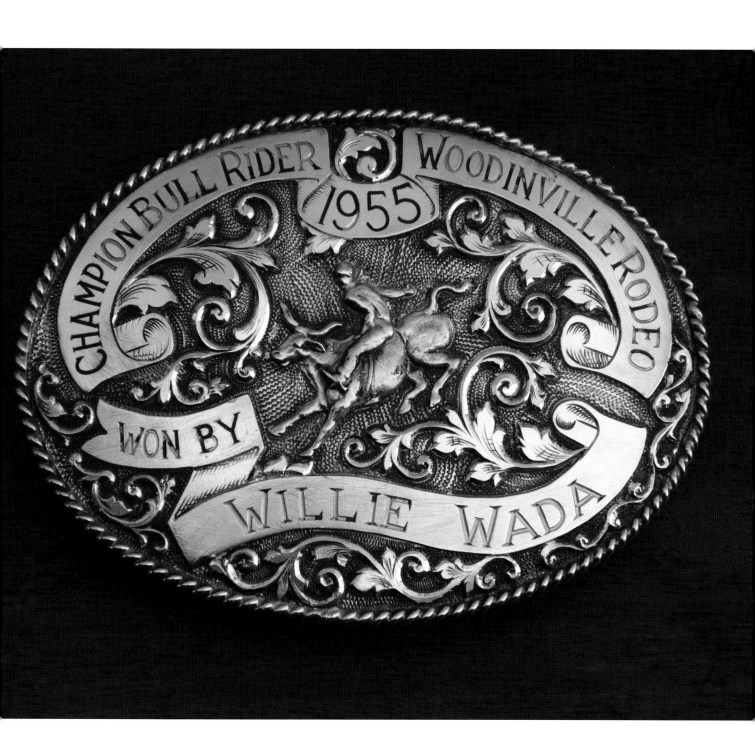

CHAMPION BULL RIDER 1955 WOODINVILLE RODEO

WON BY

WILLIE WADA

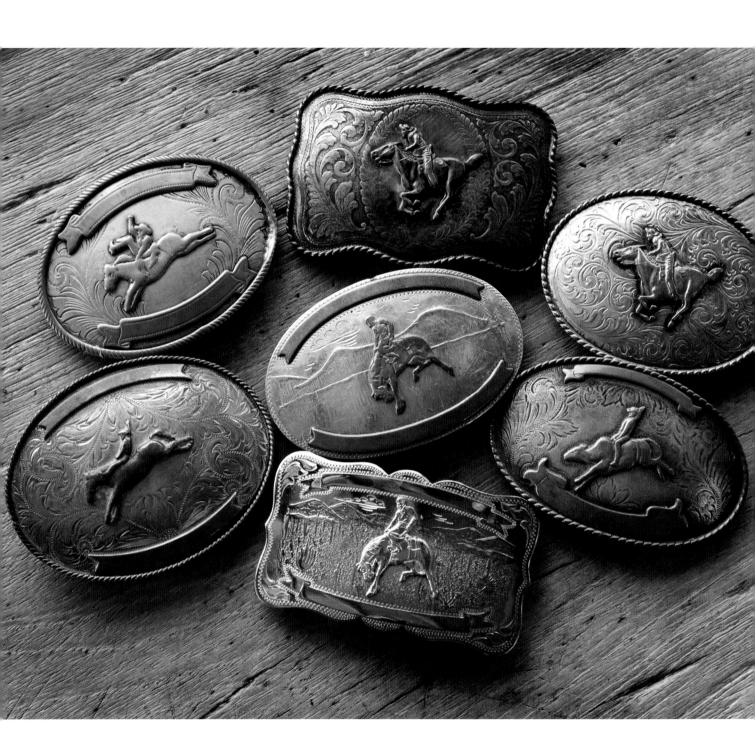

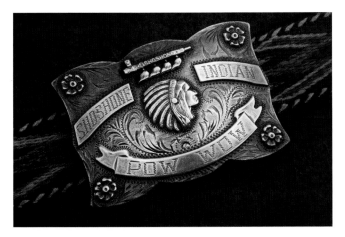

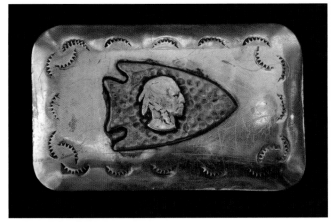

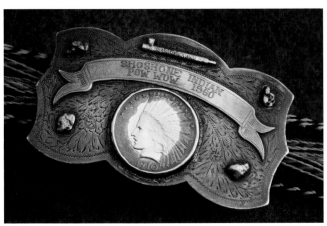

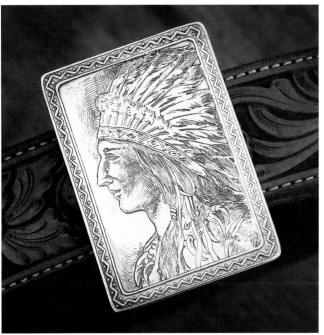

OPPOSITE: Vintage Comstock western rodeo buckles.

Native American–themed vintage buckles, including an engraved Tiffany buckle. (Clockwise from top left: Sherwood collection, courtesy Nathalie Kent, Sherwood, Corey collection.)

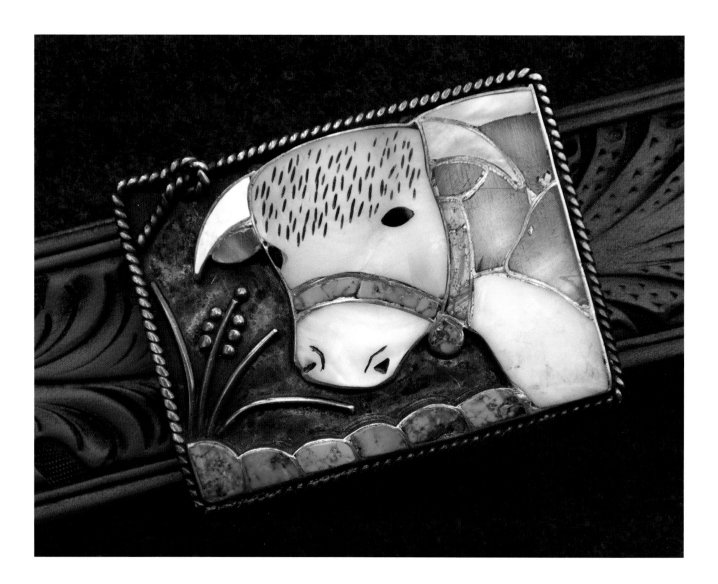

A vintage cow portrait inlaid in sterling silver with spiny oyster, abalone, and turquoise. (Sherwood collection.)

OPPOSITE: Variations on the theme of the longhorn. (Makers unknown. Sherwood and Ochs collections)

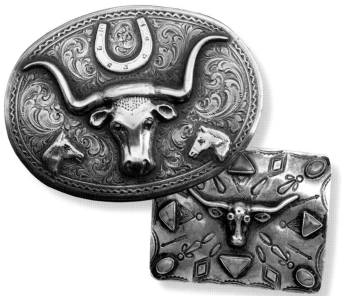

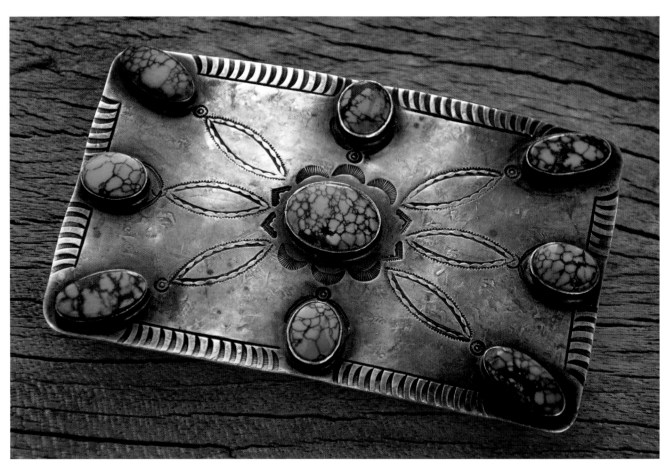

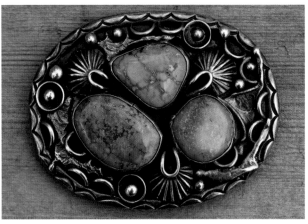

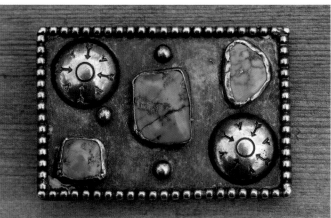

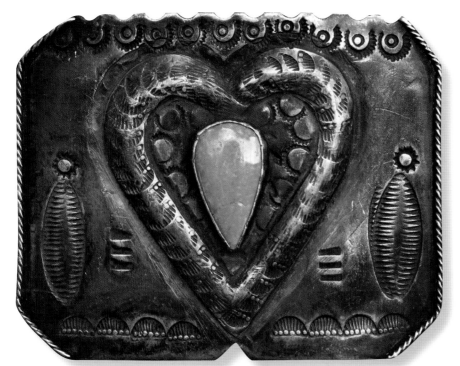

OPPOSITE: Turquoise is probably the most popular stone for buckle designs—an everlasting symbol of the Southwest.

Vintage buckles from the 1940s–1950s, still stylin' today. (Les Ochs collection.)

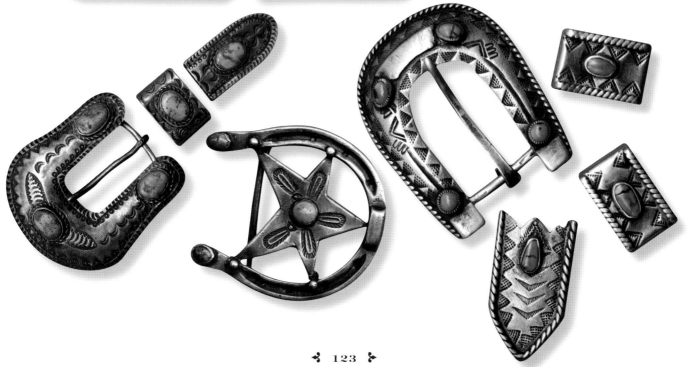

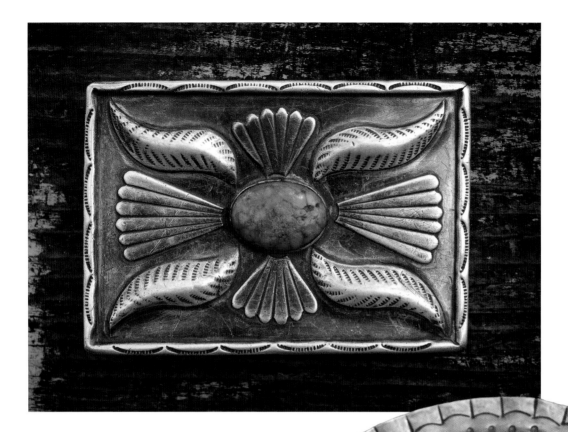

A 1940s stamped and hammered rectangular buckle. The oval in copper is unusual.

OPPOSITE: Beautiful vintage buckle art — cast, overlaid, stamped, and cut out.

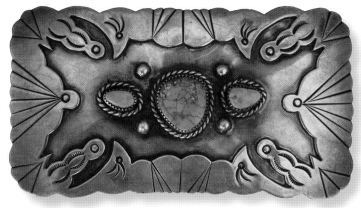

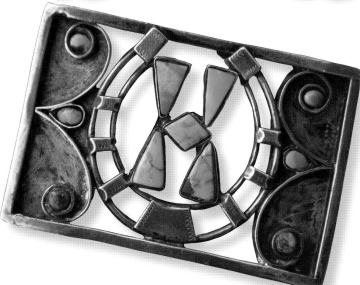

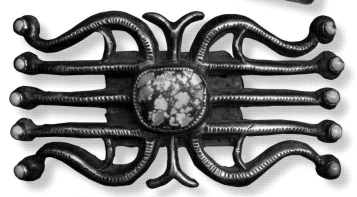

"Important buckles tell a story.

"I won this.
I did this.
I made it.
My friend made it.
The guy who made it is famous.
I think it's silver.
It's really old.
It was a gift.
It was made by a Native American.
It was my Dad's.
It used to be Bob's.
It's my favorite.
It was a prize.
I went there.
I want to go there.
It's a friend of mine's.
I own one.
I'd like to be one.
I know someone who is one.
I can do large.
I know them.
I want to know them.
I'm a member.
I'm into cowboys.
I'm into skulls.
I'm an American.
I like motorcycles.
I'm selling it.
It's my job.
It used to be my job."

—Les Ochs

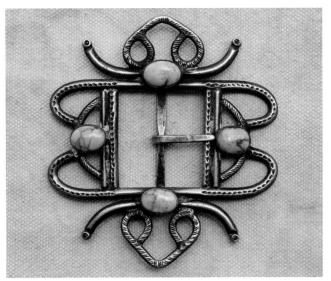
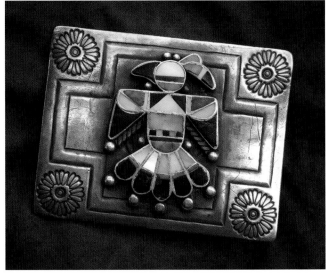
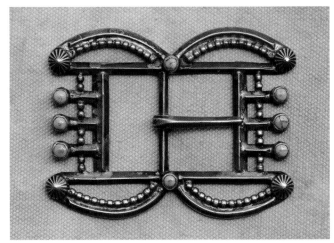
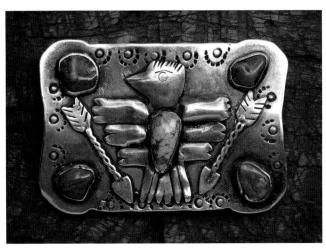

Another enduring icon of Southwest buckles is the thunderbird,
inlaid, overlaid, or in repoussé. Also tufa-cast buckles with turquoise.
(Clockwise from top left: Les Ochs, Shiprock, Ochs, Ochs collection.
Facing: unknown.)

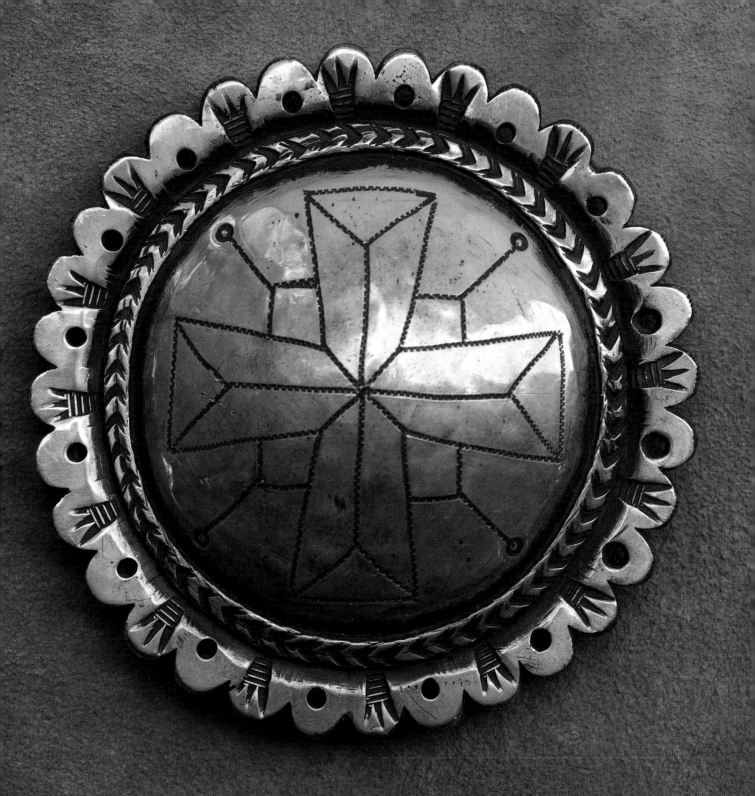

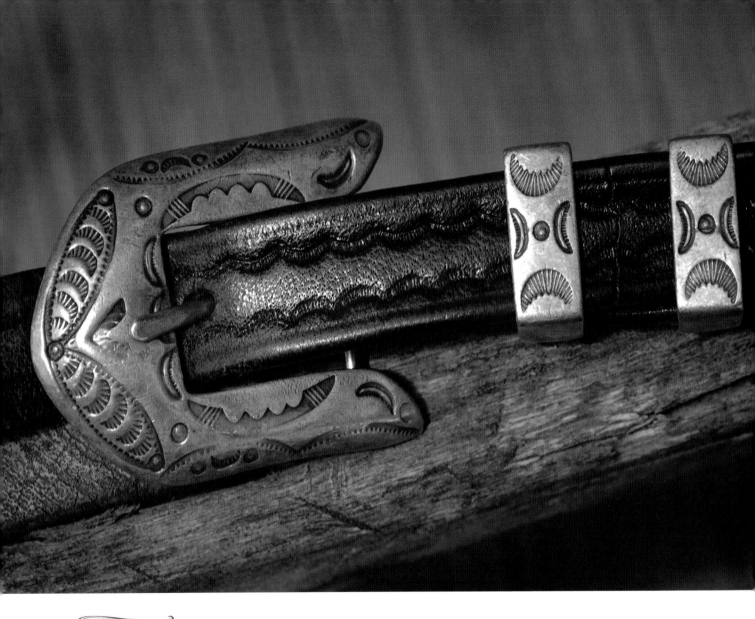

"I have collected the West all my life. Some things to show and enjoy, some to sell, some are for me alone. The newly made pieces are art in and of themselves. The older pieces generally tell a story of a time past combined with what my wife refers to as a man's personal jewelry."

—Bob Sandroni

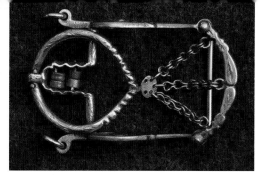

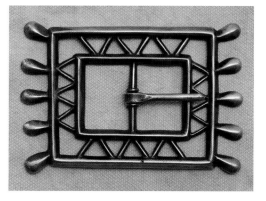

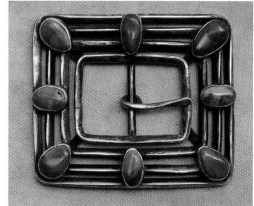

ABOVE: Vintage four-piece ranger set with hand stamping.

RIGHT: A buckle made to replicate a horse bit, a cast buckle, and a silver wire buckle with turquoise. (Top: Sandroni collection; center and bottom: Les Ochs collection.)

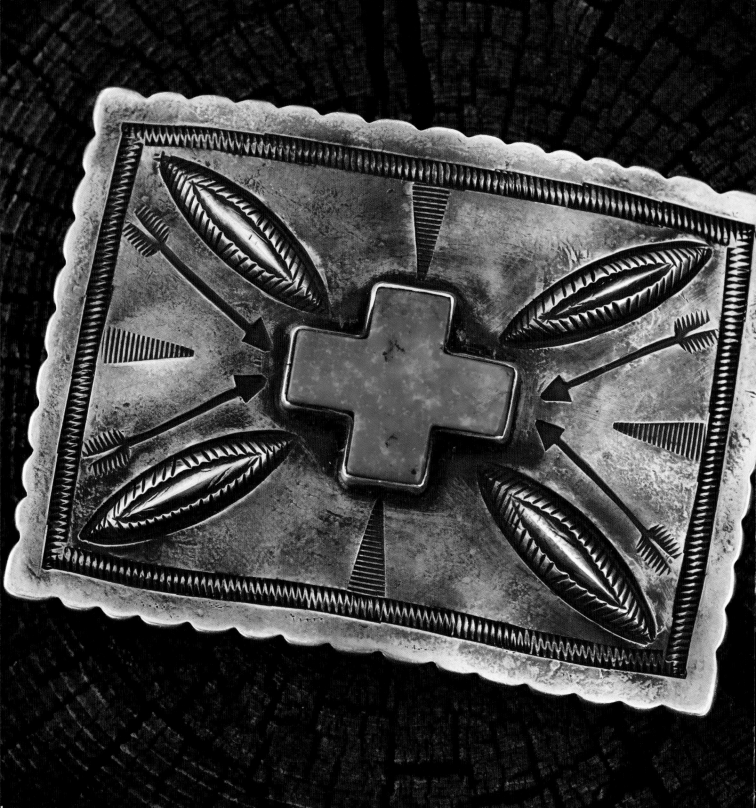

JEWELS & STONES

I AM A STONE GIRL—TRULY love real, pure turquoise! No matrix (black lines) for me.

Turquoise can range from sky blue to green. The color of the stone—whether turquoise, coral or jet—is usually what makes someone really want the buckle—or not. Some collectors love natural coral, but it is extremely rare now and hard to find.

A plain, classic, simple silver concho is a beauty by itself. But when you start adding precious stones and even diamonds, the visual impact intensifies. Multiple stones or a variety of materials takes it even further. Classic Native American buckles usually were embellished with turquoise, and they became the standard, a symbol for Southwestern jewelry.

"Buckles? And this is what you make for a living? Why, yes, of course. Doesn't everyone need something to hold their pants up? When the first Spanish came to this New World they were very stylish with all their fine silverwork from Spain—bridles, buckles, flatware, etc. One of the good things the Europeans brought to the Southwest was a desire to have their tastes for fine silverwork made here . . . Over time, buckles have become their own art.

"I have so much fun designing and making artful buckles . . . Dragons make wonderful buckle center images . . . Using multicolored semi-precious and precious stones, mixing silver with high-karat gold gives an artist a wonderful palette to create with . . ."

—Mona Van Riper

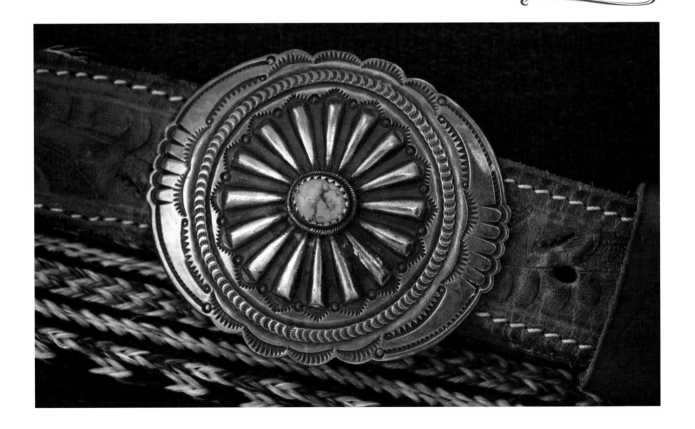

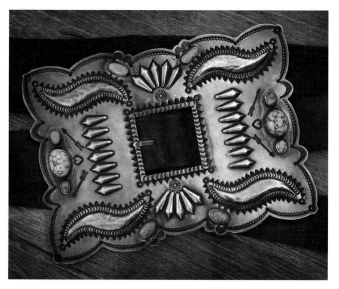

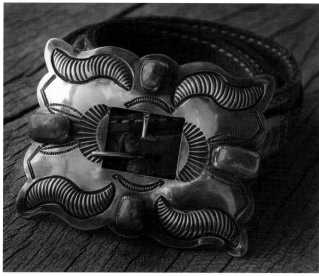

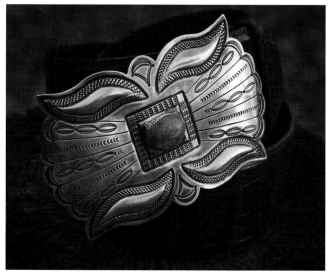

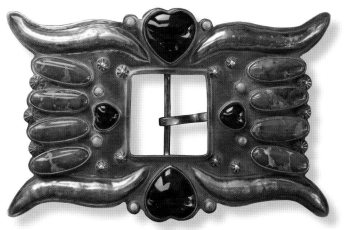

OPPOSITE: Radial design with central turquoise stone. (Stanley Carroll.)

Similar but different artistic interpretations. Turquoise is the standard stone when it comes to western buckles. (Clockwise from top left: unknown, vintage courtesy Reg Jackson, Herbert Ration, unknown.)

PREVIOUS OVERLEAF: Turquoise cross with arrows. (Jerry Faires.)

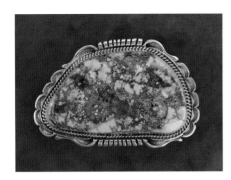

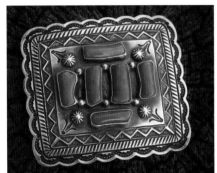

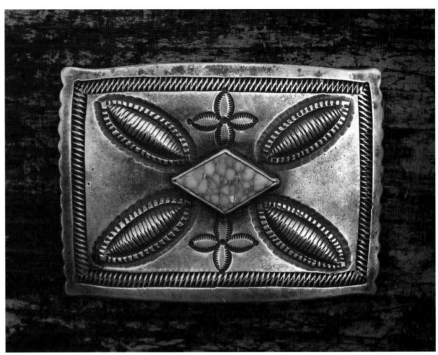

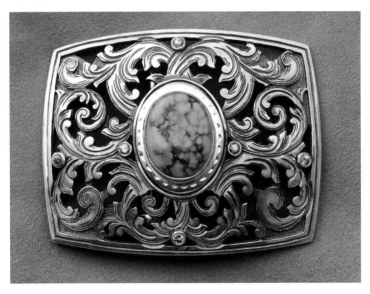

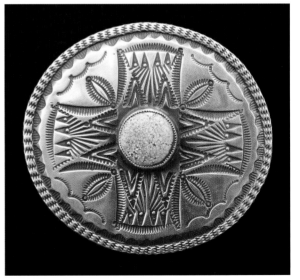

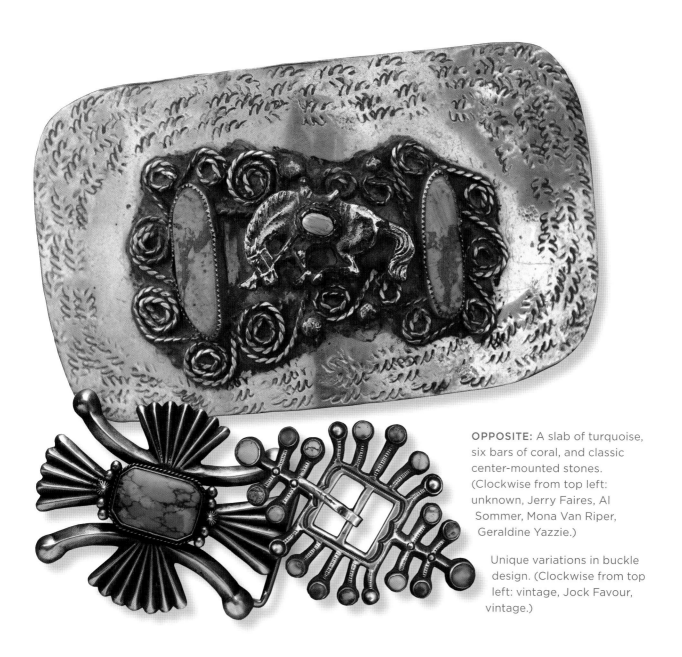

OPPOSITE: A slab of turquoise, six bars of coral, and classic center-mounted stones. (Clockwise from top left: unknown, Jerry Faires, Al Sommer, Mona Van Riper, Geraldine Yazzie.)

Unique variations in buckle design. (Clockwise from top left: vintage, Jock Favour, vintage.)

"Jewelry, being worn on the body, is the most personal of art objects. These works become statements about the wearer, announcing status, personal taste, cultural identity, spirituality, and much more.

"As wearable art, the buckle can provide all this, plus the added virtue of practicality. Often a centerpiece of dress, the buckle is both functional and decorative. Simple or bold, it may be a symbolic work of art, a thing of beauty and value, created in precious metals and gemstones. Or it may be the simplest of utilitarian shapes in the sparest of materials. No matter the choices involved, an individual expression is conveyed.

"The buckle and belt often becomes an important feature of the wearer's sense of personal identity. A man might wear the same belt/buckle every day until the leather is worn and ragged, or he might collect and wear belts for different occasions. The belt/buckle will carry with it a sense of well-being to the wearer. Emotions are involved. At least one famous golfer always wears his favorite buckle during tournaments for luck, and a famous orchestra conductor wears his standard buckle even with a tuxedo! Most all of us have a favorite belt and buckle.

"For those of us who specialize in crafting buckles, it is a source of satisfaction to create something which will possibly become an intimate part of another's persona. Something that actually matters in that person's daily life, and perhaps, for generations on down the line.

'The Belt makes the Man!' Or at least represents him."

—Doug Magnus

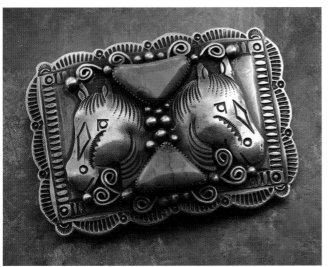
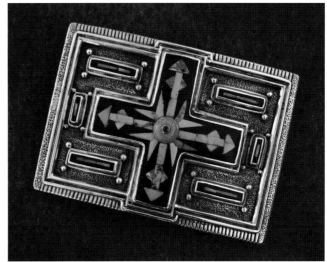
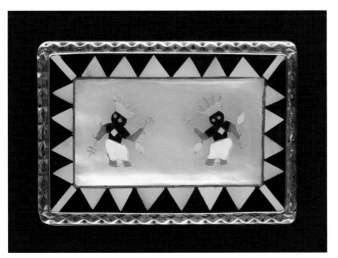
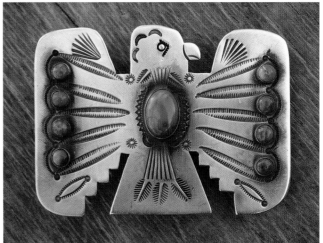

OPPOSITE: Silver and my favorite—bling—make very pretty statements. (Left to right: Matt Hackett; courtesy Mary Emmerling.)

Two horse heads embrace turquoise triangles; a highly intricate inlaid cross; tiny Zuni mosaic inlay; and classic eagle. (Clockwise from top left: unknown, Lee Downey, Al Sommer, Ohmasatte family.)

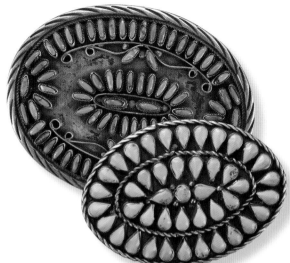

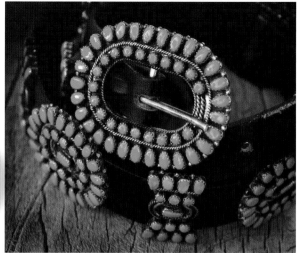

Settings of multiple turquoise stones in individual bezels intensify the style. Zuni needlepoint (upper left) and petit point stone work are classic. (All vintage. Opposite: Juan Pino.)

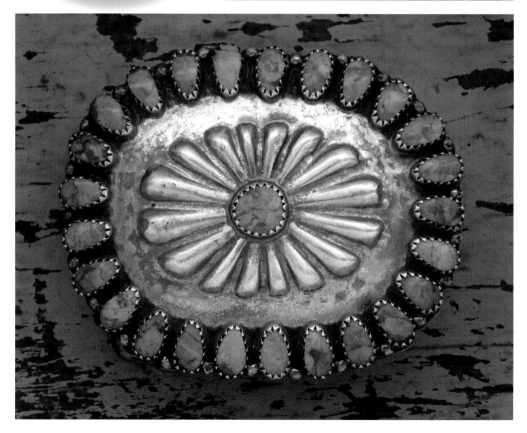

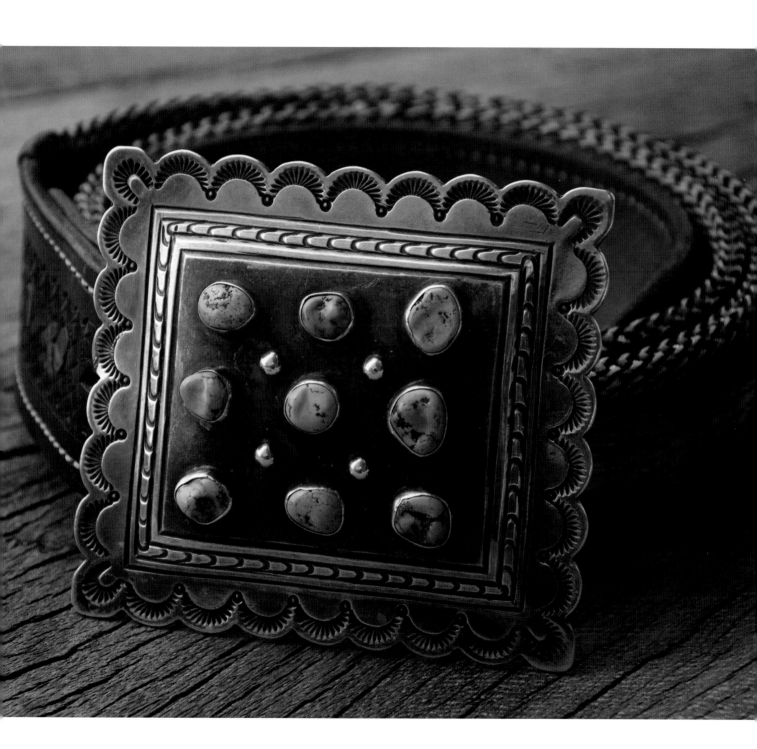

RESOURCES

ARIZONA
Nightrider Jewelry
Scottsdale Fashion Square
7014 Camelback Rd.
Scottsdale, AZ 85251
480-719-7219

CALIFORNIA
Augustina's
San Carlos St.
Carmel, CA 93923
831-624-9901

Boot Star
8493 Sunset Blvd.
West Hollywood, CA 90069
323-650-0475

High Noon LA, Inc.
9929 Venice Blvd.
Los Angeles, CA 90034
310-202-9010

Vicki Turbeville
304 Vista Del Mar
Redondo Beach, CA 90277
347-256-0127

COLORADO
Axel
201 Gore Creek Dr.
Vail, CO 81657
970-476-7625

Cry Baby Ranch
1421 Larimer St.
Denver, CO 80202
303-623-3979

FLORIDA
J.W. Cooper
9700 Collins Ave., Suite 227
Bal Harbour, FL 33154
305-861-4180

MINNESOTA
Schatzlein Saddle Shop
413 West Lake St.
Minneapolis, MN 55408
612-825-2459

NEW MEXICO
Back at the Ranch
209 East Marcy St.
Santa Fe, NM 87508
505-989-8110

Beals Cowboy Buckles
Santa Fe, NM
888-610-5550

Cowboys and Indians Antiques
4000 Central Ave. SE
Albuquerque, NM 87108
505-255-4054

Desert Son
725 Canyon Rd.
Santa Fe, NM 87501
505-982-9499

Double Take
321 South Guadalupe St.
Santa Fe, NM 87501
505-820-7775

Doug Magnus
Magnus Studio
905 Early St.
Santa Fe, NM 87505
At Packards and Nathalie.

The Flea
27475 W. Frontage Rd.
Santa Fe, NM 87505
505-982-2671
Summer only.

James Reid
114 East Palace Ave.
Santa Fe, NM 87501
505-988-1147

Jett
110 Old Santa Fe Trail
Santa Fe, New Mexico 87501
505-988-1414

Lucchese
57 Old Santa Fe Trail
Santa Fe, NM 87501
505-820-1883

Morningstar
513 Canyon Rd.
Santa Fe, NM 87501
505-982-8187

Mortenson Silver & Saddles
96 County Road 45
Santa Fe, NM 87508
505-424-9330

Nathalie
503 Canyon Rd.
Santa Fe, NM 87501
505-982-1021

Packards
61 Old Santa Fe Trail
Santa Fe, NM 87501
505-983-9241

The Rainbow Man
107 E. Palace Ave.
Santa Fe, NM 87501
505-982-8706

Red Bluff Buckles
82 Wrangler Rd.
Continental Divide, NM 87312
505-862-7042

Rio Bravo
411 South Guadalupe St.
Santa Fe, NM 87501
505-982-0230

Rippel and Company
111 Old Santa Fe Trail
Santa Fe, NM 87501
505-986-9115

Santa Fe Vintage
7501 Avenger Way, Suite B
Santa Fe, NM 87508
505-690-1075

Sherwoods Spirit of America
1005 Paseo de Peralta
Santa Fe, NM 87501
505-988-1776

Shiprock
53 Old Santa Fe Trail
Santa Fe, NM 87501
505-982-8478

Tom Taylor
108 E. San Francisco St.
Santa Fe, NM 87501
505-984-2231

Wahoo
227 Don Gaspar
Santa Fe, NM 87501
505-577-8200

NEW YORK
Barbara Trujillo Antiques
2466 Main St.
Bridgehampton, NY 11932
631-537-3838

J.W. Cooper
10 Columbus Circle, Suite 105
New York, NY 10019
212-823-9376

Melet Mercantile
84 Wooster St., #205
New York, NY 10012
212-925-8353

Ralph Lauren
109 Prince St.
New York, NY 10012
212-625-1660

RRL
57 Main St.
East Hampton, NY 11937
631-907-9201

TEXAS
Cowboy Cool
3699 McKinney Ave.
Dallas, TX 75204
214-521-4500

Maidas
5727 Westheimer Rd., Suite K
Houston, TX 77057
800-785-6036

M.L. Leddy's
2455 North Main St.
Fort Worth, TX 76164
888-565-2668

Pinto Ranch
1717 Post Oak Blvd.
Houston, TX 77056
713-333-7900

Richard Schmidt
118 N. Washington St.
La Grange, TX 78945
800-368-9965

EUROPE
Harpo
19 Rue de Turbigo
75002 Paris France
01 40 26 10 03

Hermes
24 Ru Du Faubourg Saint-Honore
Paris France 75008

Losco
20 Rue de Sevigne
Paris France
01 48 04 39 93

Western Shop
79 BD. Adolphe Max
1000 Brussels Belgium
32 (0)2 219 5517

JAPAN
Funny Co.
4-4-18 Aramoto-Nishi
Higashi-Osaka,
Osaka Japan 557-0024
06-6787-1241

ACKNOWLEDGMENTS

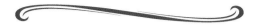

MY TENTH BOOK WITH MADGE . . . never in my wildest dreams would I have ever imagined; they would have never been possible without her. Thank you deeply for your direction and support.

Thanks to all the artists, designers, craftspeople, collectors, buckle heads, geniuses, and wackos who helped put this book together:

Nathalie Kent, Doug Magnus, Clint Mortenson, Lee Downey, Mona van Riper, Samantha Silver, Clint Orms, James Stegman, James Reid, Walt Doran, Malila and Miguel Davlos, Richard Stump, John Rippel, Chet Vogt, Casey Vogt, E. H. Bohlin, Henry "Chick" Monahan, Annelise Williamson, Marcus Ammerman, Scott Corey, Josh Alias, Herbert Ratio, Jock Favour, Jerry Faires, Catherine Mazierre, Barry Kisselstein, Tom Dewitt, Pat Pruitt, BG Mudd, Frank Spencer, Jed Fouts, Samantha Hamilton, Richard Beal, Philip Spiers, Les Ochs, Roy Flynn, Roger Skeet, Jeff Deegan, Al Sommer, Nancy Anderson, Harvey Kaplan, Wilson Franklin, Mark Dunlap, Linda Kohn Sherwood, Joseph Sherwood, Bob Sandroni, Roxanne Thurman, Dave Marold, Nancy Ogur, Susan Adams, Ronnie Dunn, Marty Stuart, Johnny Hallyday, Jeff Brock, Brett Bastian, Nancy Elby, Ann Lawrence, Teri Greeves, John Willie, Margaret Sullivan, Matt McClure, Beth Walkos, Amado Pena Jr., Jason Maida, Dan Krumweide, Michael Smith, Matt Hackett, Arnold Goldstein, Geraldine Yazzie, Harry H. Hudson, Ahmed Kahn, Stanley Carroll, Juan Pino, Adrian Teegarden, Susan Adams, and of course, Mary Emmerling and Reg Jackson.

—Jim Arndt

THANKS TO MY CHILDHOOD HEROES—Hopalong Cassidy, Roy Rogers, Gene Autry—for their Saturday-morning movies that I saw in Minot, North Dakota. I loved going to the movies and the local rodeo. These were thrilling for a nine-year-old growing up in Minot. It was the beginning of my love for western style.

I'm grateful for Tyler and Teresa Beard, who taught me all about the West.

For growing my love for western style, I thank Reg Jackson. I love all our collections, from buckles, denim, and chimayo to cowboy boots, hats, western clothing and turquoise jewelry.

I want to also thank the buckle makers, collectors, and designers named above, who helped put this book together! I have loved meeting and getting to know them at the Gem Show in Tucson, High Noon in Mesa, Cowboys & Indians show in Albuquerque, Round Top and Marburger in Texas, and the Whitehawk Shows in Santa Fe. Thanks to Barbara Trujillo Antiques in Bridgehampton, Long Island, New York, where I started all my bracelet and buckle collecting.

And always, thanks to our great editor, Madge Baird, and designers Michel Vrana and Renee Bond.

—Mary Emmerling

FERRARI

David Sparrow and
Iain Ayre

First published in Great Britain in 1994
by Osprey, an imprint of Reed Consumer
Books Limited, Michelin House,
81 Fulham Road, London SW3 6RB and
Auckland, Melbourne, Singapore and Toronto.

© Reed International Books 1994

ISBN 1 85532 439 3

Editor Shaun Barrington
Page design Paul Kime/Ward Peacock
Partnership

Printed and bound in Hong Kong
Produced by Mandarin Offset

Acknowledgements

The author would like to acknowledge the help of Allan Mapp and
Tony Willis at Maranello Concessionaires, and of Peter Rawlinson
amd Marion at the press and PR department. With grateful thanks to
Ferrari for factory access.

Half-title page
*Liquid metal transformed into fluid
Ferrari design and power at the new
Maranello foundry. In this book,
photographer David Sparrow has
concentrated upon the creation of the
supercar, in a way seldom attempted
before. With thanks to Ferrari for such
generous access to the production
process*

Title page
*Lights, action, roll 'em. Almost ready for
electronic tuning and pre-delivery
inspection. The width of the 512 (and
the Testarossa) is partly dictated by the
decision to locate all cooling systems in
the engine bay; in earlier Berlinetta cars
the radiator was up front. When an
engine is run up inside the factory, long
hoses vent the fumes through the roof*

FERRARI 512 TR

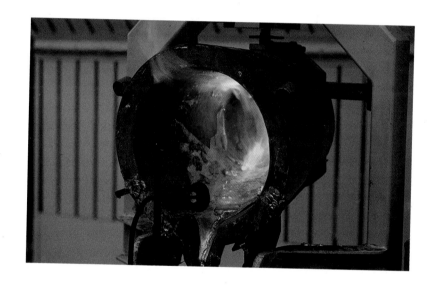

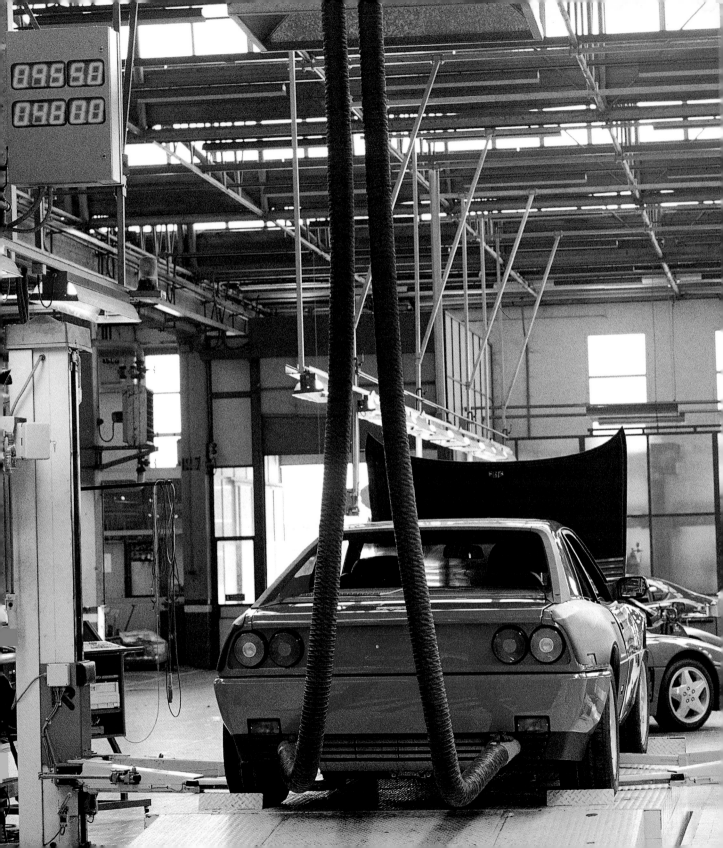

About the author and photographer

Iain Ayre was born in Glasgow in 1954, and has a low boredom threshold. After several dozen attempts to settle down in assorted careers including teaching and advertising, he abandoned proper jobs and took up writing. He has produced innumerable, occasionally unhinged articles in the motoring press, and a reasonably sensible book about the British sports car manufacturer, TVR.

David Sparrow has photographed cars of all shapes and sizes, from the humble Citroën 2CV to the mighty Testarossa. This book is the sixteenth to feature his photographs. In 1984 he won first place in the Third Olympiad of Colour Photography, held in Munich and organized by Leica, makers of the 35mm camera and lenses he uses exclusively. He has contributed to numerous magazines and two exhibitions of his work have been staged.

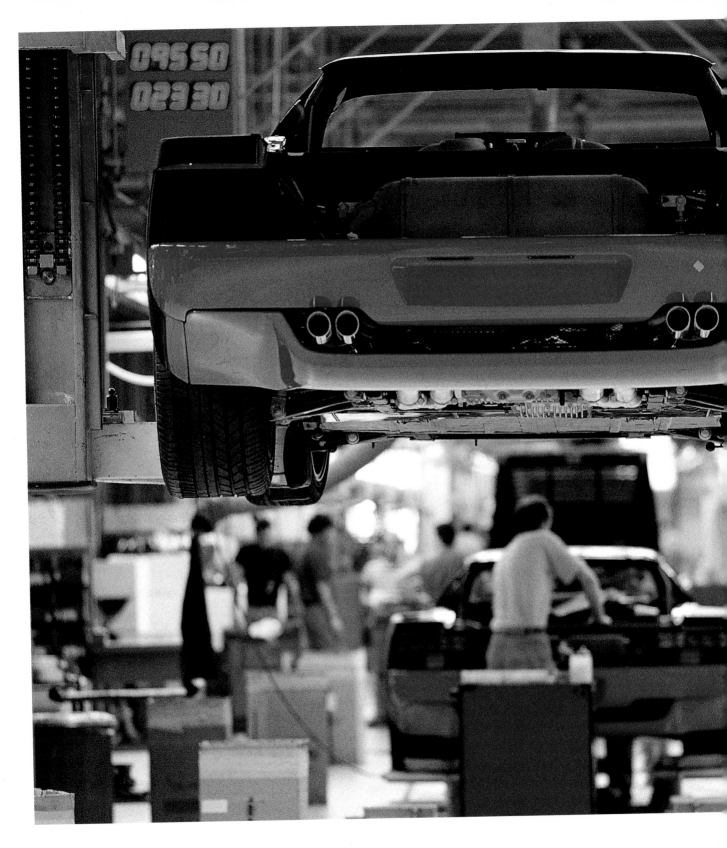

Contents

Antecedents

The first Ferrari Testarossa saw the light of day in 1956. It was a racing car, with a four cylinder, two litre engine, and it was most notable for having its cam covers painted red, as it did not distinguish itself to any great extent on the track.

However, the following year the Testa Rossa name reappeared, this time on a car fitted with a three litre V12. This was known as the 250 Testa Rossa, and after a season of tweaking, it wiped the floor with just about everyone else in 1958, winning pretty well everywhere except at the Nurburgring.

The Testa Rossa name went quiet for some decades, but the car that was to develop into the Testarossa of the Eighties appeared for the first time in 1971 as the 365 GT4 BB. The BB stood for Berlinetta Boxer; the styling was by Pininfarina, and the engine was the flat twelve Boxer unit.

1976 saw a change of body style, again penned by Pininfarina, but the central character of the car remained the same. 512i referred to the substitution of injection for the banks of massive Webers: cleaner emissions kept the Federal authorities happy, but at the expense of a

Left
The strakes along the side of the body remain unchanged from the Testarossa. Air is ducted through to the engine, the engine cooling radiators, the oil cooling radiators and the brakes

Above right
Pininfarina's new front end for the 512TR features separate air ducts on either side of the nose to direct cooling air to the front brake discs. The new discs are bigger and drilled, but even the biggest ventilated discs get a little hot and bothered when they're asked to haul a hefty car down from around 200mph

Right
The grille on the front of the 512TR is mostly a dummy, but some of it serves to carry the radiator for the air conditioning system. This used to have to rely on indirect cooling, and has been much improved as a result of the new arrangement

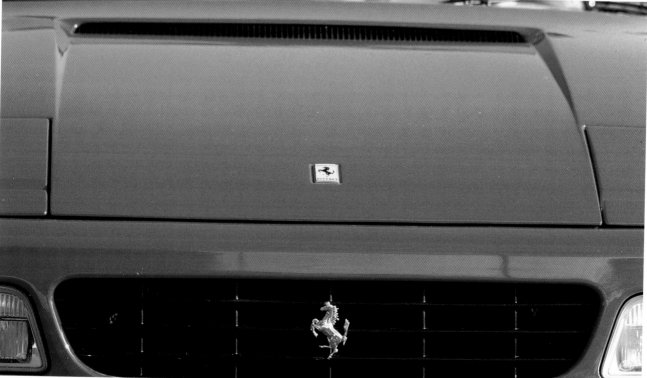

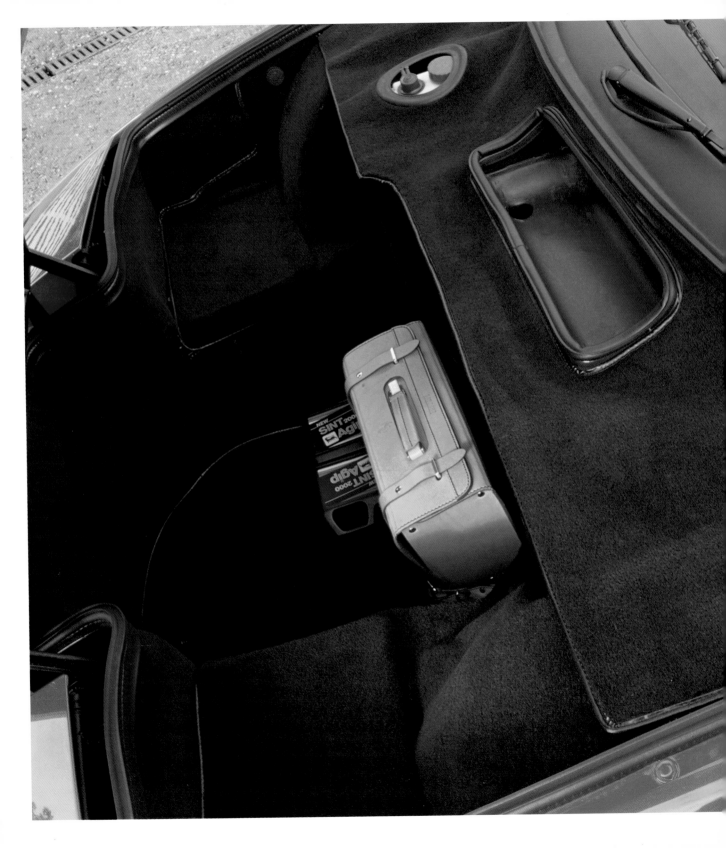

drop in power. When the Americans authorities shortly afterwards demanded fat impact absorbing bumpers as well, Enzo Ferrari rebelled. Rather than ruin the delicate lines of the Berlinetta Boxer, he decided to hell with it, he wouldn't sell the Americans any cars at all.

When the evolution of the flat twelve Berlinetta Boxer theme and the name of Testarossa came together in October 1984, Ferrari's new flagship put the company right back where they wanted to be: at the centre of attention, with the world's press lining up to drool over the new beauty.

As the years went by, however, the competition began to snap at Ferrari's heels. Porsche's 959 is quite quick, and even Vauxhall had transformed their sales rep express into the astonishingly fast Lotus Carlton.

More irritating than that, Lamborghini had launched the Diablo, which had updated the psycho styling of the Countach into a new organic shape: the styling was just as wild, but it was now bang up to date. Even worse news was that it went like a rocket. The 5.2 litre V12 from Countach days was now bored out to 5.7 litres for the Diablo, and the power to weight ratio was an outrageous 296 BHP per ton, taking the top speed over the 200mph mark.

However, the Lambo was not the most refined of cars; it had a fierce clutch and a hefty gear change, and you still couldn't see out of it. According to one writer comparing the Diablo with the Ferrari, the flat twelve Boxer sounded rather like two Porsche 911s, which is no bad thing to sound like, but the Lambo gearbox apparently sounded like a waste disposal unit.

Ferrari's response to the Diablo and to the others was a pretty comprehensive rethink of the Testarossa, with the aim of making its performance and handling better, as well as making it go faster in a straight line.

The 512TR certainly is faster than the Testarossa, but the top speed is governed to only 194 mph, so we don't know for sure what its genuine top speed is. It is the nature of the power and speed that has changed, rather than just the amount of it. The basic idea of the Testarossa was fine: the shape is sublime, and the flat twelve is a legend. There was nothing to be gained by changing the whole concept and throwing the baby out with the bathwater. Indeed, while the name of the car has changed from Testarossa to 512TR, the TR still stands for Testarossa,

The earlier get-you-home spare has now been abandoned, and the leather case in the front boot now contains an emergency puncture repair kit as well as the usual toolkit, so that you can get home on the punctured tyre. After all, a punctured tyre on a 194 mph car is scrap anyway: you don't just throw a tube in it and hope for the best

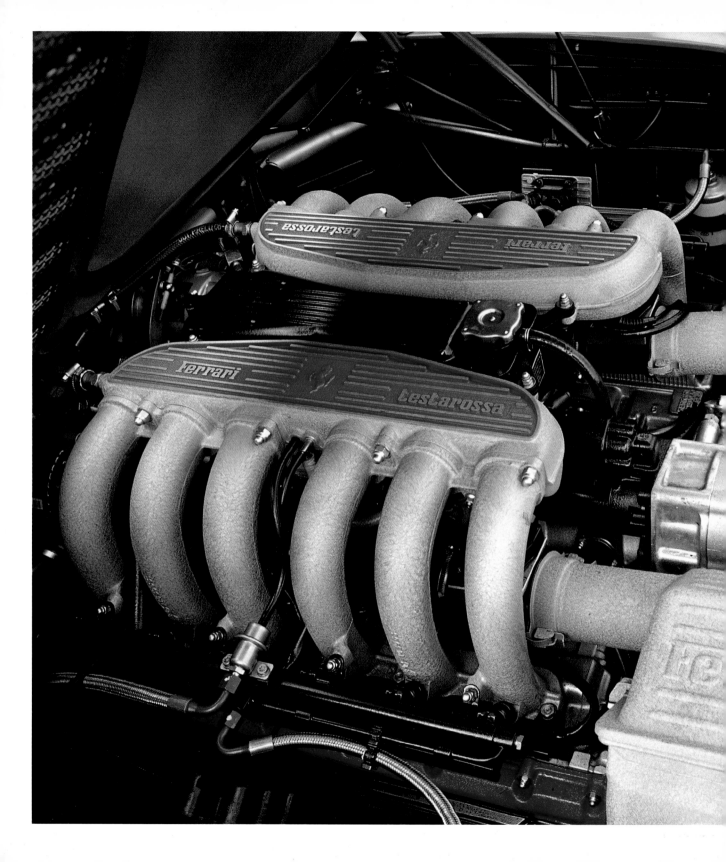

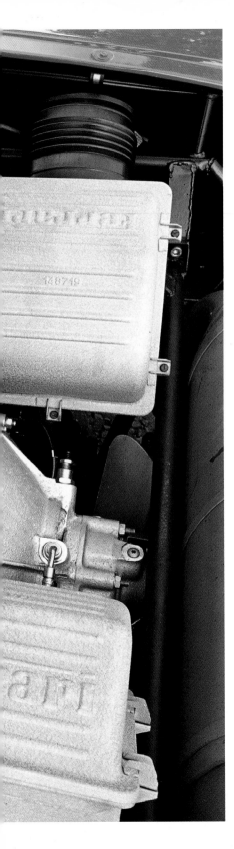

and Testarossa is still written proudly on top of the engine.

Under the cast Testarossa logos and the crinkly red paint, however, there has been some major development. The 4.9 litre flat twelve now pumps out 428 BHP to the Testarossa's 390. The torque figure remains the same at 362, but the torque now peaks 1000 rpm further up the rev range. The overall power to weight ratio is now 263 BHP per ton.

The essence of the engine development has been to provide significantly more grunt higher up the rev range, without losing the silky smoothness and tractability of the flat twelve in traffic: you can still drive the car smoothly at thirty miles an hour in any gear you like.

The changes inside the engine are extensive, and go far beyond cosmetic fiddling. The engine castings themselves have been strengthened to allow higher revs to be used for longer periods, and the pistons and liners have been changed to increase the compression ratio significantly from 9.3:1 to 10.1:1.

There have been many changes around the periphery of the engine as well as at its heart. The inlet valves are now bigger by 1.2mm, and the cam profiles have been revised.

The engine's breathing overall has been the subject of considerable tweaking. There are new longer inlet tracts, themselves better fed by fresh air directed in from the ribbed ducts at the sides of the car. The cooling radiators themselves have been reduced in size, which has allowed fresh air to be ducted in straight to the engine, creating at higher speeds something of a ram air system, all of which helps.

The old Bosch K-Jetronic electromechanical injection system has been replaced by the newer Bosch Motronic 2.7 fully electronic system with revised mapping. In my own experience, the Jetronic system can take a quarter of a million miles of utterly problem free thrashing without a hint of protest, so we can expect few problems in this area.

On the outlet side of things, a new exhaust system combined with a new catalytic convertor has allowed the entire engine and gearbox assembly to be lowered in the chassis by an inch, and has also improved engine efficiency to the extent that fuel economy has been improved by up to ten per cent.

The rest of the drive train has been updated and uprated in line with the engine. The gearbox has been strengthened to handle the extra power, and benefits from new synchronised pre-loader springs and a modified lever inclination. Inertia throughout the gearbox has been significantly reduced, and in practical road-going terms, the introduction of bearings at the gear lever end of the linkage means a useful reduction

The fabulous flat twelve engine. A lot has changed internally, but the logo on top of the plenum chambers still says Testarossa

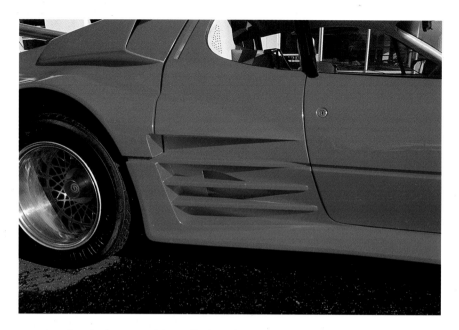

in missed gearchanges. After all, there's not much point in having over four hundred brake horsepower available if you're coasting round a corner in neutral, trying to find a gear.

This approach – looking for real improvements in drivability and thus in practical cross country speed – continues with the clutch, which is now single plate. Not only is it a lower inertia clutch and thus a performance improvement, it is also very light and smooth, so in practical terms you can drive the car faster and for longer.

Again from personal experience; I once reviewed a car fitted with a small-block Chevy V8 and a full competition clutch. After a while your leg begins to hurt too much to change gear any more, so you ease off, stop trying to go fast and just leave it in fourth, bimbling about admiring the scenery and listening to the sidepipes burbling. This approach would not be quite in the spirit of Ferrari, really, would it?

Above
The side strakes that were to develop into the seriously convincing sets of slats on the sides of the Testarossa and 512TR as more and more air was needed at the business end of the cars

Right
The direct antecedent of the Testarossa and 512TR family, the Berlinetta Boxer. This one is smothered in aftermarket body panels, but you can't disguise the essential beauty of the design

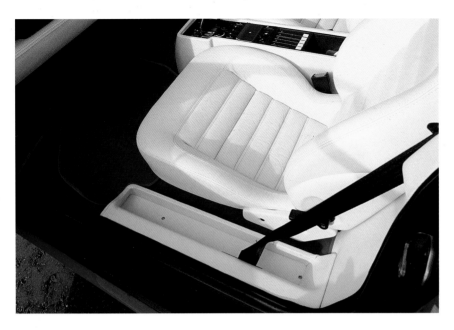

The radical revamping of the engine and drivetrain meant that forward motion had now been quite comprehensively seen to, and it was time to have a look at cornering and stopping. The most notable outwardly visible changes from the Testarossa to the 512TR are the wheels and brakes. The new five-spoke wheels are 18" in diameter, two inches bigger, and are shod with eight inch wide 235/40 Pirelli P-Zeroes at the front, and massive 10.5" 295/35 tyres at the rear. This compares with the old 60 series 16" tyres on the Testarossa. The brakes are also uprated, with the discs bigger in size and drilled for ventilation.

New ducting at the front has improved the cooling airflow to the brakes, and the rearrangement of the rear air scoop at the business end of those delicious body fins has allowed an improvement in the cooling of the rear brakes as well. In addition to that, from October 1993 there has been a Bosch electronic ABS system fitted to the brake master cylinder. If you prefer to feel what's happening and work the brakes yourself, you

Above
The new leather seat squabs on the 512TR are trimmed in rectangular panels. The seats themselves are firmer and more comfortable in the later version of the car

Right
The nearer red car is a 512TR, the blue one beyond it is a Testarossa. The flying buttresses on the Testarossa come to an end a good few inches before the end of the car, but on the 512TR they go pretty well as far as the tail

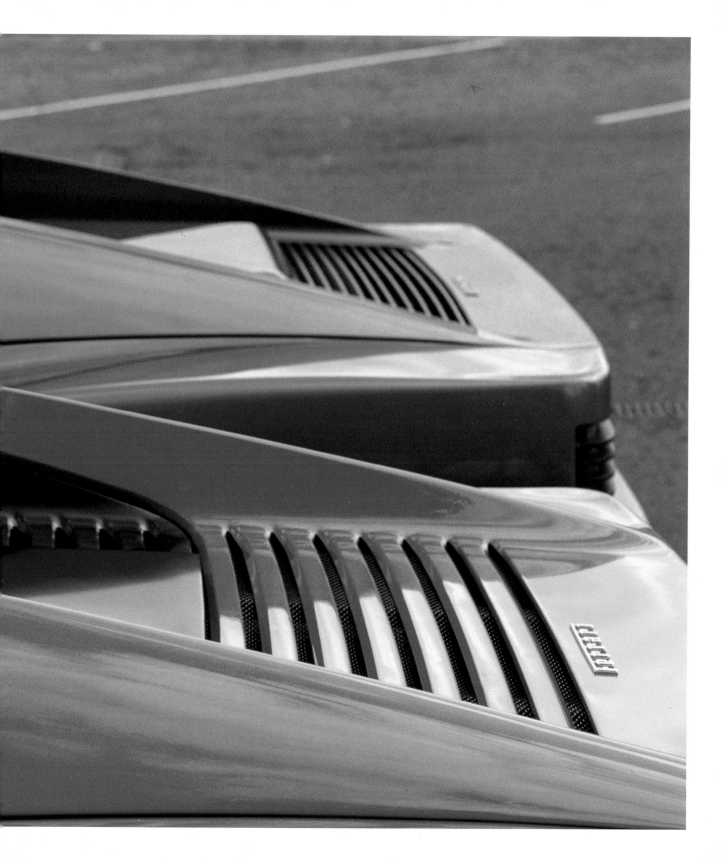

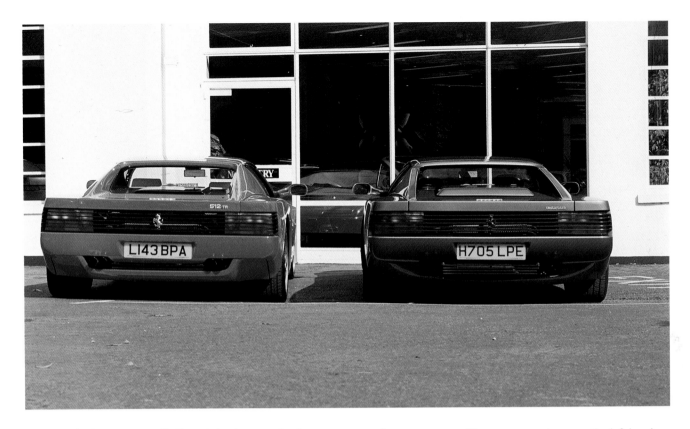

can switch the system off. Certainly the new brakes are razor sharp: at low speeds, the car simply stops dead if you press the brake with any effort, and factory testing suggests that if you slam everything on at 200kmh, you will shriek to a halt some 20 metres more quickly than a Testarossa. However, given the price of 35 and 40 series Pirellis, it's probably just as well to take their word for it.

The handling of the 512TR, already sharpened up by the lower profile, wider tyres, has also been extensively developed. Unsprung weight has been cut by making the steering joints, the front stub axles and the rear hubs out of aluminium alloy, and by the use of aluminium bodied shock absorbers and lightweight steel springs. The wishbones themselves have been stiffened up, the overall suspension geometry and camber adjustments in particular have been slightly revised to keep the tyres more upright relative to the road, and the overall ride height of the whole car has been lowered. The centre of gravity of the car went down significantly when the engine and gearbox assembly was lowered by an inch. The slimming programme applied to the car in its entirety has cut about 100lbs from the overall weight.

The new rear valance on the left hand car is a considerable improvement over the Testarossa: the line is cleaner and more decisive, and blends in much more harmoniously with the shapes on the rest of the body. Aerodynamically it also improves matters

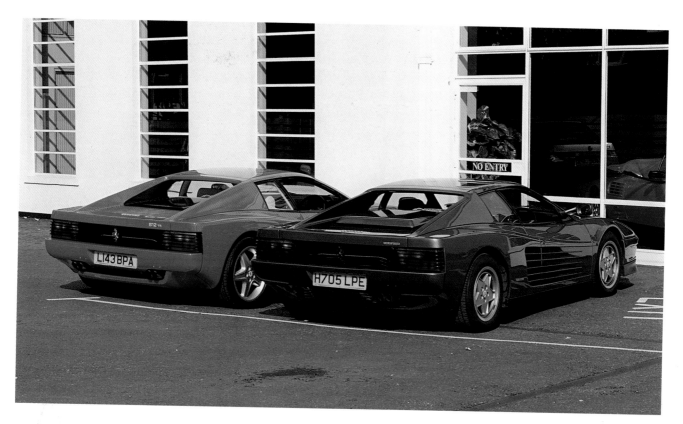

The rear quarters of the two cars compared: Ferrari are to be congratulated on resisting the temptation to fiddle too much with a basically very attractive design. Hands up who knows what colour Ferraris ought to be painted?

There's no point in having extra-sophisticated suspension if it's not mounted on a rigid platform, so there have been some improvements here as well. Ferrari's earlier oval tube chassis beams have been brought back to stiffen the spine of the car, with notable results: the torsional strength of the body has been improved by 12.5%, and the front to back bending strength is up by a remarkable 25% – and it was by no means bad in the earlier Testarossa.

The overall result of the revised suspension and chassis package can be seen by the results: where the old Testarossa subjected to a cornering force of IG would indulge in 3.5 degrees of body roll, the 512TR only rolls to 2.4 degrees, representing a considerable improvement.

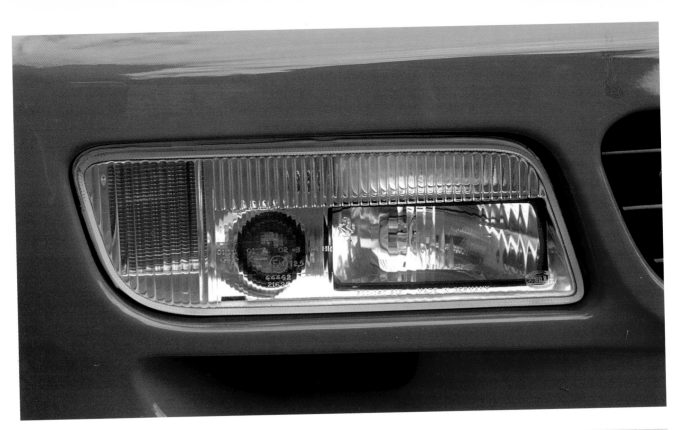

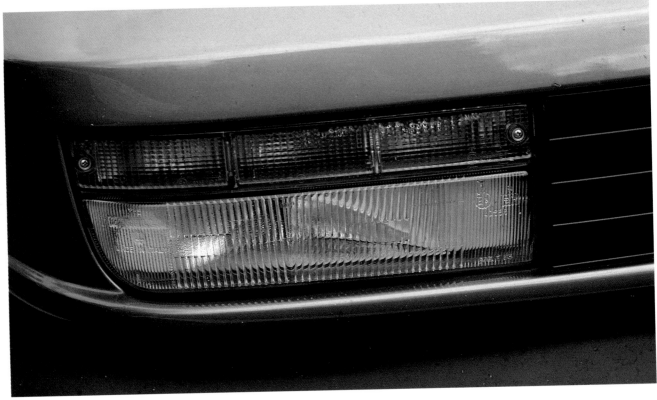

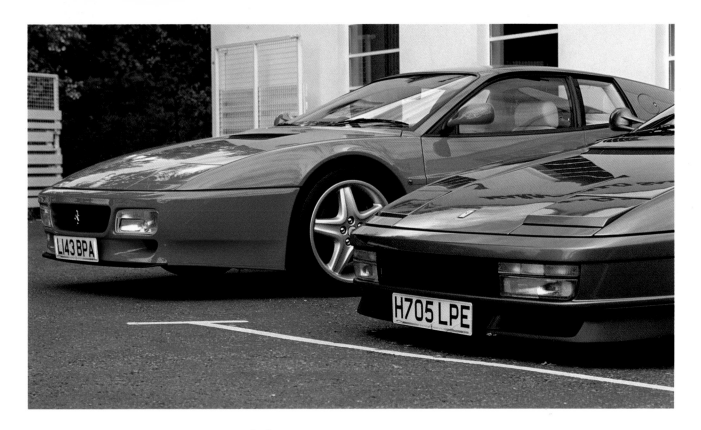

Left
New and old auxiliary light arrangements. The new Pininfarina valance incorporates softer and more curvy glasswork to complement the shape of the new dummy grille

Above
The front valances old and new compared side by side: Pininfarina's new version definitely adds some character to the front end, and also provides a subtle but effective updating job

A closer look at the old and new front ends highlights the differences between them. The crisscrossing on the Testarossa bonnet is not the result of mass psychosis in the paint shop, but shadows thrown by the window frames in Maranello's attractive Art Deco showroom

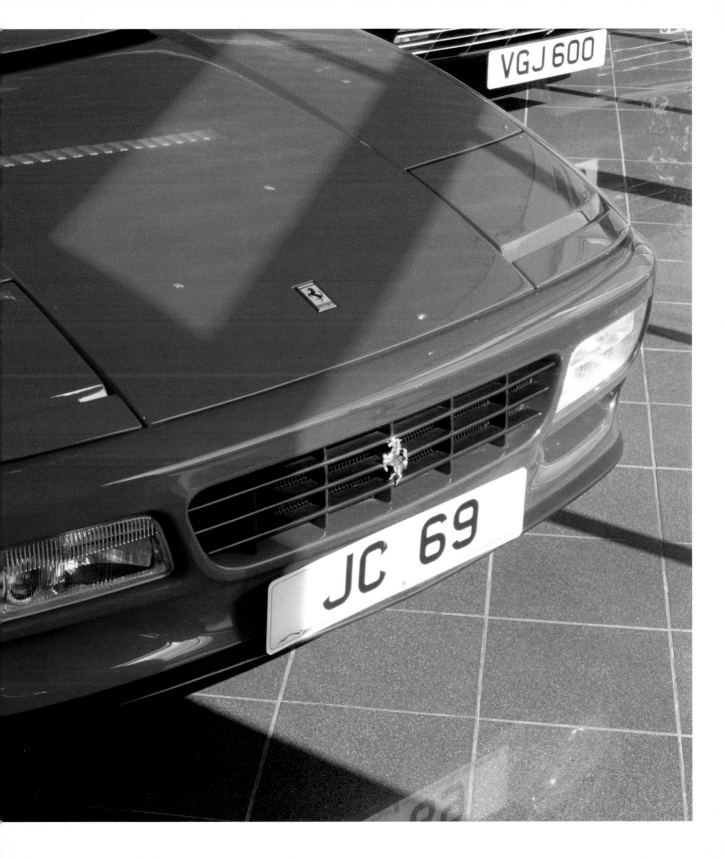

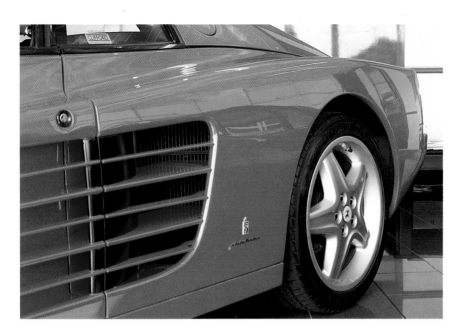

New and old rear quarter panels and those wonderful strakes remain the same: however, the substitution of 18" thin spoke wheels and ultra low profile tyres brings the shape confidently into the nineties

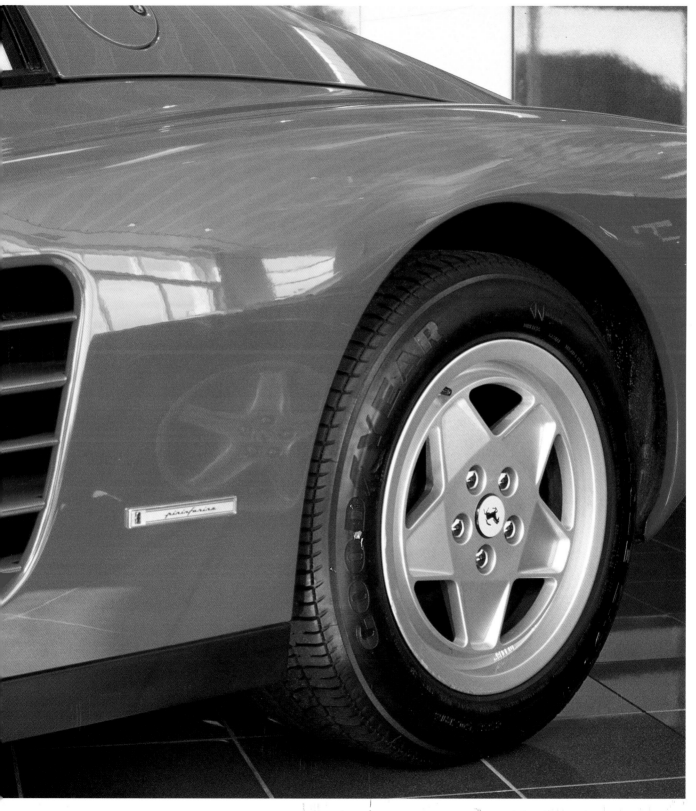

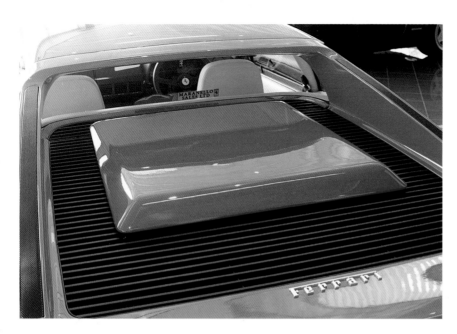

The large body coloured panel on the Testarossa's rear deck has been replaced by a smaller black one. However, the function of the panel remains the same, i.e. to shift as much air through and out of the engine bay as possible

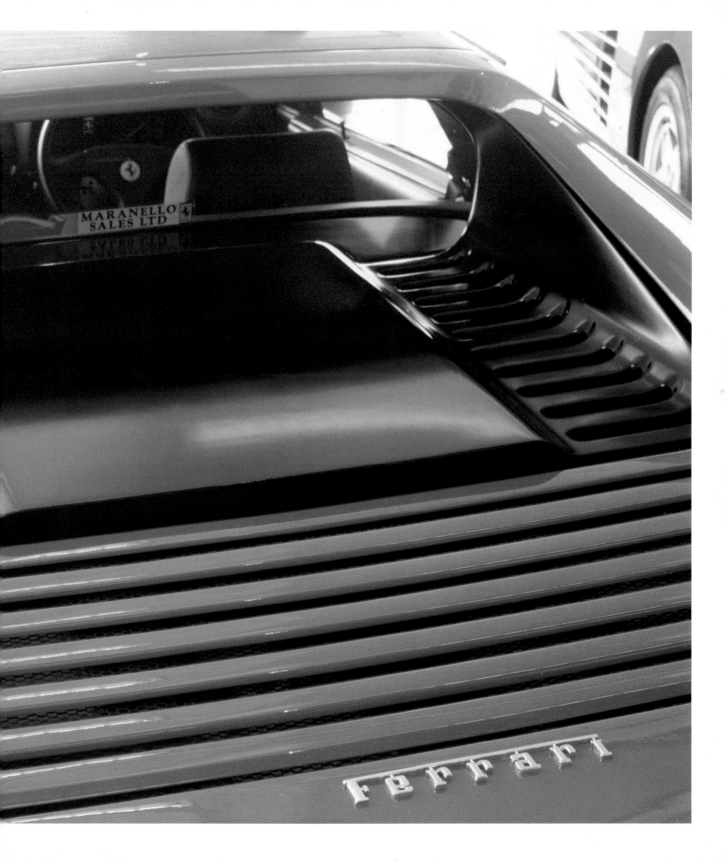

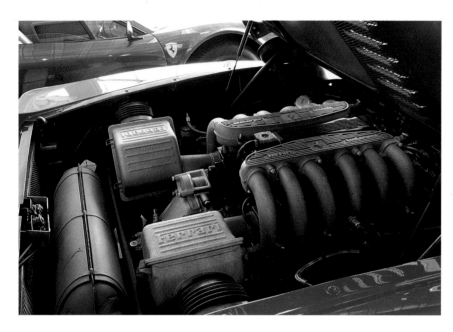

Above

Looking across the engine bay in the 512TR. Air inlet tubes should according to motoring theology be exactly matched in length, and as long as can reasonably be achieved. Big square airboxes provide effective protection from airborne rubbish. Big single silencer box conceals a catalytic convertor beneath it

Right

Nestling between the airboxes is the clutch bell housing, containing the new lighter single-plate clutch. Drive is then taken by gears down to the gearbox and final drive unit beneath the engine

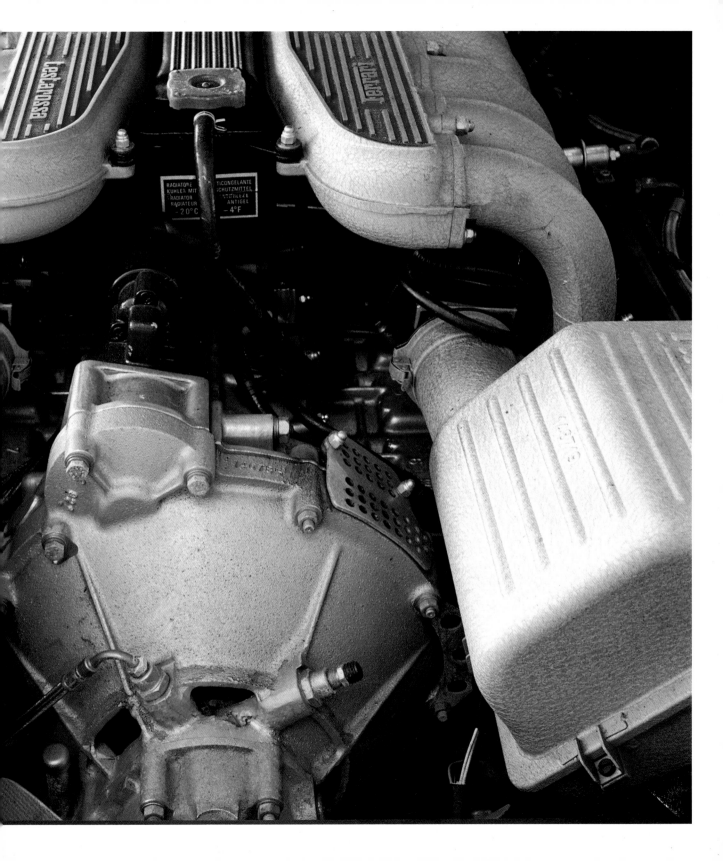

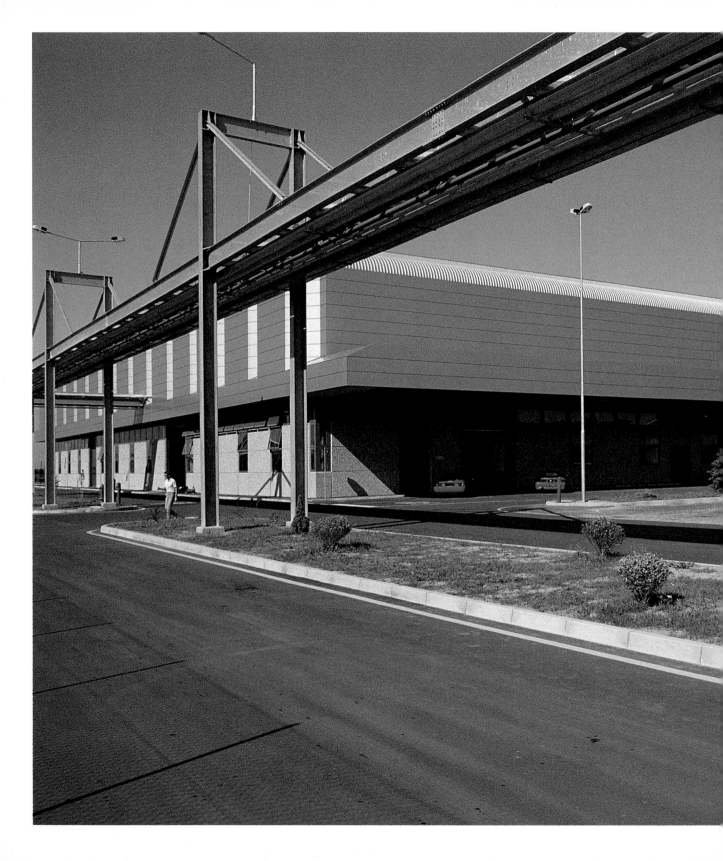

The Anatomy of a Boxer

Enzo Ferrari always felt that the heart of his cars was the engine, and the Boxer is an engine that lives up to his name. From its inception to its current form a generation later, no other engine has ever had quite the same presence. While a big and inadequately silenced V8 will always warm the heart, Ferrari's flat twelve on full song has the power to make the hairs on the back of your neck prickle.

In tune with Enzo's philosophy, while the less important bodywork and peripherals of the car could be handled by somebody else, the engine could not be made anywhere other than by Ferrari themselves at Maranello.

The new foundry at Maranello is a huge, high ceilinged building, full of light and air, and as squeaky clean as the rest of the Ferrari complex. Compared to the usual mental picture one has of a metal foundry, this one looks more like a computer room, or the kitchen of an upmarket restaurant.

However, despite appearances, this is a very effective foundry indeed, and it turns out no less than 70 Boxer blocks a day. The engine blocks are made from an alloy composed of a blend of aluminium and silica, which gives an effective combination of rigidity and long-term strength with the lightness necessary to make a flat twelve engine a practical proposition in a fast road car.

The moulds for the engine castings are coated with either sand imported from France, or with earth from the Italian town of Sarona. The coating provides the outer texture of the castings, and allows them to be easily removed from the moulds without sticking.

The moulds are then injected with gas and with bonding agents, the former to clean out impurities and the latter to attach the parts of the moulds together. Some moulds are quite straightforward, and consist simply of two halves: others are much more complex, and involve several sections which have to be assembled and attached to each other.

When they have been assembled, the moulds are baked until they are hardened, and are finally heated with a blow gun until they have been purged of any gases that might have remained in them. They are then ready for use.

The new foundry building – the Ferrari factory has been quietly expanding, although the number of cars will always be kept low to protect their exclusivity

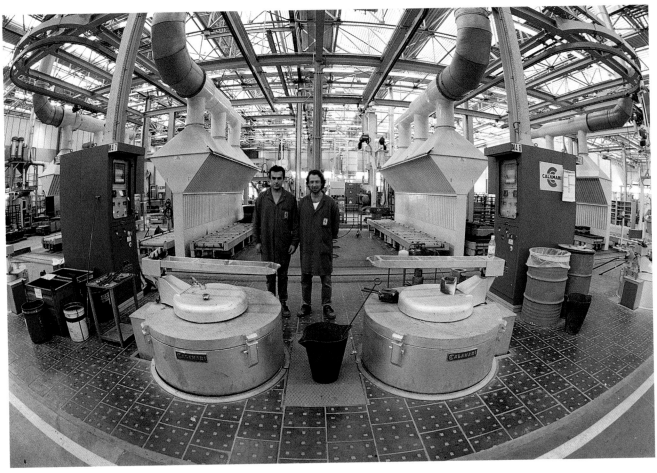

While this has been going on, ingots of alloy have been loaded into vats, and the furnaces beneath the vats have been heated until the ingots have fully melted and have achieved a temperature of 600 degrees celsius. The alloy is then ready to pour, and is moved to the moulding area on a series of overhead cranes: oven gloves wouldn't quite hack it.

For each Boxer engine, 50 kilograms of alloy is carefully poured into the mould. When the molten metal has filled the mould right to the top, the cooling process can begin. This is a delicate business, as the solidifying metal must be cooled at a slow and controlled rate. If it is allowed to cool too quickly, there is a likelihood of setting up casting stresses, which ultimately mean weakness in the walls of the engine: not something you want to countenance in a car capable of nearly 200mph.

The moulds are gently and slowly cooled, and when that process has finished, they are briefly reheated and subjected to a controlled

Inside the foundry, the surroundings are remarkably clean: not the usual grim clutter of a traditional foundry at all

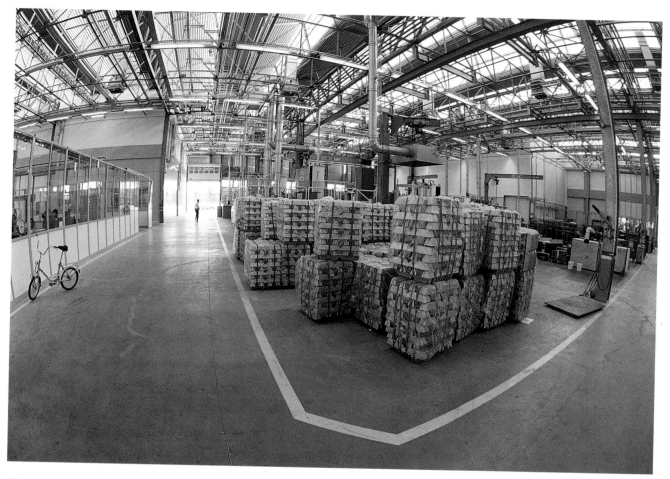

Aluminium ingots are bought in large and cost-effective amounts, then stored prior to use

vibration. The casting and the mould are loosened, and the mould is dismantled and prepared for its next cycle.

The castings are checked carefully, and a random selection of them is subjected to more intense testing. This involves magnification by 1500 times, and the close inspection of the outer surface of the casting for any signs of fractures or surface faults. Next, the casting is subjected to internal inspection by X-ray and then by spectrometer to examine it for any problems or impurities that might have occurred within the metal.

Some of the markings on the castings are made as part of the moulding process, and others are added later, such as the number of the particular engine, a date mark and the identification of the individual who made the casting. Flash, which is the extra metal left around the edges of each casting by the moulding process, is cleaned off, and the castings are passed on to the next stage.

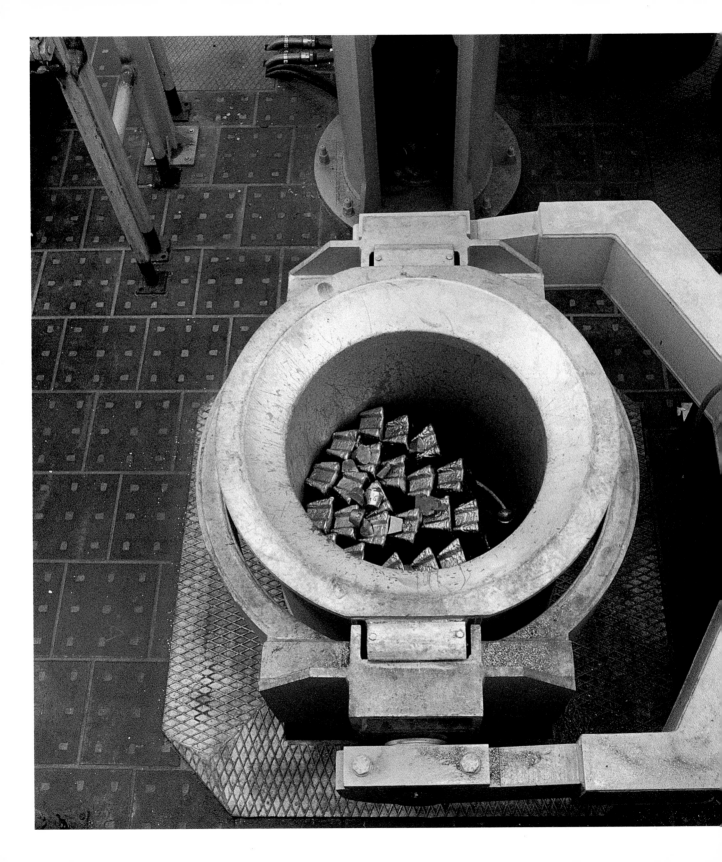

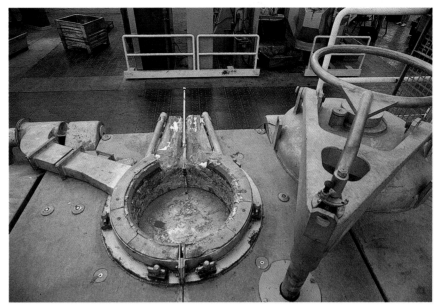

The milling, drilling, tapping and finishing of the castings for Ferrari engines, gearboxes and other cast components is carried out on big automatic Mandelli machines, which are controlled nowadays by computers. All that is needed from the machining of the castings is accuracy and reliability, so controlling the processes by computer is the most efficient way of handling the task: after all, computers don't get bored, although they are quite capable of making mistakes.

The steel parts of the engine are actually made from billets shipped out from the UK, so in a way the heart of the engine is British: an intriguing thought. The crankshafts are made of forged molybdenum steel, and are machined at Maranello and then nitrided for additional strength. The camshafts are also made from specialized toughened steel, and other specialist metals are also involved in the construction of the engines.

Although the inlet valves are straightforward enough in being made of ordinary steel, the exhaust valves have to survive some extreme conditions in such a very high performance engine, and they are made of nimonic steel so that they can handle the task demanded of them. The

Left
The ingots are put into a vat, which is then loaded into a smelter

Above
The aluminium melts at 600 degrees, and is then ready for use

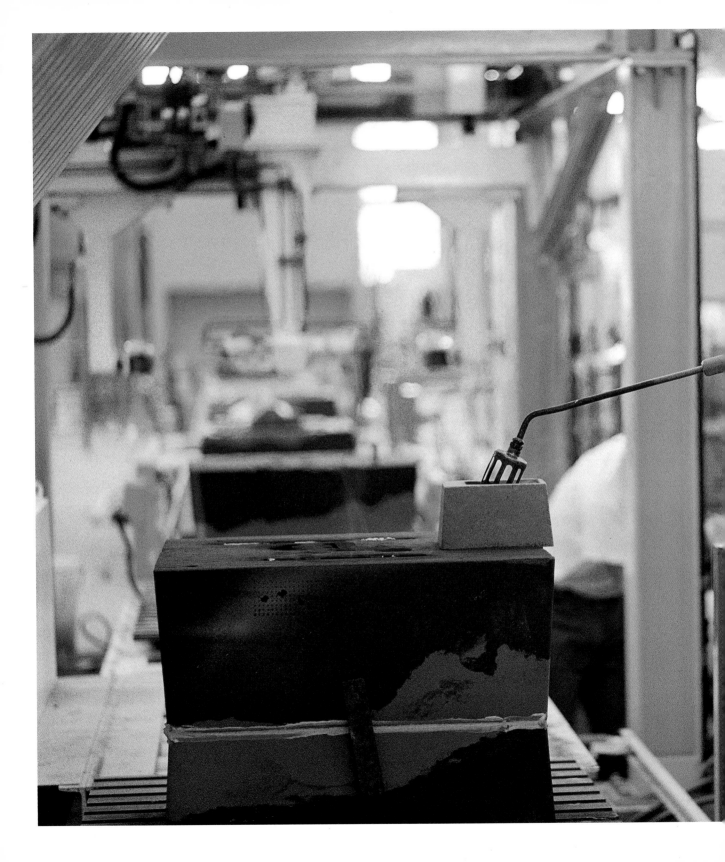

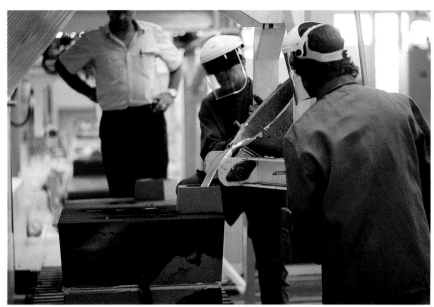

valve seats are still best made from straightforward cast iron, and the valve guides themselves from bronze.

The cylinder liners, rather than being made of the more usual steel, are in the 512TR engine made from aluminium coated with Nickasil. This is an advanced alloy which gives a very acceptable rate of bore wear, but which is still very much lighter than a steel liner. As ever, less weight means more performance.

The artistry and the delicacy of the human craftsman comes back into play when we get to the assembly of the engines, where persuasion and manipulation is necessary to get the whole thing to go together just so.

The basic engine castings are mounted on a stand which allows them to be spun around their own axis like a kebab, and the engine build begins. First the crankshaft main bearings are fitted, then the crankshaft itself.

The cylinder liners are next, followed by the conrods, big end bearings and pistons. The pistons come in their own box, in a matched and balanced set for each engine. One of the trickier tasks is to get all

Above
The vat containing the molten metal is tipped up carefully to pour the aluminium into the mould

Left
Heating the mould with a blowtorch drives out gases and helps avoid impurities

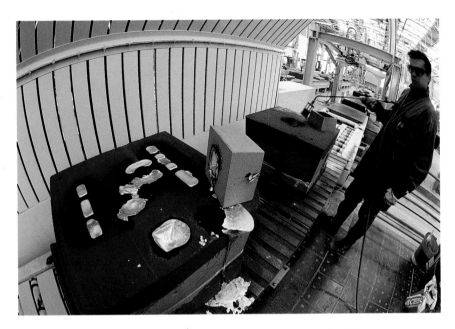

twelve of the pistons, attached to their twelve sharp-edged connecting rods and big ends, all fed into the cylinders without the slightest scratch on the delicate surfaces of the cylinder bores or the crankshaft bearing faces.

With the bottom end of the engine now in one piece, the cylinder heads are assembled and attached, and the oil system is plumbed in. This consists of two scavenge pumps and a pressure pump. This relatively complex system is necessary because the engine works on a dry sump basis: you don't want the weight of a gallon or two of oil up at the top of the engine, but you do need it for cooling. The solution is to use two big oil cooling radiators mounted low down in the chassis, and to keep the minimum of oil in the engine itself.

The valve timing is by toothed belts, which are designed to expand and contract to the same extent as the engine, and allow a high degree of reliability while at the same time keeping the noise down to an acceptable level. Again, this all connects ultimately to performance – a noisy engine is tiring, and tired drivers cannot sensibly use all the power.

Above
The casting is left to set, with the cooling process carefully controlled to avoid flaws in the finished item

Right
Casting moulds come in all shapes and sizes, but the basic principle remains the same

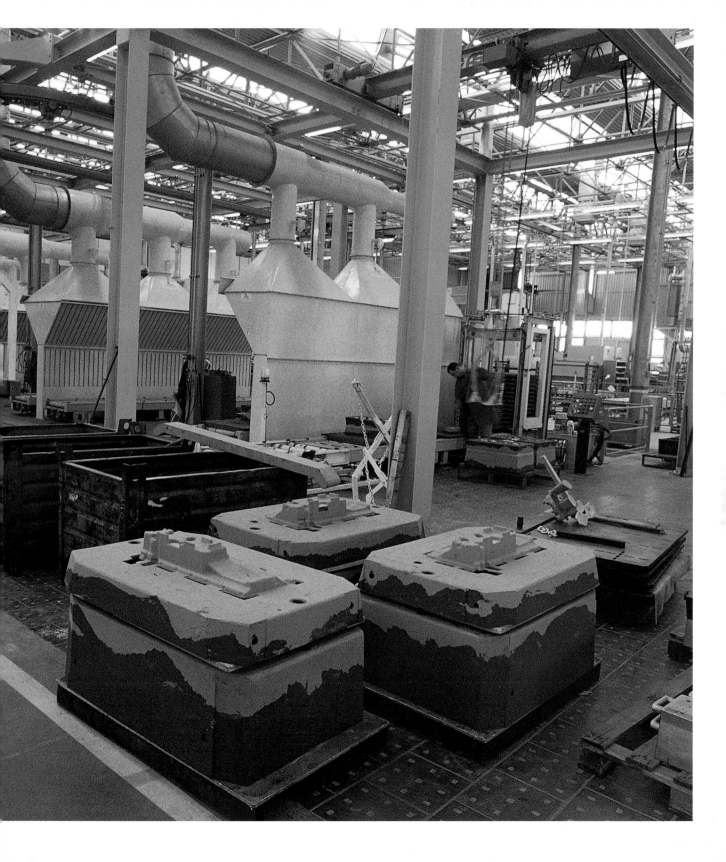

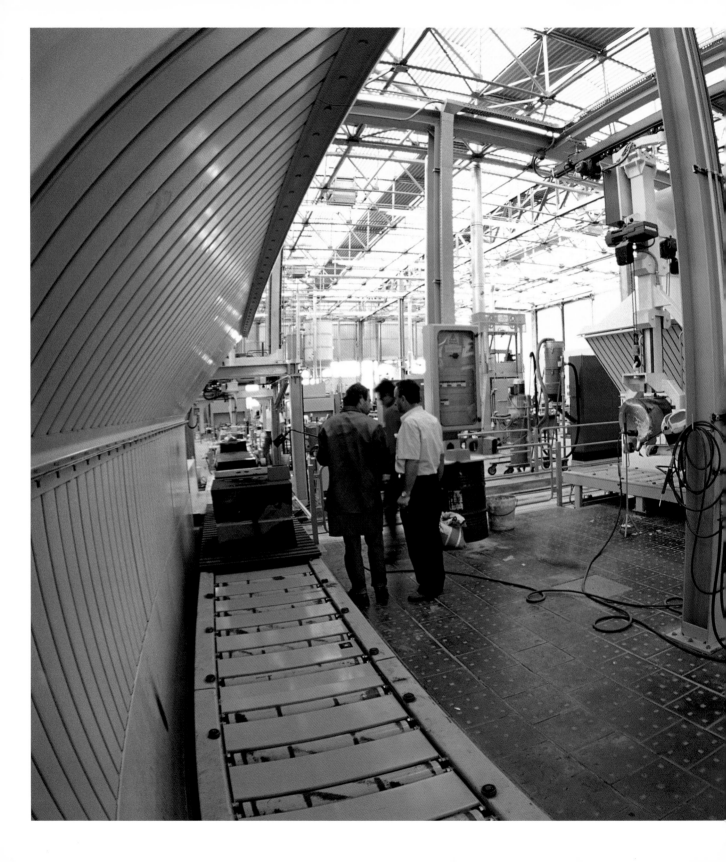

The fuel and electrical systems are attached, and the engine is run up for four hours. This is partly to eliminate the possibility of a problem at the build stage, and partly to begin the running in process under conditions controlled by Ferrari rather than by their owners: after all, you cannot assume that everyone knows how to run an engine in properly, or even that they would do so if they did know how.

Finally, the clutch and its housing, the transfer gears to the gearbox, the gearbox itself and the final drive units are all bolted in place, and the Boxer engines go into store and await their body chassis units, which are on their way from the ITCA factory to Maranello.

Above
Larger castings are moved around the place by overhead cranes: juggling the hot metal from one hand to the other just wouldn't work with this stuff

Left
Casting is a heavy industrial process, and some fairly unpleasant fumes are generated. These are extracted from the factory through large air extraction tubes

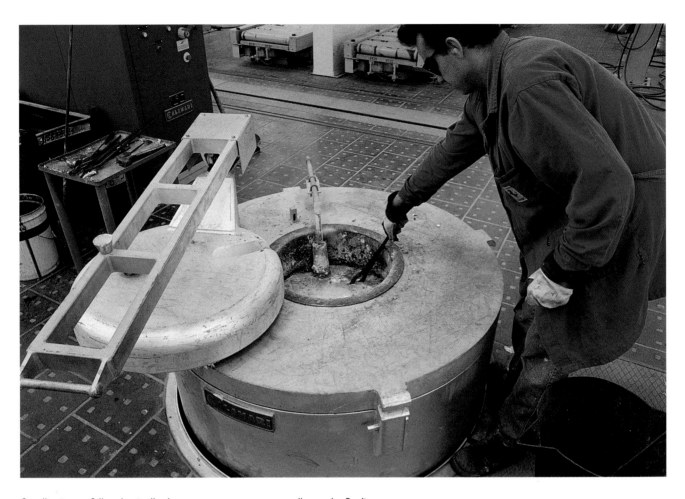

Smaller items follow basically the same process, on a smaller scale. Bodies may come
from elsewhere, but all Ferrari's casting work is kept in house

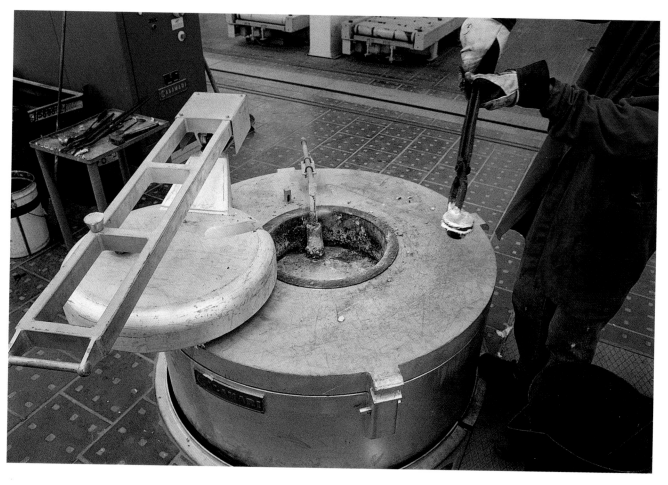

A small mould is dipped into a vat of molten aluminium and lifted out. Thick gloves and considerable care are in order here

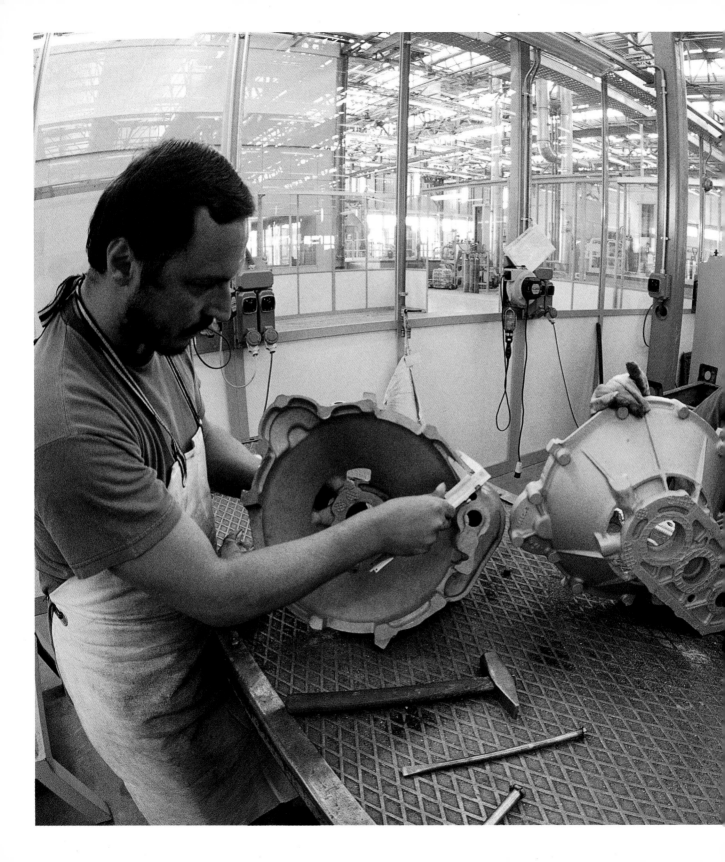

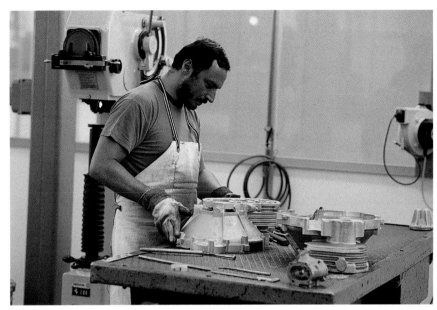

Above
When they have fully cooled and hardened, the finished castings are then cleaned up and machined. The casting being dealt with here is a clutch housing

Left
Another finished clutch housing, being fitted up to the casting that holds the transfer gears to take power from the crankshaft to the gearbox

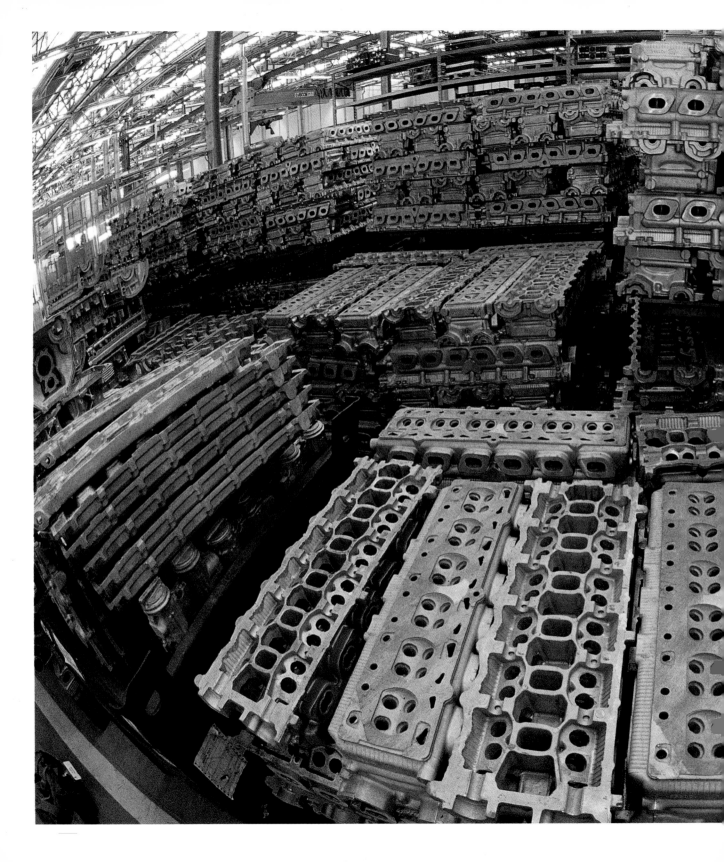

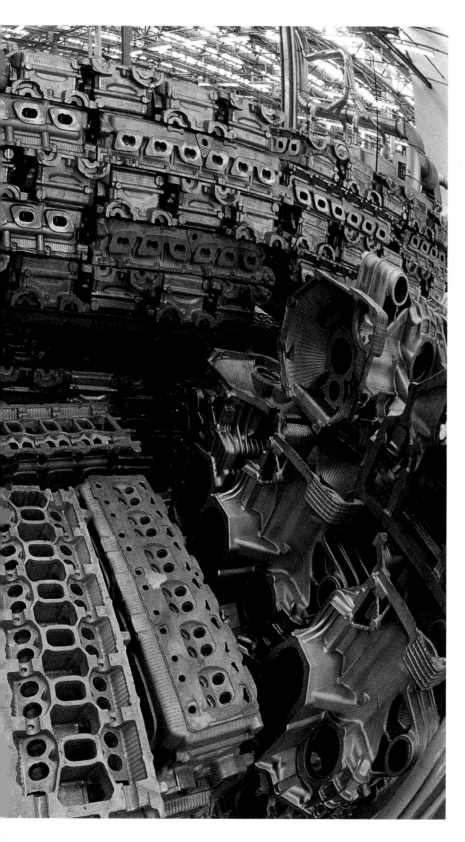

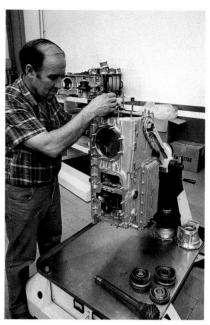

Above

*A gearbox casting, beginning to look very
purposeful indeed as it fills up with its
contents: a set of gears toughened and
uprated to handle more than 400
horsepower*

Left

*Some of the results of all that hard work
in the foundry: heads, cam covers, engine
blocks, bell housings*

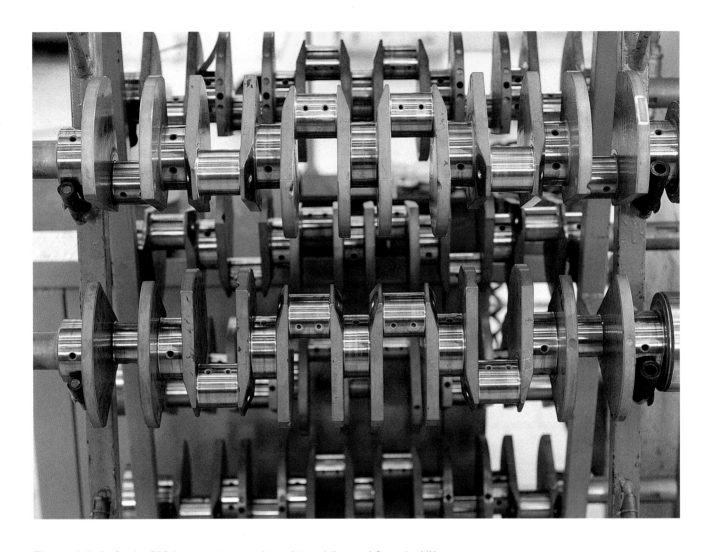

The crankshafts for the 512 boxer engine are shipped in as billet steel from the UK and machined at the Ferrari factory

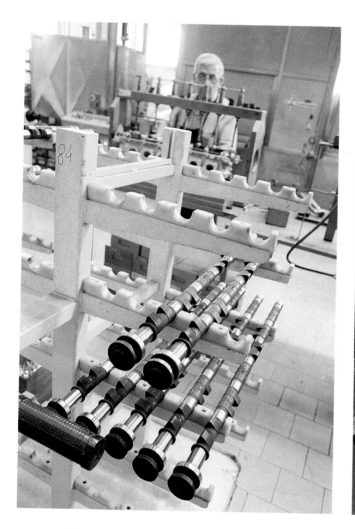

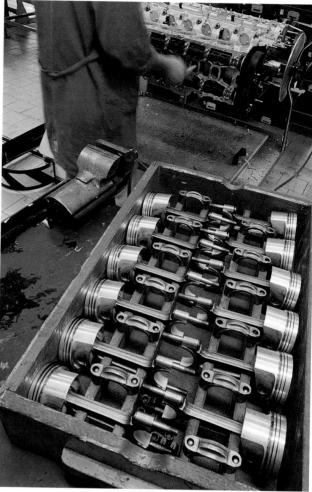

A rack of camshafts, ready to be fitted. The profile of the four cams fitted to the boxer has been upgraded for the 512TR

Each set of pistons fitted to the boxer engine is fully balanced, and supplied to the engine build section in its own box

49

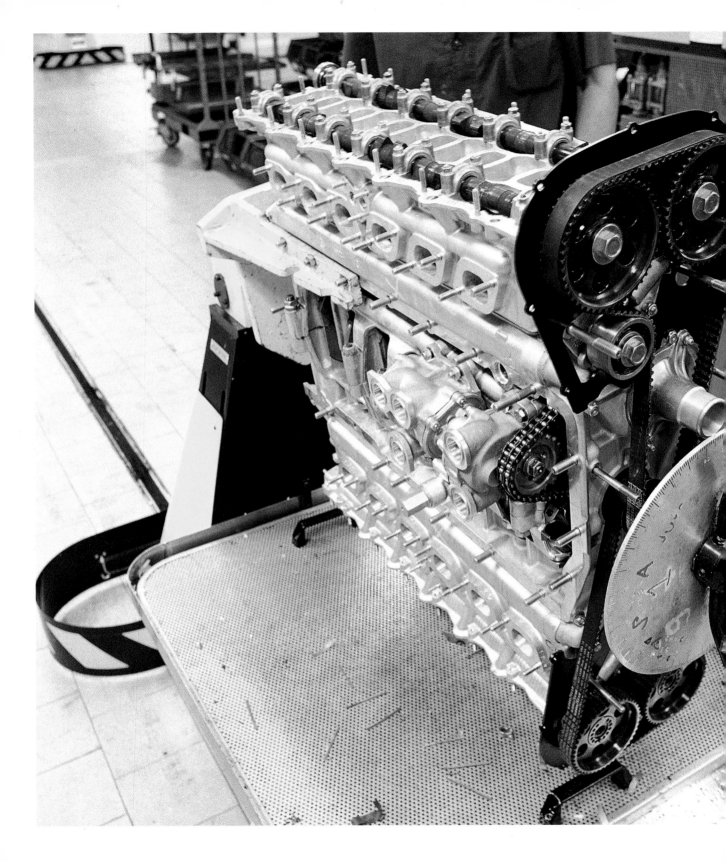

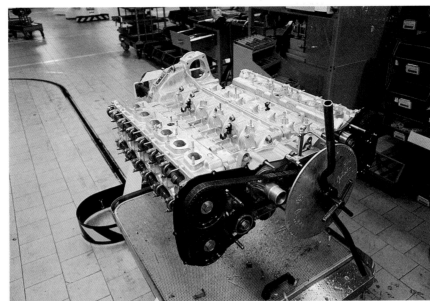

It helps when you're building up the engine to be able to get at it all easily: this frame allows the whole engine to spin like a kebab

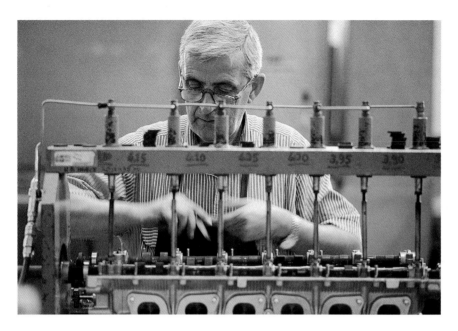

Above
The metals used may have changed, but the process of fitting an endless number of valve guides has remained the same for many years

Right
The cleanliness and order of the foundry is carried through to the areas where the engines, gearboxes and other mechanical parts of the Ferrari are assembled

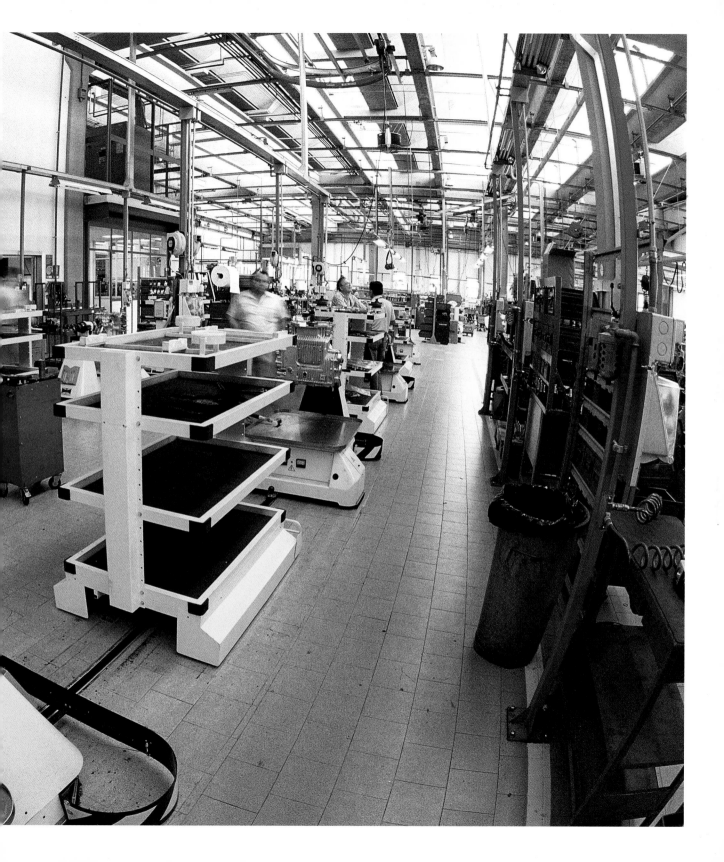

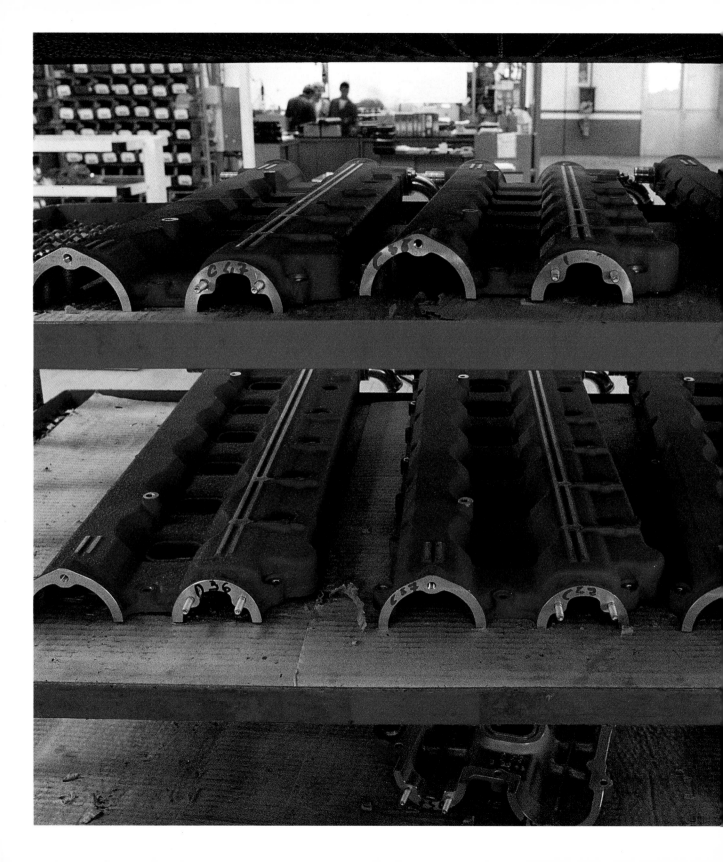

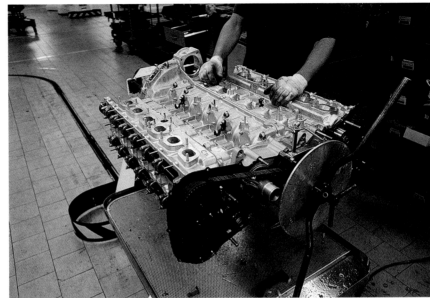

Above
The engine is put together by hand with meticulous care: the use of robots is reserved for lesser cars

Left
The traditional red cam covers that have decorated Testarossa engines since the middle Fifties, and will continue to do so for the foreseeable future

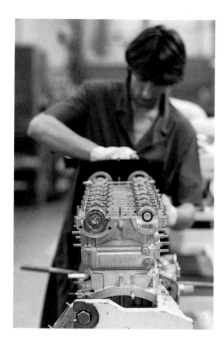

Above
*The final assembly on a cylinder head:
the next step is fetch and fit the red cam
covers*

Right
*A total of 72 cylinders of sophisticated
muscle, all sitting in the store ready to be
fitted to their body chassis units*

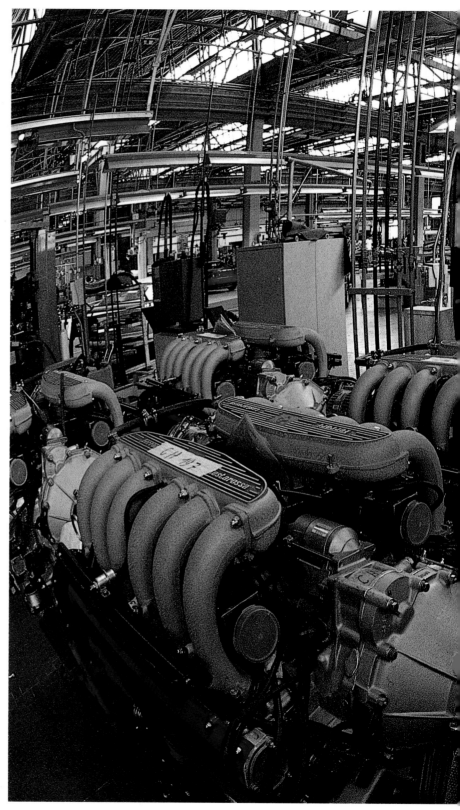

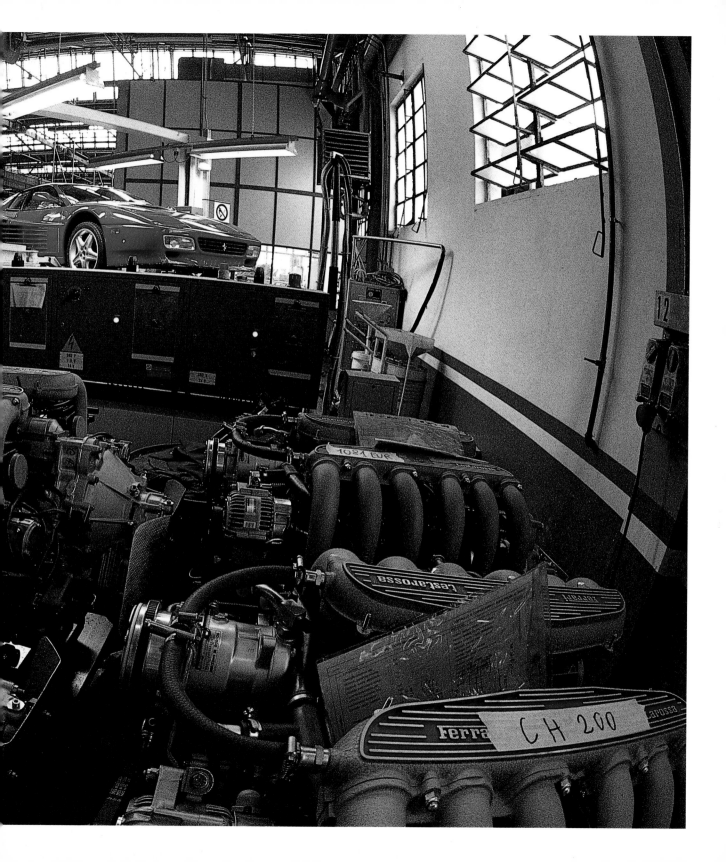

Crafting a 512TR

While the heart of a Ferrari, the engine, will always be built by the factory themselves, they have for many years been quite happy to have their bodywork and peripherals made by other partners who have their own specialisations.

One of these partners is the ITCA company, who specialise in the construction of high quality car bodies and chassis, and who still make them the old fashioned way, by hand and with a proper chassis.

Unit construction and the use of monocoques is certainly a cheaper way of building cars, but cheap cars are the business of the multinationals, and not really a concern for anyone at Ferrari other than for going shopping in.

The chassis of a 512TR begins to take shape as a skeleton of steel tubing, each component of which is attached with care and skill. Part of the development of the 512TR from its Testarossa antecedent has involved changes in the specifications of the chassis beams. In particular, some of the beams beneath the floor are now oval in section, which has resulted in some remarkable gains in the structural stiffness of the car.

The skeleton structure is gradually clothed in the gorgeous panelling of the bodywork, a lot of it still made by hand. The aluminium bonnet, for example, is still rolled by hand in a procedure unchanged for generations. The delicate curves of pre-war Bugattis and Alfas were rolled on just such a machine, and the same applies to cars built before the First World War as well.

The massive and complex doors for the 512TR are made in steel by more conventional methods, and the steel roof of the car is also produced by more modern means. The steel parts are treated by a complex rust electro-dipping protection process known as Zincro X, which sounds rather more like a detergent than a Ferrari body process. However, not many examples of the 512TR will be parked outside on the street to suffer the ravages of nature, so the Zincro X treatment is to some extent academic.

There have been some subtle but significant bodywork developments in the changes from Testarossa to 512TR. At the front, the old grille was mostly occupied by the outside of the spare wheel well at the bottom of

The assembled and painted body shells are stored until it's their turn to take their place on the production line

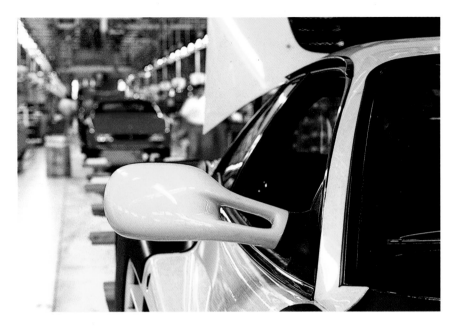

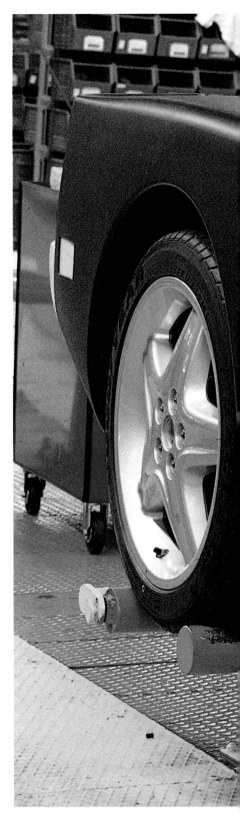

the front boot, with air going around the curve of the wheel well to cool the brakes, and with an extra duct added to provide airflow to the air conditioning unit. The Pininfarina redesign of the front panel and valance has given the car a much more distinctive look, and has resulted in a considerable improvement in its practicality.

Two big ducts below the grille now direct more air to the brakes, which are of course bigger as well as being more highly stressed and heated due to the increased performance of the car. The spare has been abandoned, to be replaced by an emergency seal-and-pump-up kit to inflate a punctured tyre. This has allowed a much bigger boot, and has also allowed the mostly dummy grille to carry the cooling radiator for the air conditioning system, right out at the front of the car in the airstream. Both the brakes and the air conditioning have benefitted from these developments.

The rear panel and valance has also changed for the better, both from a stylistic and aerodynamic point of view. Rear valances in most cars are

Above
A spectacularly long mirror looks back along the flanks of a partly built car to the production line

Right
Throughout their progress along the production line, all the bodyshells are fitted with thick layers of protective padding to avoid damage to the paintwork

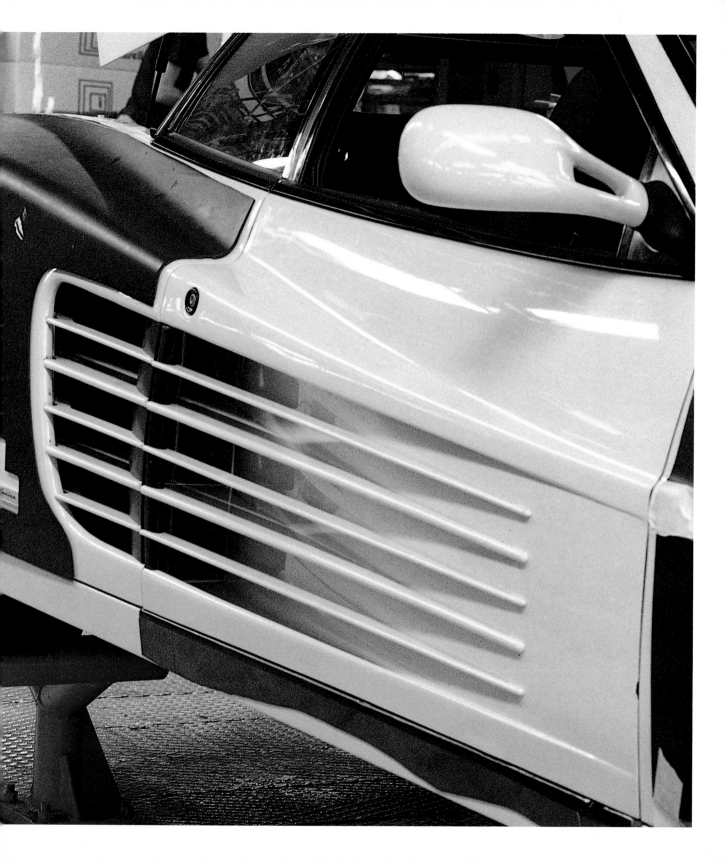

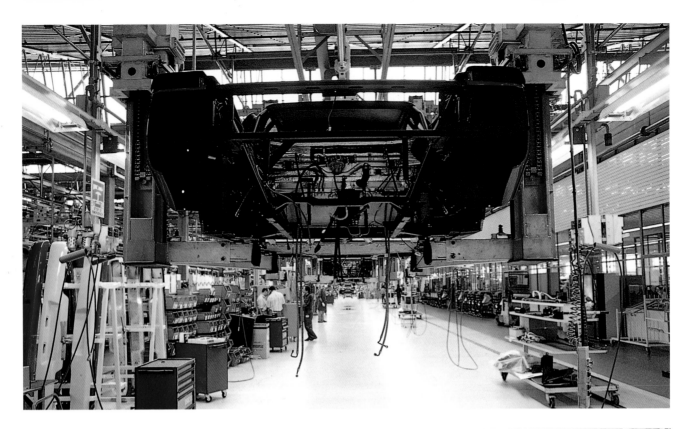

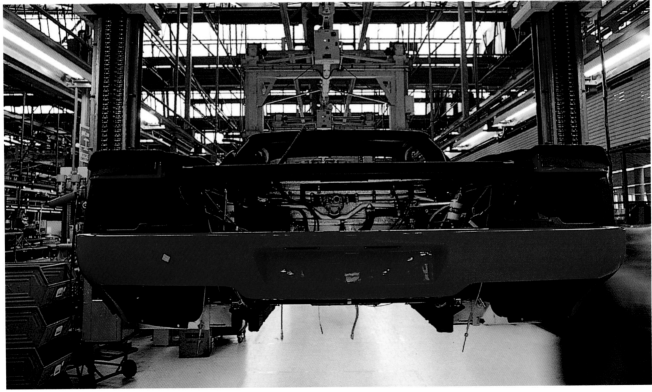

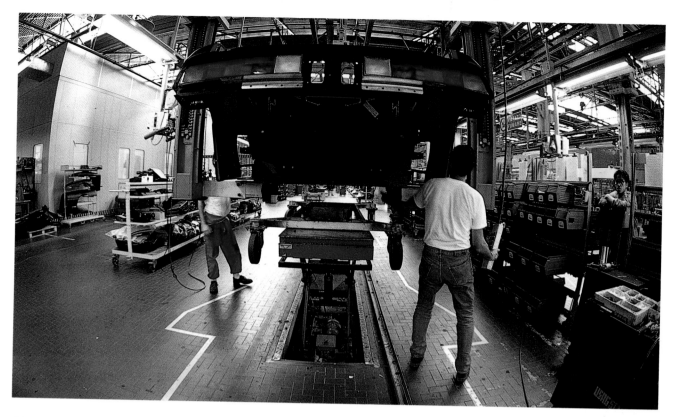

Above

All Ferraris are now made this way, and travel around the factory on cradles slung from overhead tracks: it's much easier to get at the underside this way

Above left

At the beginning of the assembly process, the car is barely recognisable: we're looking at the engine bay in this shot

Left

As the panels begin to go on, it becomes clear which end of which Ferrari you're looking at

not of major strategic importance, but when your top speed is 190mph plus, an extra percentage point in aerodynamic efficiency and stability makes a considerable difference.

The only other real change on the bodywork is a rework of the rear deck covering the engine. This is mostly a grille rather than a panel, and in combination with the rear panel it serves to move the air out of the engine bay as quickly as possible in order to let fresh air through the side fins to the radiators, oil coolers and brake ducts. The deck has been tidied up slightly in cosmetic terms, but the main difference is that the lowering of the entire engine and drivetrain has allowed the centre of the deck to be lowered. This means rearward visibility is much improved. The only other change on the rear deck was to extend the flying buttresses just by a couple of inches, so that they come to an end just a little closer to the tail.

As far as the rest of the bodywork is concerned, the age old American mechanical dictum was brought into force – "If it ain't broke, don't fix it." The Testarossa body shape is gorgeous, and any significant fiddling could easily have spoiled it: Ferrari behaved with admirable restraint, restricting themselves to a few small and genuine improvements, and otherwise left the body alone. The slatted sides and the voluptuous sweep from the mirrors up to the rear deck have been

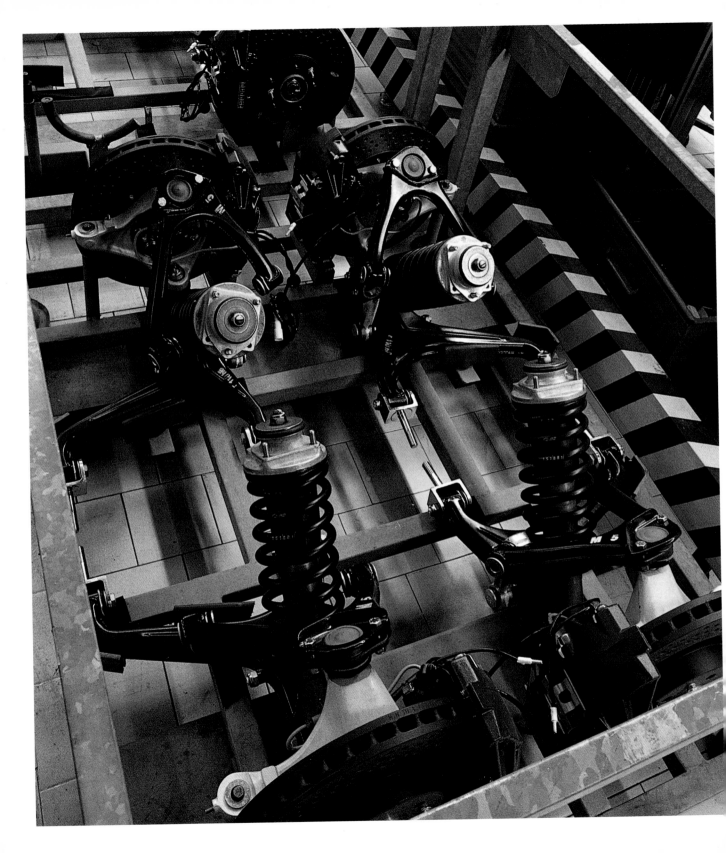

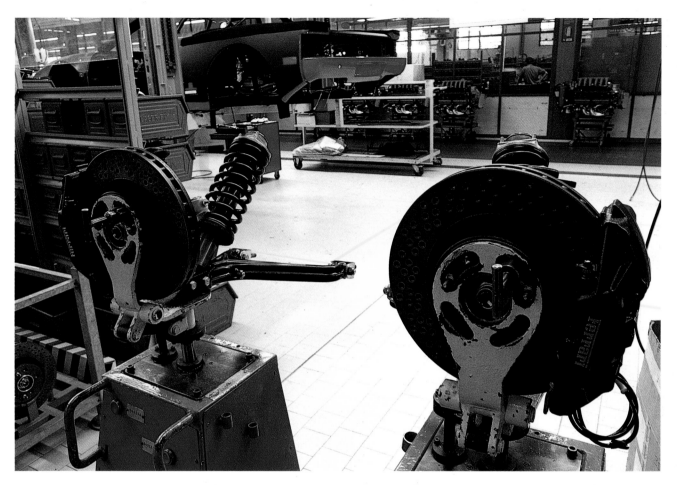

Left
Completed sets of front suspension, ready to be bolted up to their cars, await their turn

Above
The hub assemblies are raised up into position on bottle jacks, and when they are in exactly the right place, the bolts are slipped in and tightened up to the right torque

left completely as they were. There was nothing that could have been done to improve that area of the car, so they left well alone.

When the chassis and body of the 512 have been completed, they are shipped from ITCA to the Pininfarina works at Grugliasco for finishing. The first thing Pininfarina do is to degrease and rinse the whole assembly, which is then immersed in zinc phosphate. After being cured in an oven to set the zinc phosphate, the body chassis unit is dipped in an electrically charged bath of primer, to make sure that every nook and cranny is painted.

When the first coat of primer has been cured, the process is repeated twice, to ensure a thick covering of protective paint. After that, mastic sealer is applied by hand to all the inner seams and joints, and the car is undersealed. This is all far easier with an ordinary production car, which is essentially constructed like a biscuit tin. The Ferrari has a

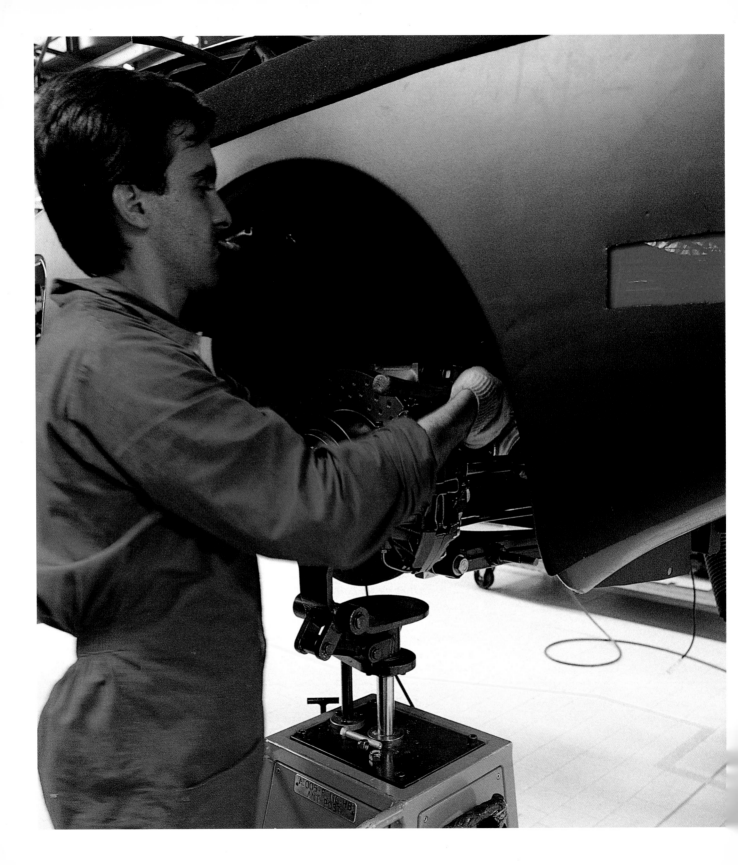

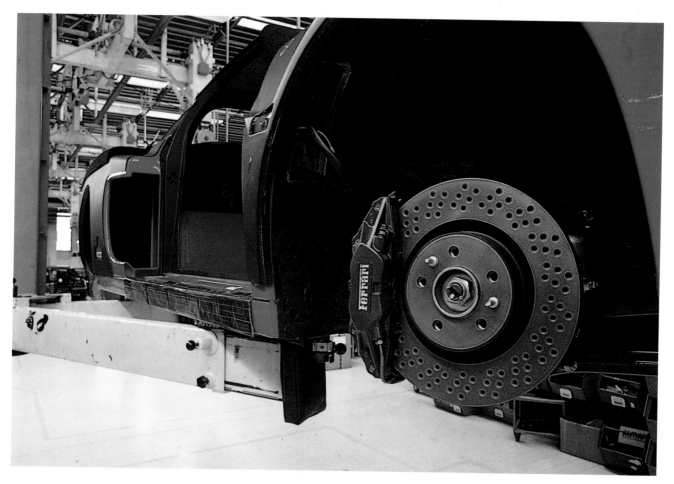

chassis as well as a body, which complicates the procedure of painting and weatherproofing it.

The next step also involves days of patient, measured hand work, as the first layers of primer are rubbed down by hand with fine abrasives. When the sensitive and experienced fingers of the paint shop craftsmen can no longer feel any flaws in the surface, the next coat of primer goes on, and finally the colour coat stage begins. When that has hardened, the inside of the car is painted matt black, and the finish coats of hard, glossy laquer are applied over the paint.

The windscreens and glass nowadays benefit from space age technology, and are bonded in place rather than held in with the old fashioned rubber. The bonding agents that are used form an extremely strong attachment, and this not only avoids leaks, it makes a significant contribution to the stiffness of the body, as the screens and the body

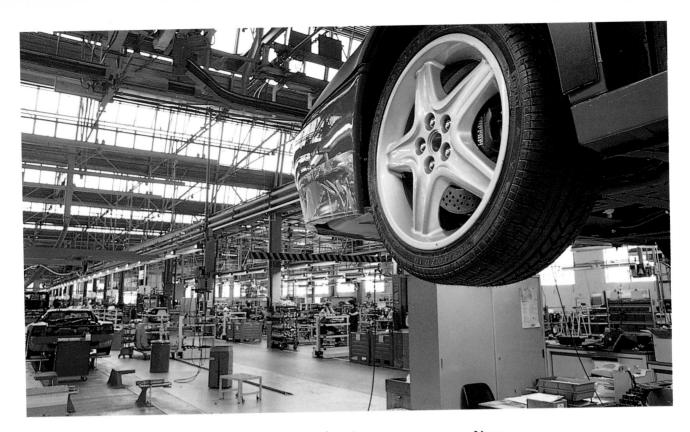

form a rigid unitary structure, not as per usual a weak point.

The bodies as they progress through the Pininfarina plant wear soft, protective foam plastic sheets, to ensure that stray screwdrivers and the large number of other sharp objects found in factories don't scratch the paint. With the glasswork in place, the next item is the wiring loom. With the loom in place, the interior trim and the other electrics can be fitted, and the first of the mechanical componentry can be secured in place, in the form of the steering column: in the 512TR, this has also been the subject of a few detailed improvements.

The air conditioning plant is now plumbed in, with all the front to back hoses and the rubbers around the body openings. The dashboard and instruments are fitted and connected up, and the seats complete the interior. The pop-up headlamps and their electric motors are fitted and tested.

The cars are now about ready to complete their assembly, for which they are taken to Maranello for the fitting of the Ferrari manufactured components. At the Ferrari works, the cars are fitted with the sections of sub chassis that carry the various suspension and steering components. These have already been built to the sub-assembly stage, and are jacked up off the floor on large bottle jacks until they are in position, and then bolted in place.

Above
Massive new thin-spoke wheel is shortly due to turn in anger for the first time as the car approaches the end of the production line

Above right
White gloves are worn throughout most of the factory. In this shot, the interior is beginning to be assembled

Right
The basic door structures arrive with their hinges on but little else

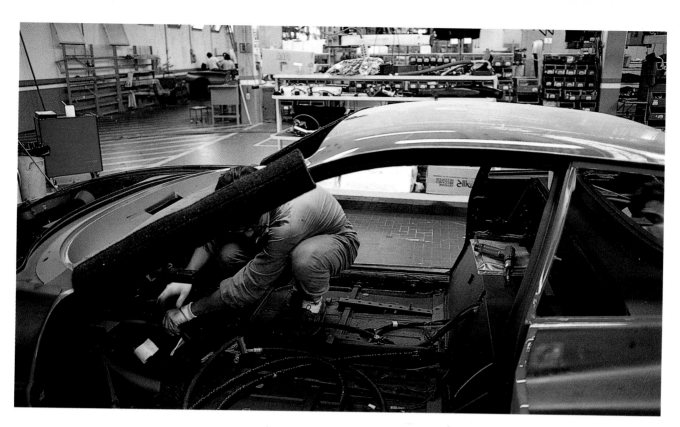
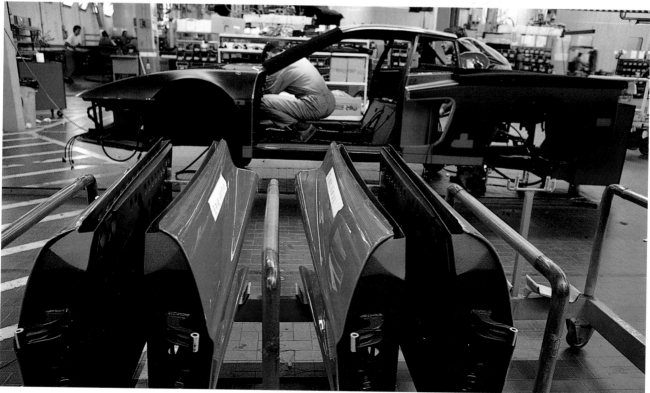

This factory, like the foundry, is also squeaky clean, and more like a kitchen than a car plant. As each 512TR progresses along the production line, suspended on cradles at a convenient working height, the vast and empty engine bay fills up with remarkable speed. A baffling tangle of hoses, tubes and wires suddenly begins to make sense as the twin oil coolers and engine coolant radiators are plumbed in, and by the time the engine, gearbox, driveshafts, suspension and brakes have all been fitted, there is very little spare room at all.

In the earlier Berlinetta cars, the radiator was at the front, and coolant was piped through the cabin to the engine. However, this system was cumbersome and heavy, and had a tendency to cook the driver and passenger if they had the misfortune to get stuck in traffic during the summer. The massive body width and the enormous air intakes on the Testarossa and 512TR design are partly due to the relocation of all the cooling systems to the engine bay, leaving the front boot clear for storage.

Above
The electrically operated mirrors finish off the doors: they are now about ready to be fitted to their cars

Left
The doors are mounted on mobile assembly stands for fitting out with handles, windows, electrics and other components

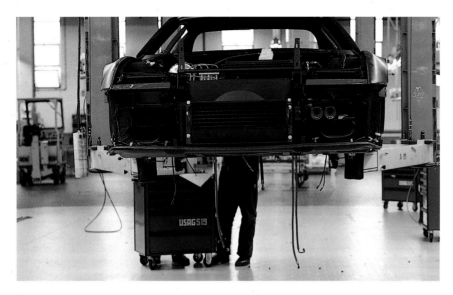

At the front, the use-of-space story is the same: although the removal of the spare wheel has freed up a lot of room, there's no point in then filling it up with componentry when your customers would rather fill it up with luggage, particularly when you offer them hand-made leather luggage designed especially to fit their car. Technological developments have meant the need for more actual equipment to be squeezed into the limited space at the front of the car as well. From October 1993, the car has been available with a Bosch electronic ABS braking system, which after all had to go somewhere: it is a somewhat easier task to find a home for such an item on a Granada than it is in a Ferrari, where usable space is at a premium.

The new sharper steering rack finishes off the front end, and with the new and imposing 18" wheels held up to the hubs and bolted on, the 512 is about ready to stand on its feet for the first time. The engine has already been run for four hours before going anywhere near the car, so the various fluid levels are filled up and checked for leaks, and the car is started up, electronically tuned and wheeled out into the sunshine for pre-delivery inspection and dispatch to its eager owner.

Above
Looking at a 512TR from the front: you can see the radiator from the air conditioning system. The engine cooling radiators are in the back of the car

Right
The production line makes a U-turn: the yellow lines suggest it's unwise to leave anything in this area or it will get run over

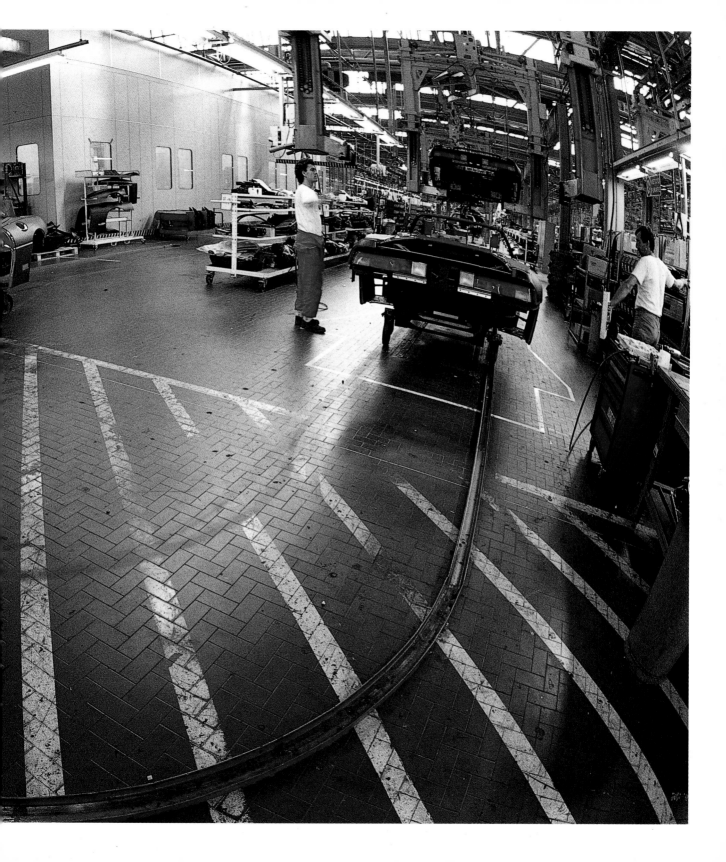

Left
A front panel being finished off ready to be fitted. Lights, grille, then a final polish up and bolt it in place

Below
The electrical cabling for the steering column is pulled through the bulkhead. Even in a relatively simple electrical system, there are miles of wiring to be painstakingly connected

Right
The pedals are awkward to fit on to the chassis, as they are at the bottom of the passenger compartment and offset towards the middle of the car

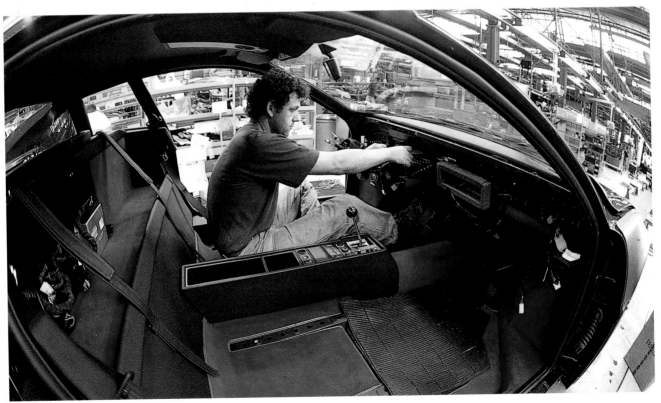

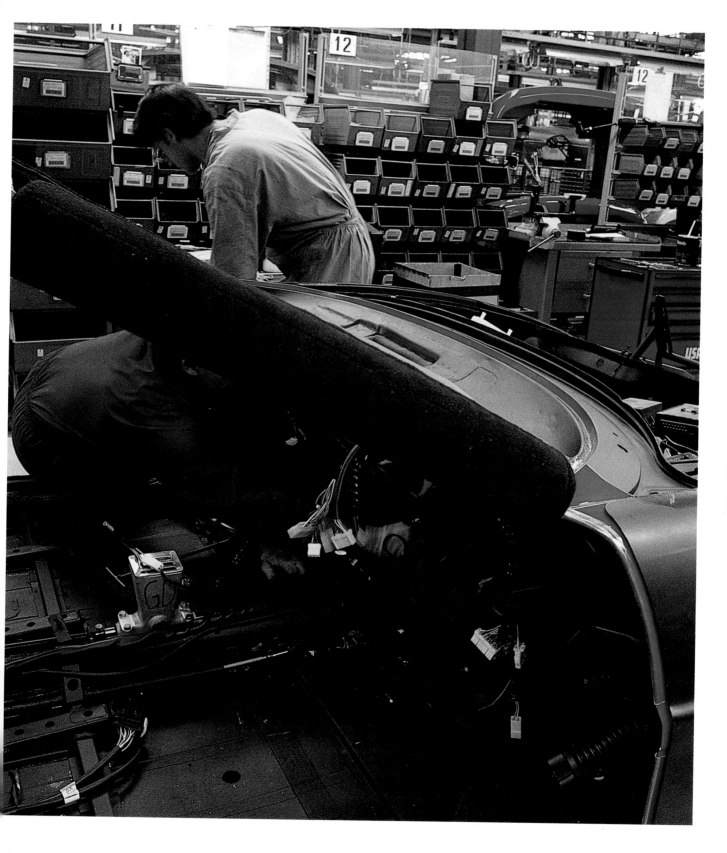

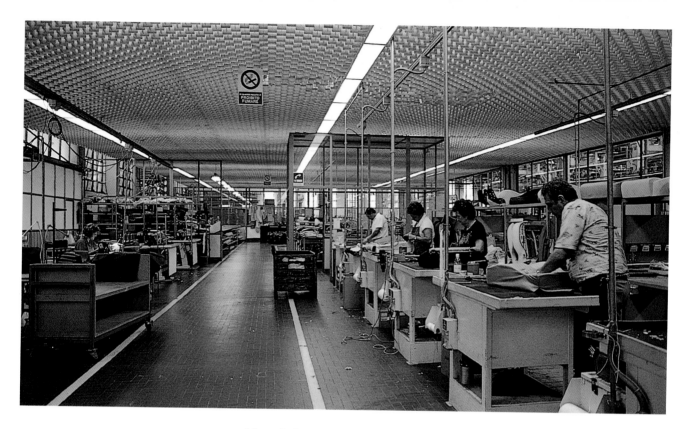

Above left

The air horns. Nobody would seriously expect Italians to build cars without a set of air horns, would they?

Left

The Bosch ABS system fitted to the brake master cylinder: if you don't like the feel of it, you can choose whether or not to switch it on

Above

The trim shop, where the best quality hides are transformed into Ferrari interiors

Left
Sewing the hide into the right shape to slip over the foam plastic formers that give the seats their shape

Right
Elastic straps across the bottom of each seat are quite strong to make the seats firm and supportive

Below
Looking through the storage racks, one of the trim shop staff glues leather on to a shaped piece of interior trim

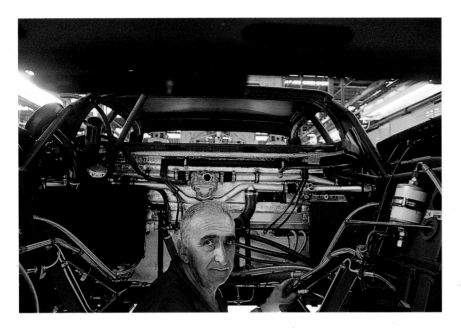

Above

The engine bay is completely lined with pipes, hoses and wires, ready to be connected to the engine when it is fitted

Right

Also fitted into the engine bay before the engine are the big water cooling radiators with their fans, and the smaller oil cooling radiators

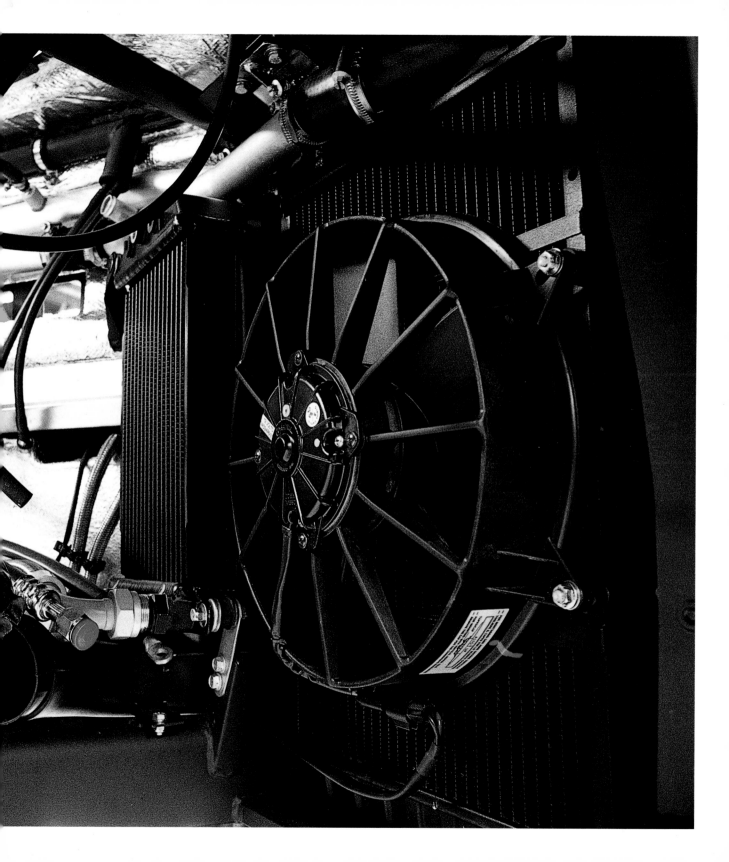

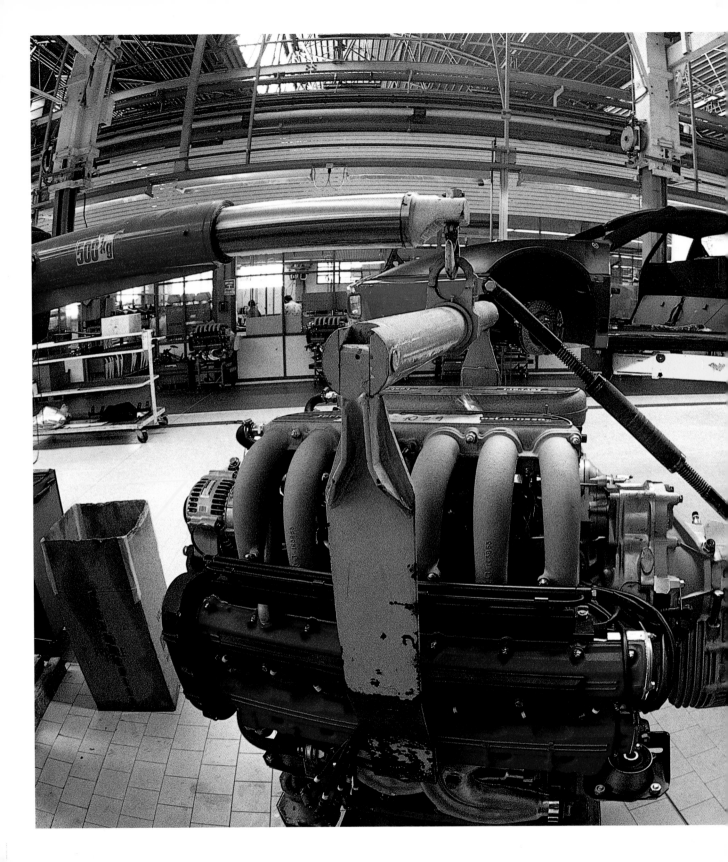

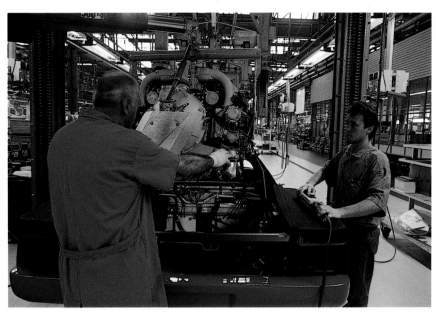

Above
The engine is manoeuvred across the top of the engine bay and carefully lowered into the car

Left
An engine held aloft in a crane is about ready to be wheeled across to the line and fitted to a car

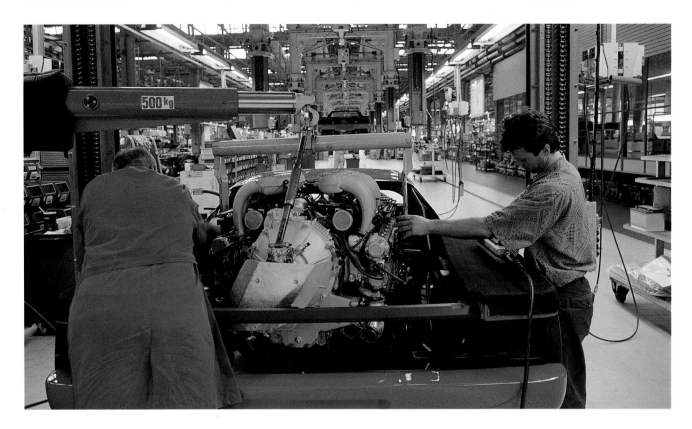

Above
Using a hand control, the crane is lowered inch by inch as the engine and gearbox line up with the mountings and driveshafts in the bottom of the engine bay

Above right
With the engine in the car and bolted in place, the peripherals can now be fitted to take it closer to completion

Right
Despite the apparent visual evidence to the contrary, the engine on a Ferrari 512TR is not in fact glued in

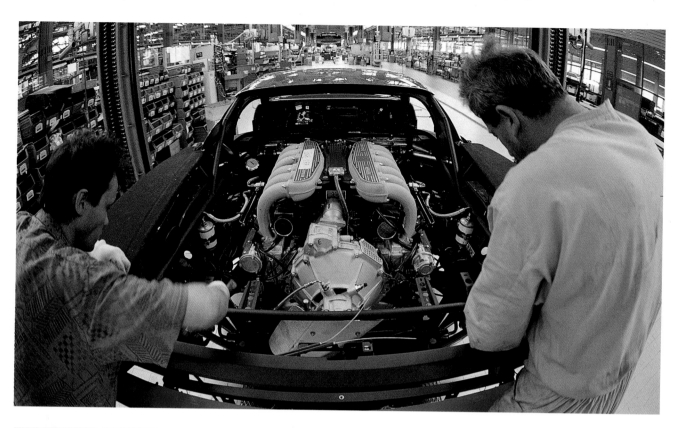
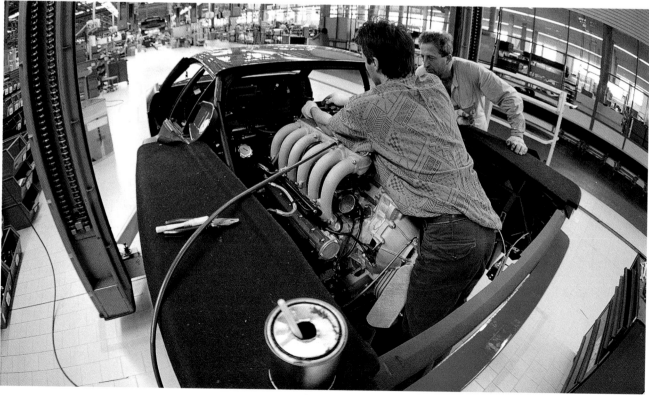

Above
Looking down into the engine bay, we can see the offside oil cooler

Right
The latest Bosch Motronic electronic ignition system is fitted to the new Ferrari

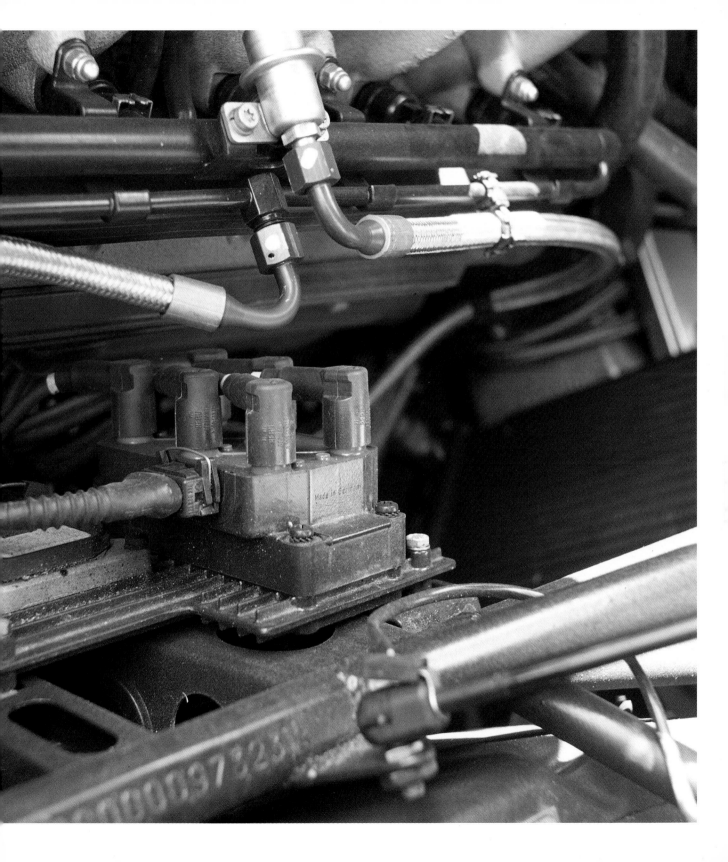

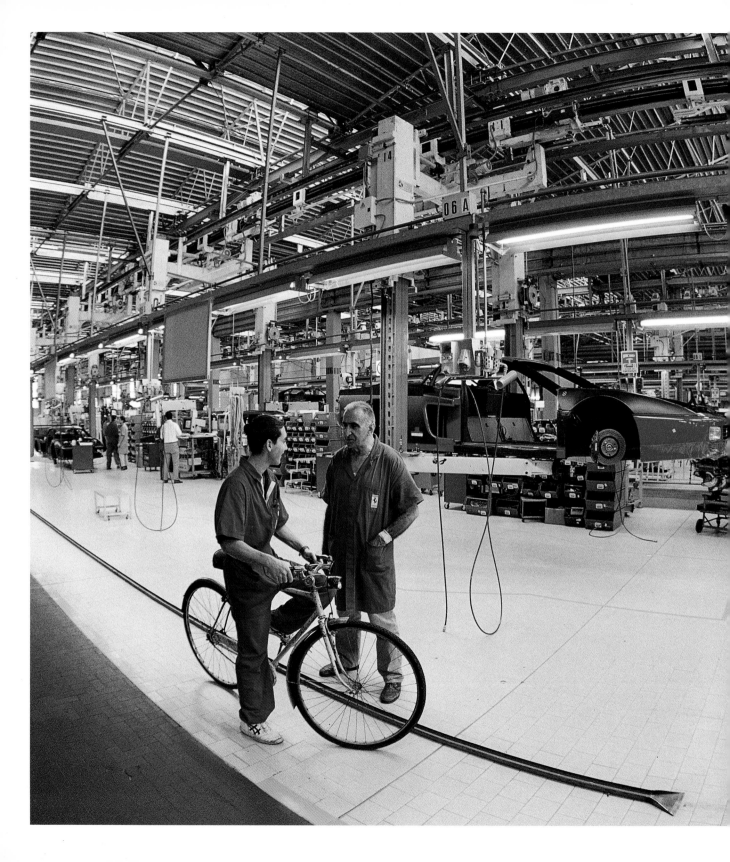

Above
The factory is so big that dozens of pushbikes are used to allow the workforce to get around the place

Left
With the engines fitted, the next step is to line up the big rear deck panels and bolt them in place

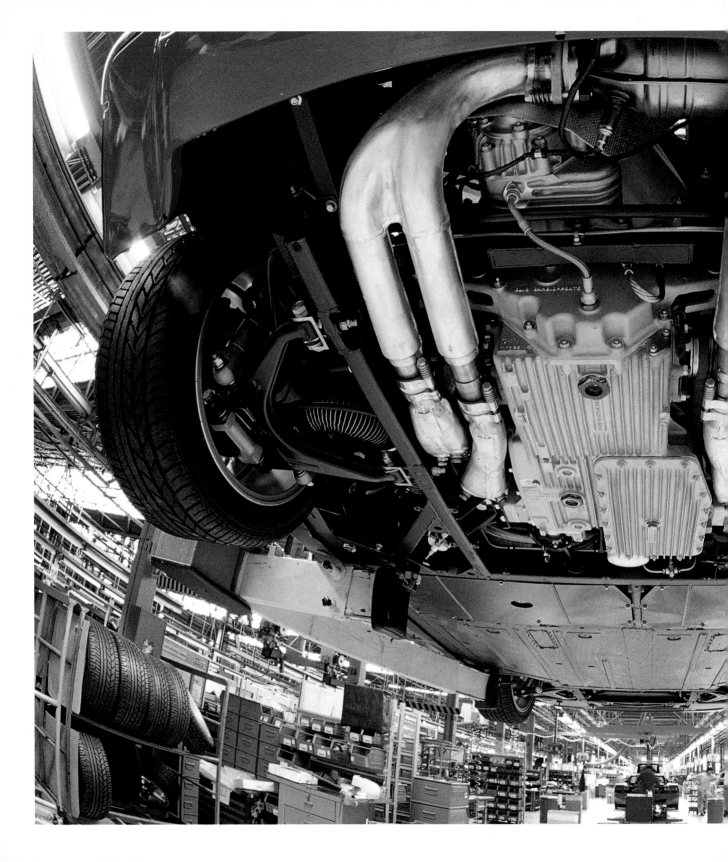

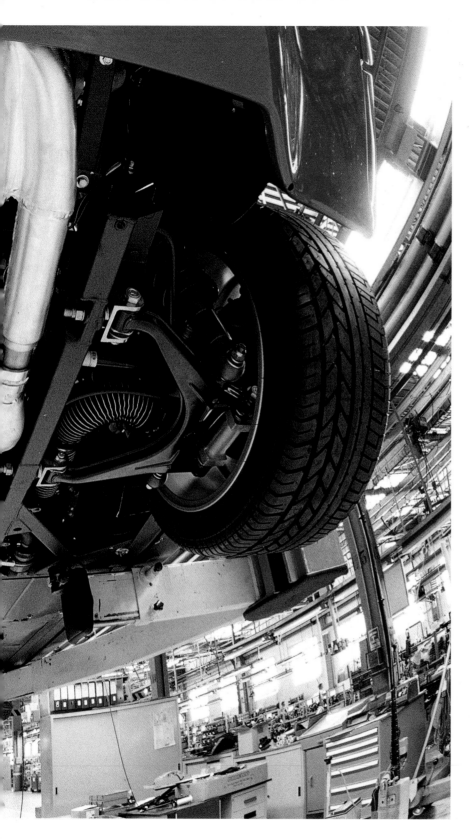

Above

Ready to go: various types of Ferrari parked outside the new Technical Assistance building. The original Ferrari factory building can be seen in the background

Left

Looking up at the engine bay from beneath: the hoses in the bottom wishbones duct cooling air to the brakes from the side air intakes

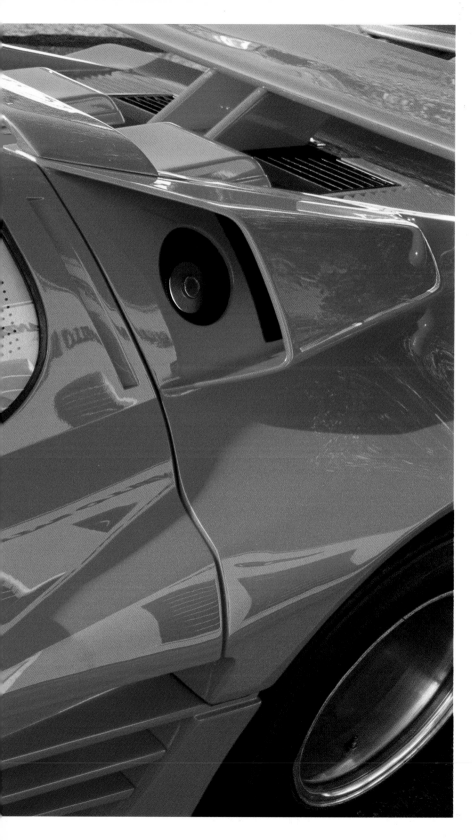

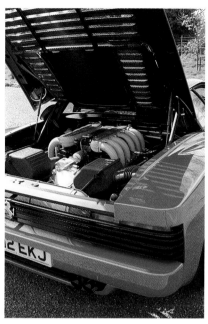

Above
*The heart of the matter: the engine.
Nothing else in the world sounds quite
like Ferrari's flat 12*

Left
*An ancestor of the 512TR, treated to a
spectacular body kit and rather
astonishing interior*

Overleaf
*The massive discs are cooled by air
ducted in through flexible pipes. It may
not be as entertaining as driving one, but
the editor was of the opinion that just
lying underneath a Ferrari for a couple
of hours looks like time well spent, when
you look at this photograph*

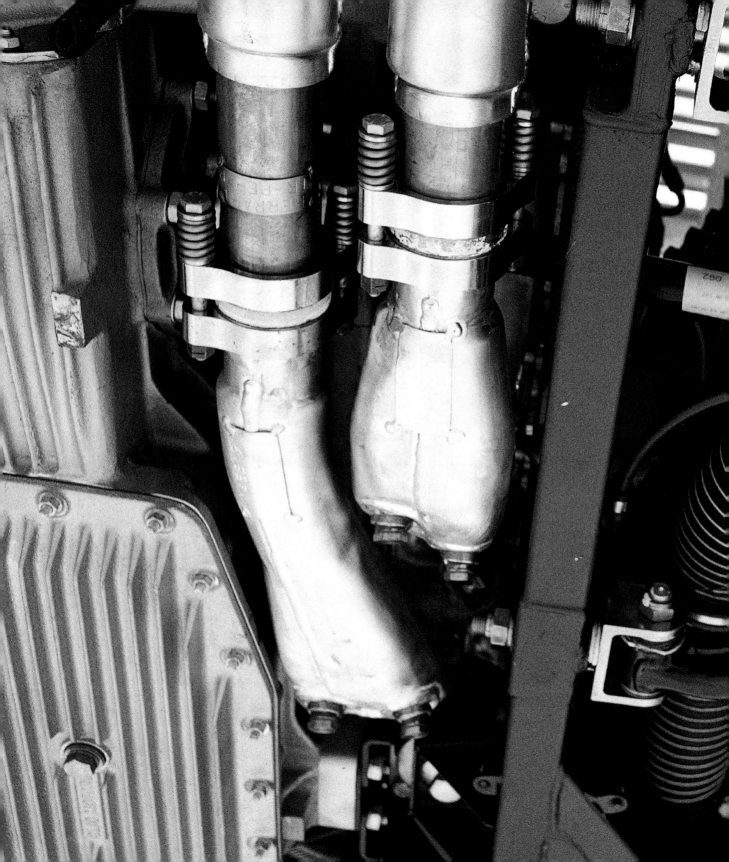

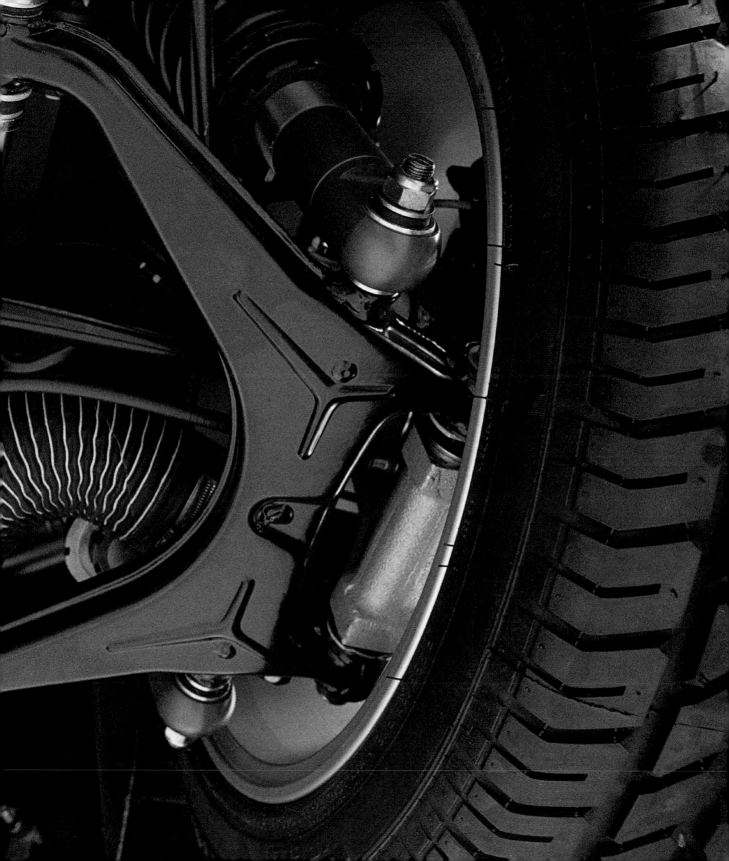

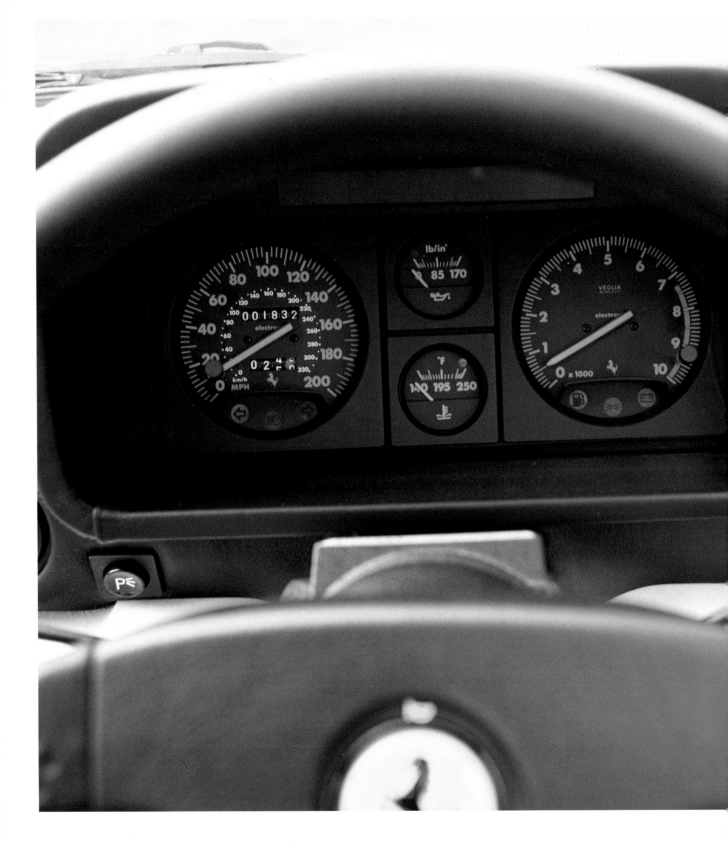

In the Driving Seat

The proof of the pudding is in the eating, as they say, and the same certainly applies to tiramisu and gelato as well as the jam roll most of us have to drive most of the time. On the day of my visit to Maranello Concessionaires for a spin in a 512TR, I actually rolled up in a thing called a Midge, which uses ancient Triumph mechanicals for motive power.

At least mine's a Vitesse powered one, so it has a bit of energy, but on the day in question it was suffering from very pungent oil incontinence and a sagging rear spring, so a VW Beetle would have felt good by comparison, never mind £130,000 worth of Ferrari.

In common with virtually every other human on the planet, I was rather looking forward to getting my hands on a Ferrari. In common with not too many others, my job has allowed me to drive a few cars that have given me a yardstick with which to judge a car like the Ferrari.

I write regularly for the kit car press, as well as writing the odd book on TVR and so on, and I have probably driven quite a lot of the more interesting cars around, some genuine and some replicas.

Most people dismiss kit cars as plastic and homemade. On the other hand, most kit car people dismiss production cars as dangerously insubstantial biscuit tins that are only any use as collections of parts from which to build real cars.

From my own point of view, I take something of a middle road. Though ordinary production cars are simply not interesting enough to talk or write about. I tend to think of them in the same way as I do fridge-freezers: as long as the light comes on when you open the door, the brand name and the details don't really matter.

Cars start becoming interesting when they have power, history, character, strength and fun built into them. Over the last few years, I have built and owned a replica of a Shelby Cobra that was powered by a 300bhp Chevrolet V8, and as I write, my new car is half built in its chassis jig: it will be the first of a small run of close replicas of an early Jaguar XK120, built from the excellent mechanical componentry left over when an XJ6 body comes to the end of its short but expensive life.

Over the years, there have been several highlights among the cars that I have reviewed for magazines. I was rather hoping that the Ferrari

All the important instruments are mounted in the main binnacle in full line of sight

would be a combination of the best facets of all three of last year's big favourites. In theory, the Ferrari has everything that I want in a car: it's a beauty, it has a proper chassis, it has been built for performance without regard to cost, and it makes lovely noises: so far so good.

My experience of cars is a very particular one, in that most of the vehicles I review, drive and own are obscure, oddball things, usually built in tiny workshops by eccentric individuals, and almost without exception very fast indeed. I have only driven a few production supercars before. (It is important to give some kind of indication of experience and tastes if you are reporting a test drive, something which is always going to be essentially subjective.) The closest in general approach would be the TVR Chimaera, an excellent car. Although it's mid-front engined rather than rear engined, the TVR and the Ferrari have quite a lot in common: a no-compromise performance-first approach, a genuine Grand Touring ability, a mix of the best of old and new technology - and the extensive use of high grade leather in the cockpit.

However, the central purpose of a Ferrari is sheer driving pleasure, so perhaps the best approach to the 512TR was to think of the cars I had most enjoyed driving over the past year or so, and then to put the Ferrari up against them and see if it gave me the same buzz.

Of the cars I've really enjoyed recently, three spring to mind immediately. The first was a genuine 1936 Jaguar SS100, a fully restored beauty with a surprisingly potent six-cylinder engine, a black bakelite four-spoke steering wheel six inches from your chest, and a bonnet longer than a Mack truck.

This had a beam axle at the front, a live axle at the rear, and so much character and personality that it almost talked. I loved the song of the pre-war gearbox and the throaty explosions of the fat exhaust, the green hedgerows flashing past reflected in the huge chrome headlamps... and the surprising amount of sheer grunt available to power out of corners, clamped tightly in a tiny leather bucket seat with your elbows working busily at the big black wheel to keep the front and back ends where you wanted them.

If the Ferrari can come anywhere close to the character and sheer presence of the 1936 SS100, and the sense of history that comes from a genuine milestone car, I shall be impressed, I thought to myself.

The Ferrari Boxer engine in 512TR form produces 428 horsepower, and the closest I've come recently to that level of power would have to be the new Dax Tojeiro demonstrator, which is fitted with a big-block Chevy V8. The engine in that is fairly standard apart from improved breathing, and pokes out about 360bhp at the wheels. The thing is, it only weighs about a ton... As if that weren't enough, the torque figure was approaching 500 ft/lbs.

Right
The 512TR steering wheel is sightly smaller than one on the Testarossa, and there has been a slight adjustment on the number of turns lock to lock. Prancing horse, however, remains the same

Below right
Minor instruments are relegated to the smaller binnacle, which in the 512TR is separated from the dash rather than mounted on the single upward sweep of the Testarossa dash. True, you can't see the clock very conveniently: but then who gives a damn what the time is when you're driving one of these?

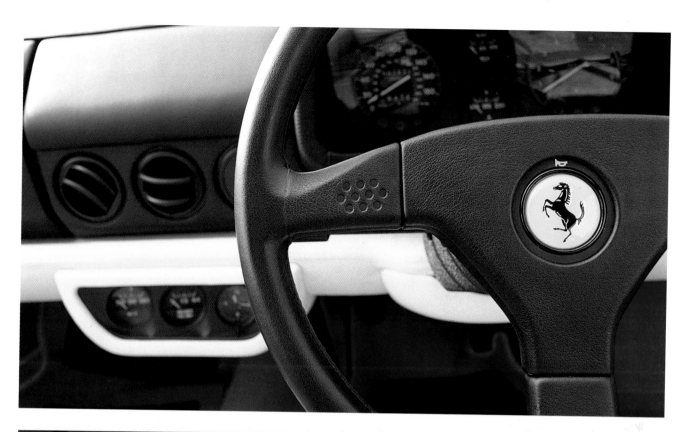

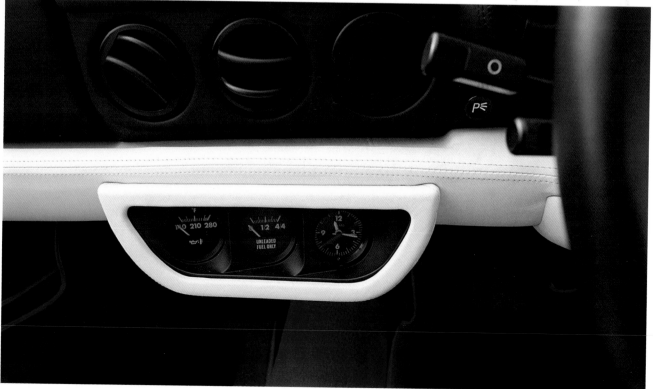

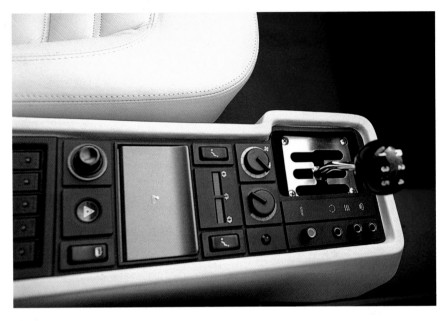

Like all Cobra replicas, the Dax is very low, very squat and very wide, and when you've negotiated your way into the tiny cockpit and strapped in, you realise that you're going to have to reach almost behind you to change gear: the engine in this beast is almost under the dashboard, pushed back and down in the chassis as far as it will go. Push the starter and there's a crackling spit or two, then a big meaty thud as the engine fires a slug of gas down the tangle of headers and down the sidepipes. The entire car twists violently from the torque, and we slip it into gear through the rather agricultural change and get going. The power comes in big, solid lumps, and the angry snarling from the end of the sidepipe a few inches below your elbow reminds you not to take liberties.

After an hour or two, I had the feel of the Dax, and I will always remember one particular corner, a long, smooth right hander with nothing but empty fields on either side of the road: in other words, if I completely lost it, the worst that could happen would be a cockpit full of

Above
The gear lever linkage now features a bearing at the bottom, and the change is slicker and easier as a result. It still changes with the familiar clack, though, and the polished guide plate still looks the business

Right
The pilot is very definitely expected to sit in the Italian driving position, with short legs and long arms. The ribbing pattern on the seats is 512TR rather than Testarossa

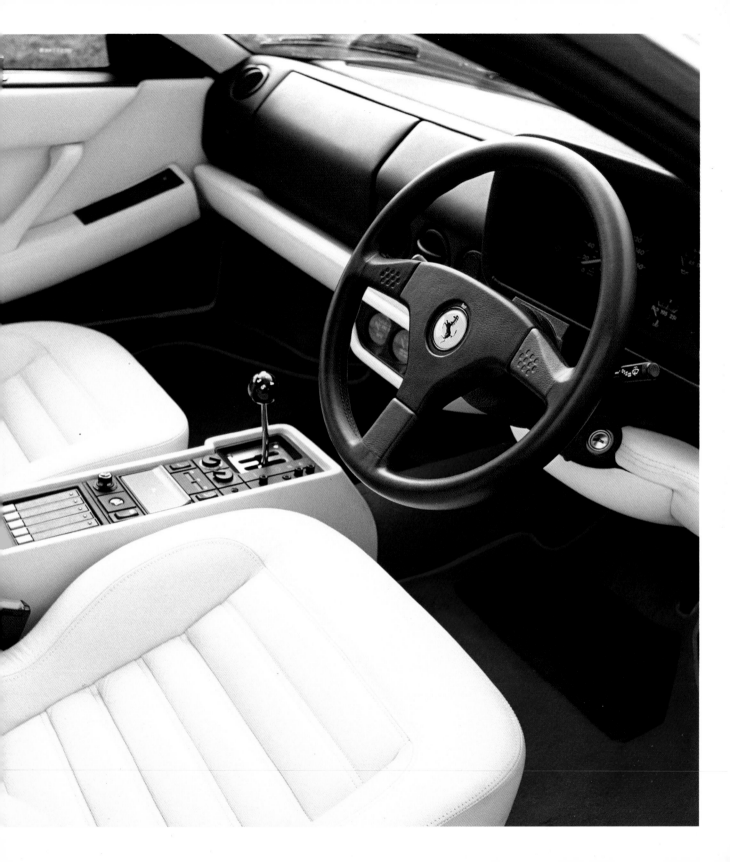

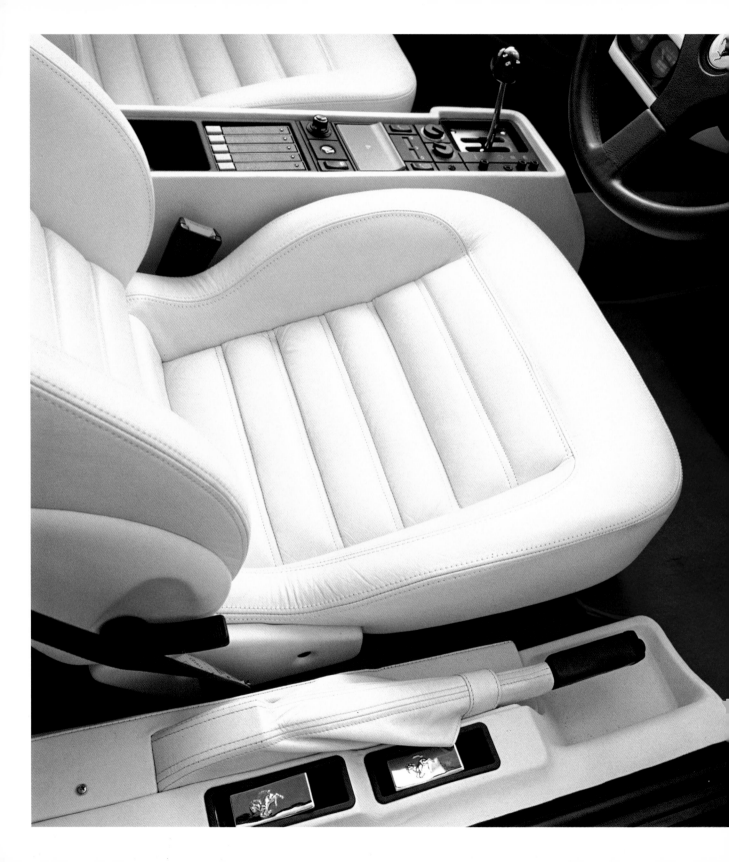

stubble and surprised spiders. I blipped into third and smoothly but firmly floored the throttle. There was a deafening double bellow from the sidepipes, the back end squatted down an inch or two, and the car shot forward at an unbelievable rate. I hung on, keeping the wheel and throttle steady as my neck muscles began to hurt. Out the other end of the corner, and a bit of a rebel yell from sheer excitement as the engine redlined and I changed up.

Fun, but not what you might call refined: a bit like riding a Scud with brakes. The Ferrari should be able to do this sort of thing much better than the Dax. The Ferrari is also supposed to have very delicate and sensitive controls, according to a friend of mine who is a Ferraristi and has a 308 in pieces all over his garage, undergoing a slow and careful restoration. According to him, that responsiveness and the feedback from the controls is part of the pleasure, unlike the point and squirt

Above
Some minor controls have been relegated to the roof console. A nice touch was to make the switches very big so that you can operate them without taking your eyes off the road. The view in the mirror through the rear window is much better with the new lower level of the rear deck

Left
Handbrake is on the right. Pull levers set into the panel are beautifully detailed with engraved prancing horses

approach of a lot of seriously powerful but less well developed cars.

The third delightful and completely unexpected recent surprise was wheeled out of a grubby shed in a back street yard in Darwen, Lancashire. The controls on this little beast were the most delicate and responsive that I have ever experienced, and the whole visit was a revelation. What was it? It was a JZR, and it is extremely unlikely that you will ever have heard of it.

Built by bike freak John Ziemba at a rate of less than a hundred a year, the JZR is a close replica of the pre-war Morgan trike. The originals were fitted with a JAP V-twin motorcycle engine, and were pretty quick even then. The JZR is built with the 650cc V-twin taken from a Honda motorbike, and the rear end of the bike is bolted straight to the chassis. A light tracery of tubing is skinned in steel and GRP, and at the front there are double wishbones, coil over shocks and wire wheels with crossply tyres to match the back tyre.

The secret is that the clutch, brake and throttle were originally

Above
The finishing touches: natty prancing horse detailing on the leather of the seat backs

Right
The open door of a Ferrari 512TR is an inviting sight, and a black interior looks even better than a cream one. Anyone who doesn't get excited at the prospect of climbing in and driving it has no soul

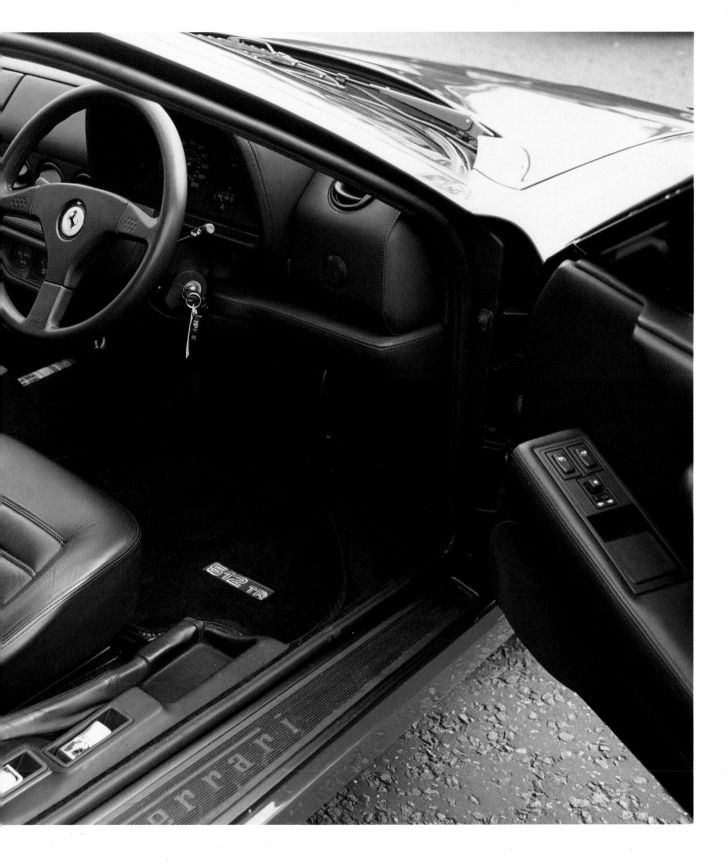

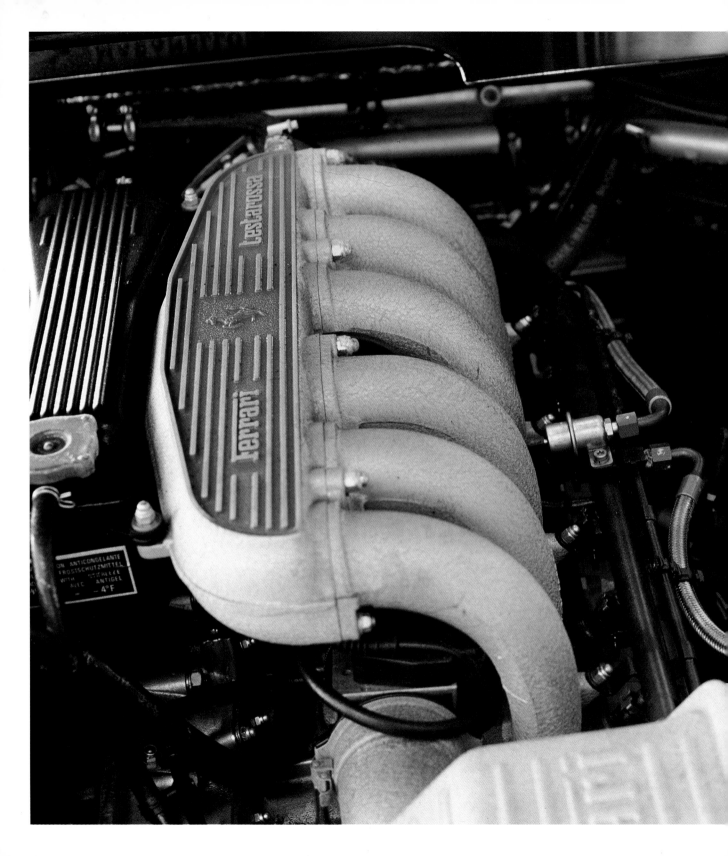

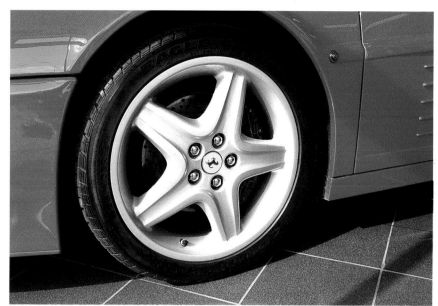

worked by your fingers on the bike, so the weighting of the foot controls is incredibly sensitive. Again, the car steering and suspension at the front was originally built with a car engine and gearbox in mind, so the lightweight Honda twin loads no weight on the steering at all. You could drive one of these with two fingers and two toes, no problem.

When you fire up the little twin and get out of town, you realise what an astonishing little car it is: the engine revs to 11,000 rpm, gearchanges are instant, and the balance on the three wheels is perfect. Into a corner, over with the wheel and the crossplies slide a little: a bit of throttle and the back end slides too – and all absolutely under control – you can feel every bit of grit on the road, and with no weight transfer across the back as happens with four wheeled cars, the drift is completely predictable. Great entertainment, as visceral as a motorbike: but the big bonus point is that you can't fall off it.

Above
The new 18" low profile wheels and tyres give even sharper feedback and precision than that of the Testarossa, and make a significant change to the overall aspect of the car

Left
This fabulous piece of precision engineering gives you a serious kick in the back as it hurtles you towards the horizon at nearly two hundred miles an hour: it also makes some of the most gorgeous noises you will ever hear from a car engine

There's no way any full sized car is ever going to give you the kind of delicacy that an ultra-light three-wheeled motorbike will, and the Ferrari's dry weight is more than three times the kerbside weight of the trike. Mind you, considering that the Ferrari is physically quite a big car, and has ten more cylinders, a roof, several very big windows and a full leather interior, it says a lot for the weight saving skills of Ferrari that the 512TR is only three times as heavy as the JZR. The trike doesn't even have a reverse gear fitted: if you want to go backwards, you get out and push.

As I swung the grubby nose of the old Midge into the forecourt of the listed Art Deco building that houses Maranello, those were the comparisons that were running through my mind: if the 512 TR has the presence of an SS100, the sheer maniac grunt of a big-block and the delicate feel of the JZR, I thought, then its supercar status is justified by more than just its top speed.

Shortly afterwards, a gleaming and freshly polished 512TR burbled out into the car park and glistened at me. Three guesses what colour it was? Yes, it was red. Like about 90% of all Ferraris, apparently. (Rumour has it that the current head of Ferrari, Count Luca di Montezemelo, used to drive a yellow Ferrari, and suffered some grief from Rome's taxi drivers as a result.)

This one is very definitely red, and the interior is as black as the outside is red. The car is certainly a beauty in the flesh. The sweep of the rear wings, which starts at the back of the front wheel arches, rises up into the massive shoulders of the car and then flattens out into the rear lip, which is aerodynamically effective enough to negate the need for any vulgar spoilers.

This is definitely one of the small number of genuine classics to emerge from the eighties and nineties, and as a piece of stationary sculpture it rewards inspection. The way the curves, muscles and planes blend and swoop, the whole car could have been carved out of a solid lump of red. They're quite right about bright red being the only colour for them: yellow is not a serious colour, and black looks good but obscures the shape, which is after all a large part of the reason for buying a Ferrari in the first place.

Open the big, heavy door and slide into the seat, then pull the door shut with a meaty thud. The black headlining and sunvisor are very close to your head, which is slightly oppressive. However, if the car's roof were higher, it wouldn't look the way it does. At least it doesn't have that horrible Ford GT40 trick: on that, the 40 refers to the roof being 40"

Outside the Maranello building at Egham, the 512TR sits warming up, just asking for me to leap into it and take it out for a thrashing

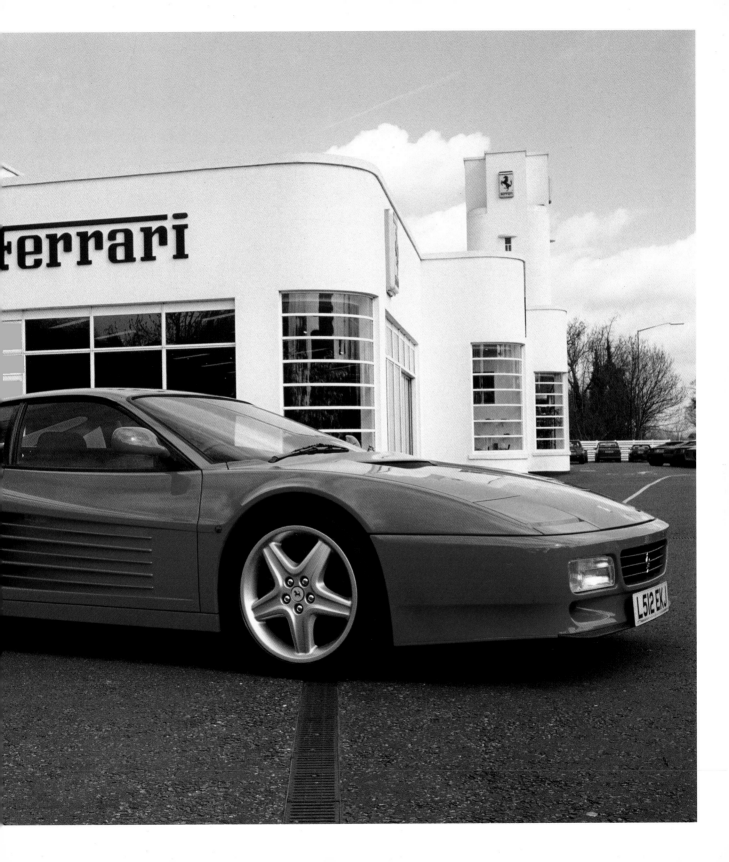

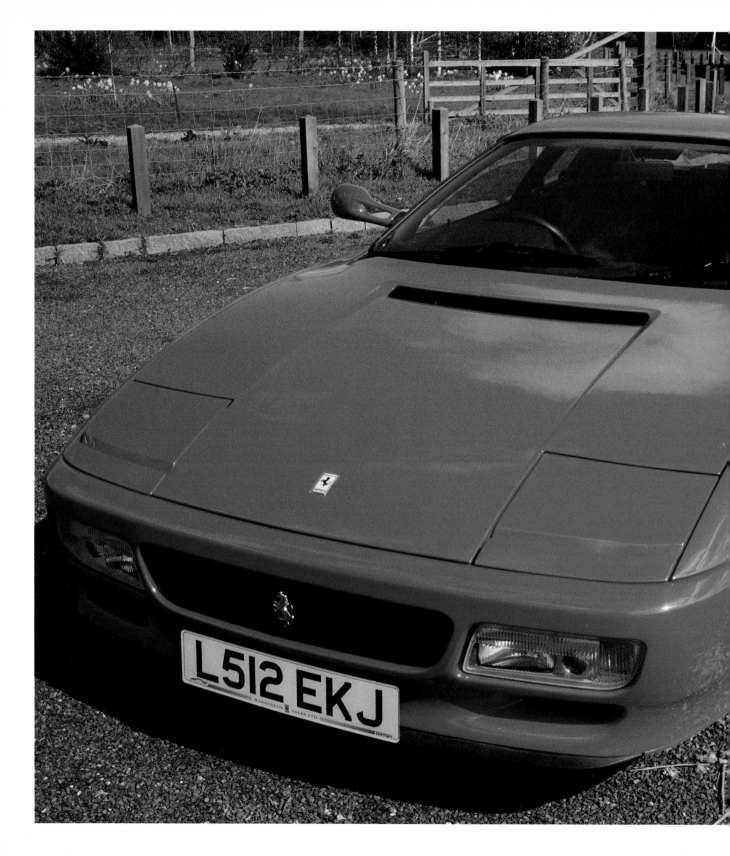

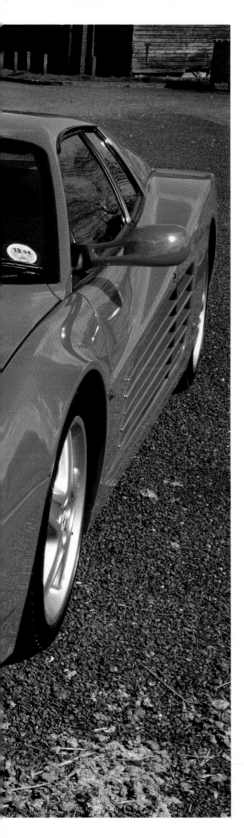

from the deck, and the only way any primate other than a monkey can get into one is to have half the roof swing out with the doors: when you've weaseled your way into the thing, you then have to pull the door shut, and as the approaching roof section is only an inch or so from your scalp, the GT40 door feels as though it's going to cut your head off. You have to either shut your eyes or duck.

To be fair, if you like the Italian driving position, you would be sitting further back than I did in the Ferrari: I'm of average height, but I prefer the steering wheel to be close to me rather than at arms' length, in more of a vintage driving position than the Italian short leg, long arm approach. I wonder if Italians really are that shape? Perhaps some research should be done.

With a little shifting back and forth I'm soon comfortable, and as soon as I turn the key, I forget about the roof height: the lights all come on in the dash, but nothing happens at all in the engine department. I've broken it already. Ah. Apparently you have to slot a little electronic key into a slot in the dash and wait a few seconds until it has beeped twice, then you can start the engine. Okay. Beep... beeeep. Pull it out, put the key back in the ignition: lots of lights all over the dash again. Turn the key, and after a few brief churns there's a muffled explosion from behind and I can hear lots and lots of rather delicious mechanical noises blending from behind as the needles rise across the dials. Buzz the window down so I can hear the engine properly.

There's a lot going on, very close to your ears. Four cams, forty-eight valves, twelve pistons. A few gentle blips on the throttle, and the chord from behind rises and falls. The gear lever sits in its machined plate, and I twist it left and back into the dogleg first gear, then move slowly off across the car park.

This is the first seriously wide car I have driven that doesn't feel huge to drive. It's as wide as most light trucks, but it feels no bigger than a Spitfire. I bet this demonstrator is going to go through a significant number of nearside front wheels and tyres, as people misjudge the width and smack the kerb with it.

It would be seriously embarrassing to have to ring up Maranello and ask them to send out a van with another wheel, so I drove the Ferrari as if it had a sidecar fitted as well as its own massive width, and managed to avoid any embarrassing incidents.

First stop was a photo location, where I spent a bit of time giving the car a practicality test, more or less by coincidence. I didn't like it where I'd first parked it, because the sun was in the wrong place: climb back in,

Reluctantly, I stopped partway through my test drive to take some pictures: the car looks as though it's doing a hundred when it's parked at the side of the road

111

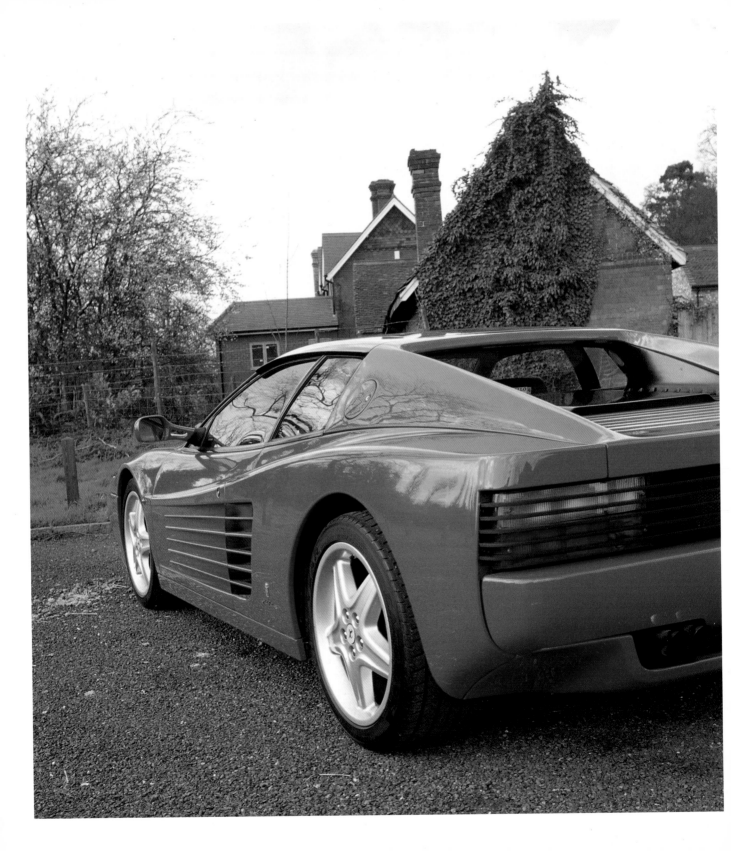

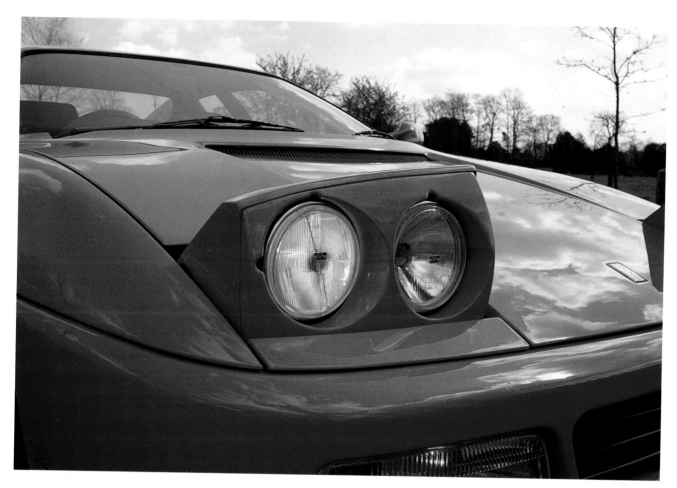

Left

That lovely sweep up from the back of the front wheel arch right up to the tail panel was left completely intact when the rest of the Testarossa was updated to turn it into the 512TR

Above

The neat pop up headlamps are necessary because the wing is too low and flat to have permanent headlights in it: the car still looks more than reasonable even with the lamps in the up position

start it up, reverse, over a few feet. No, better the way it was before. The steering is not powered, and doing three point turns in small places with foot-wide tyres is always hard on the forearms without power steering, but the 512TR was not really troublesome. I can't say the same for the Lamborghini Countach, in which I once found myself doing exactly the same thing: to reverse one of those, the easiest way seemed to be to sit on the sill with the door open, and steer with one hand. Seeing out of one of those is a problem anyway: the bar between the side windows is exactly in your line of sight, so you can never decide which window you're supposed to be looking through.

However, the Ferrari is not like that at all. The new lower rear deck probably helps this, but whatever the reasons, you can see out perfectly well for reversing. You can't actually see the corners of the car from the driving seat, and with the cost of the corners on a Ferrari you don't

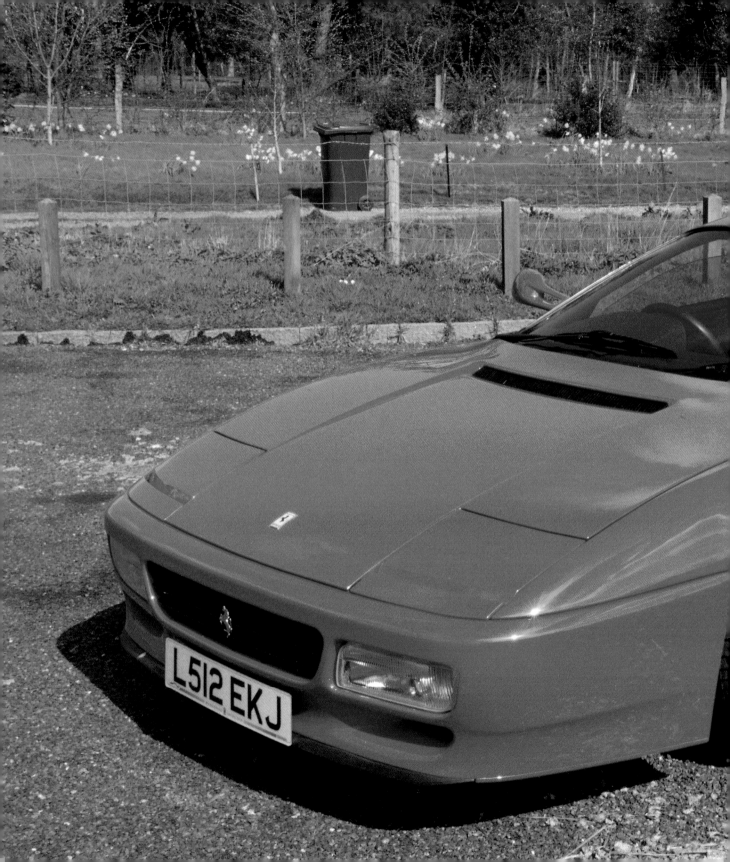

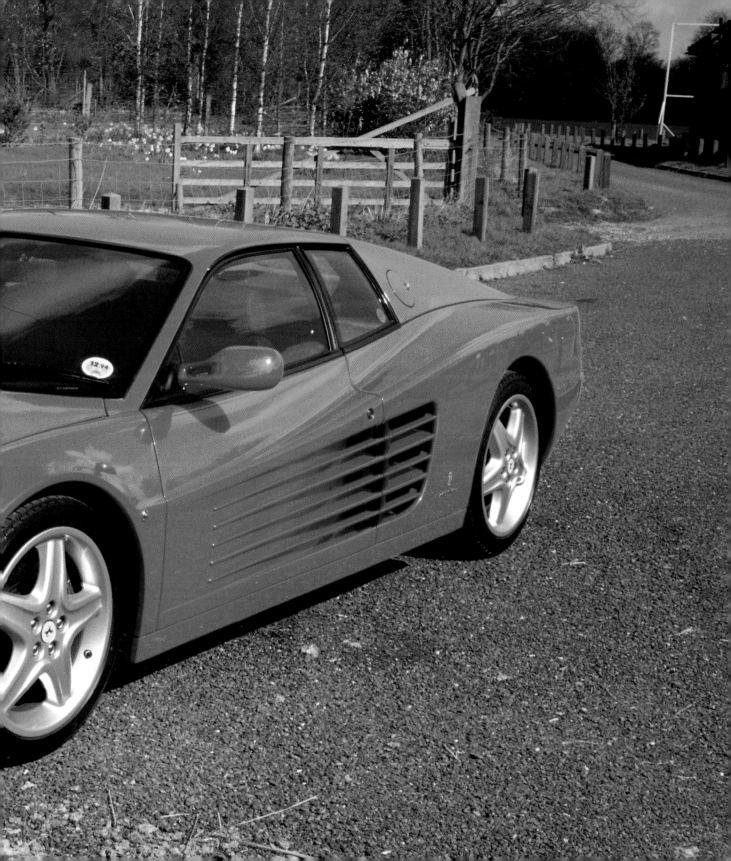

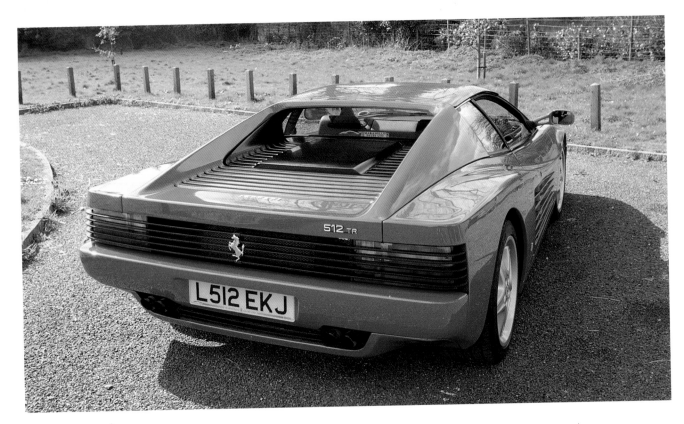

exactly indulge in touch parking, but basically it's practical enough for shopping.

As the idling engine heats up, the big engine cooling fans kick in. They make a fair amount of noise, but they don't really come on very often at all, only if you're stuck in a jam or messing about reversing and parking for a while.

Photos done, and a blast on the open road beckons. The gear change feels slightly remote from the gearbox, but the change is smooth enough. The best way to get a clean change is not to use your fingertips and wait for it to snick in, but to get the revs right, and then to dab the clutch and shift the lever positively: the box gets the message pretty well every time.

I realised at that point that I'd forgotten to make any mental notes about the clutch: I simply hadn't noticed it at all. This must be a good thing, as very high performance cars often have really sullen clutches. This one just gets on with the job, smoothly and easily.

As the driver and the engine warm up a bit, I give the car a bit more throttle, and the chords from behind begin to sound more urgent. The

Preceding pages
Very wide, very low, very red, very fast, very Ferrari

Above
New rear valance really blends in rather well: the whole look of the back is tidied up and neatened just by changing one or two details

Right
With the rear deck open, the engine is revealed in all its glory. It seems a shame to shut the engine out of sight most of the time

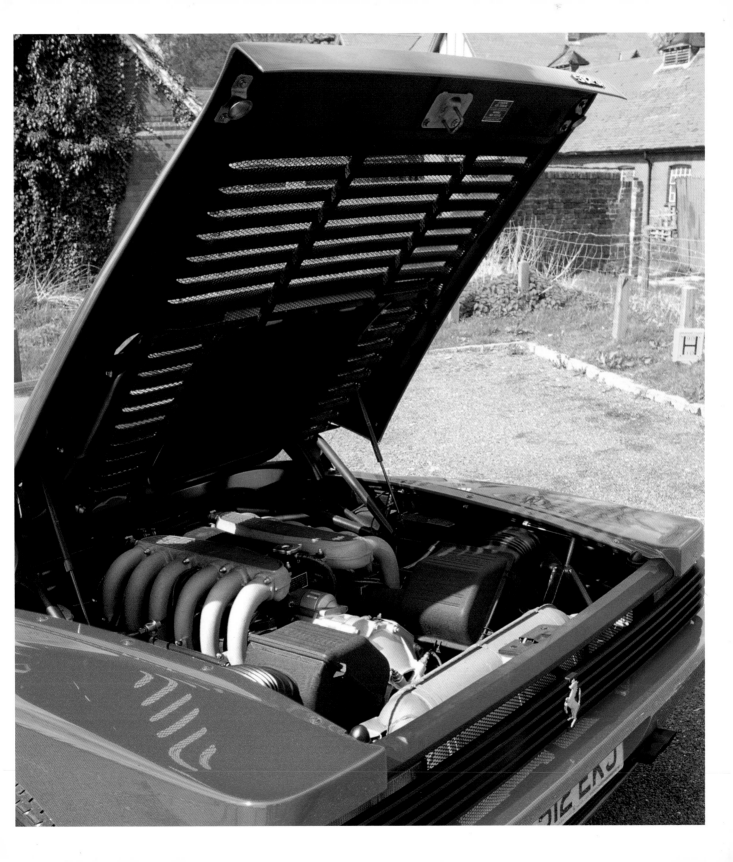

mix of different noises blends into a mesmeric howl as the revs rise and the scenery begins to blur.

A few sharp corners, a twitch of the wheel and a dab on the throttle and a straight opens up. The mirrors are empty and so is the road, so I press the throttle far down into the carpet, and I feel my back thump into the leather seat squab as the instant, creamy smooth power hits the road and the 512 really gets going.

There's no sudden slam of power, the way you get with a turbo or a cammy V8: the flat twelve just accelerates flatly and cleanly, with an effortless surge. When the engine is in its higher reaches, it is genuinely the sort of feel you get on the racetrack.

On smooth corners, you can get most of the Ferrari's power down on the road, and that is a rare thing. I've driven a Metro – no, don't laugh, it was a 6R4 – at Goodwood, and you get the same sensation in the Ferrari of being able to use nearly all the power of the engine, actually to get it down on to the track and translated into extremely fast

Above
Looking down into the offside of the engine bay at the new Bosch ignition system. Part of the spaceframe chassis can be seen on the right

Right
The Testarossa legend cast into the top of the plenum chambers leaves little doubt as to the heritage of the engine

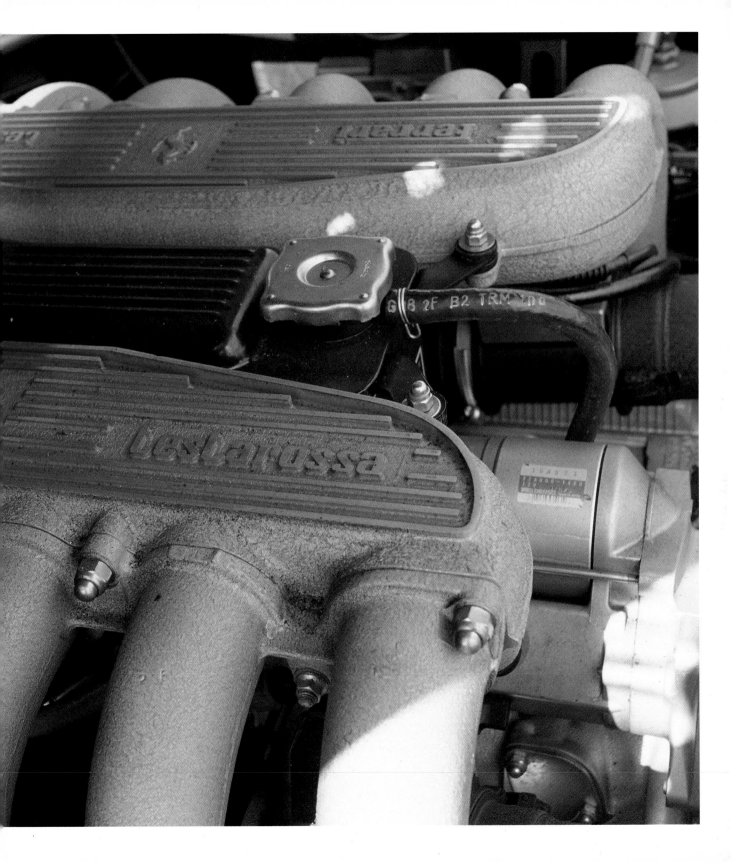

forward motion. Most of the cars I've driven with this level of power would simply finish up back end first in the scenery if you tried to give them anything like full throttle round a corner.

The Ferrari has a strange dual identity: even after a short drive, you cannot fail to realise that it has the sort of power and handling that puts it firmly among the fastest cars in the world, but when you get back in the traffic again, it reverts to being a practical tourer. For example, I tried driving it at 30mph. Most performance cars, with a few notable exceptions, can be reasonably comfortable driven at 30mph. However, I would be prepared to bet that there aren't many that can be driven at 30mph in all five of their gears.

The seats aren't as supportive as you might have expected, although they're comfortable enough over the relatively short distance I drove. However, the main reason for that is the wide seat squabs. The reason for their width is obvious, when you think about it: most of the few people in the world who can afford £130,000 for a sports car have to earn it first, and that usually takes long enough for middle-aged spread to supersede the Kevlar-bucket-seats-and-501-Levis stage.

The suspension is firm without being too harsh, and while it does bang around a bit over potholes, the car could be driven many hundreds of touring miles without making you too tired. The engine note and the level of cabin noise is about right: if you ease off and just cruise around, the cabin environment is reasonably serene. If you let the cat out of the bag, the demonic howl from the back is every bit as noisy as you want it.

While the 512TR is certainly completely civilised in traffic, there are constant reminders that the real reason for its existence is to be driven very quickly indeed. For instance, the binnacle in front of you only contains four instruments: the tacho, the speedo and the oil pressure and engine temperature gauges. At very high speeds, those are all the instruments that you need to be instantly aware of. The secondary instruments are relegated to a little pod lower down on the dash. After all, you can always check the engine oil temperature and the fuel level in the tank when things through the windscreen have calmed down a bit.

As to the clock, which is also relegated to the secondary position ... when you're driving a Ferrari, who cares what time it is anyway? Another neat touch was that some of the minor controls have been located right out of the way in the console mounted in the cabin roof. Nothing particularly special in that, certainly, but the Ferrari touch was there as well: the push switches are great big things, so that you can find them and operate them without taking your eyes off the road. At 194mph, this

The front aspect of the 512 is aggressive without overdoing it. The new Pininfarina front end definitely adds character

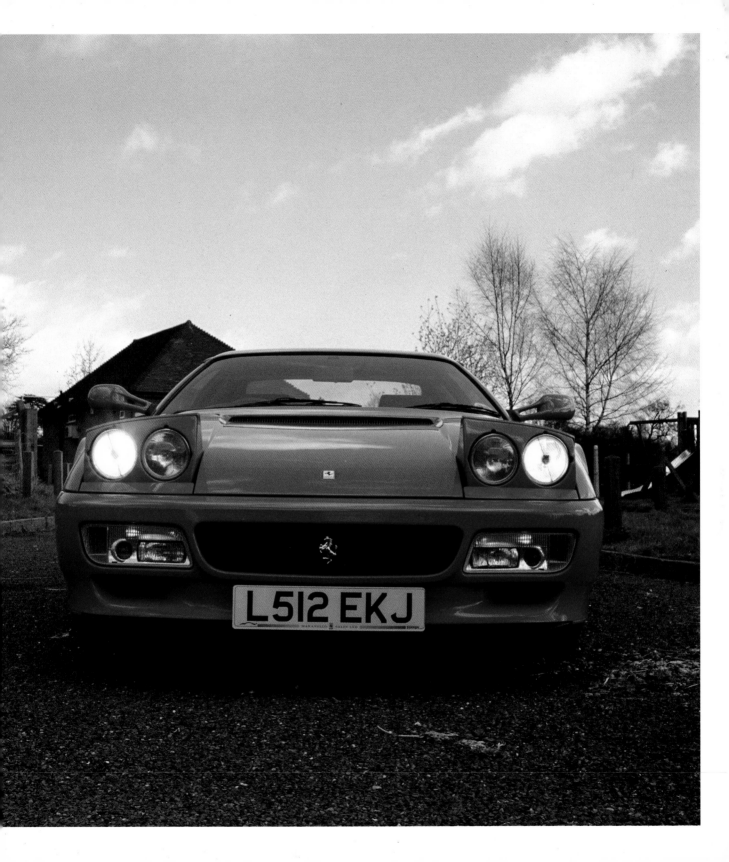

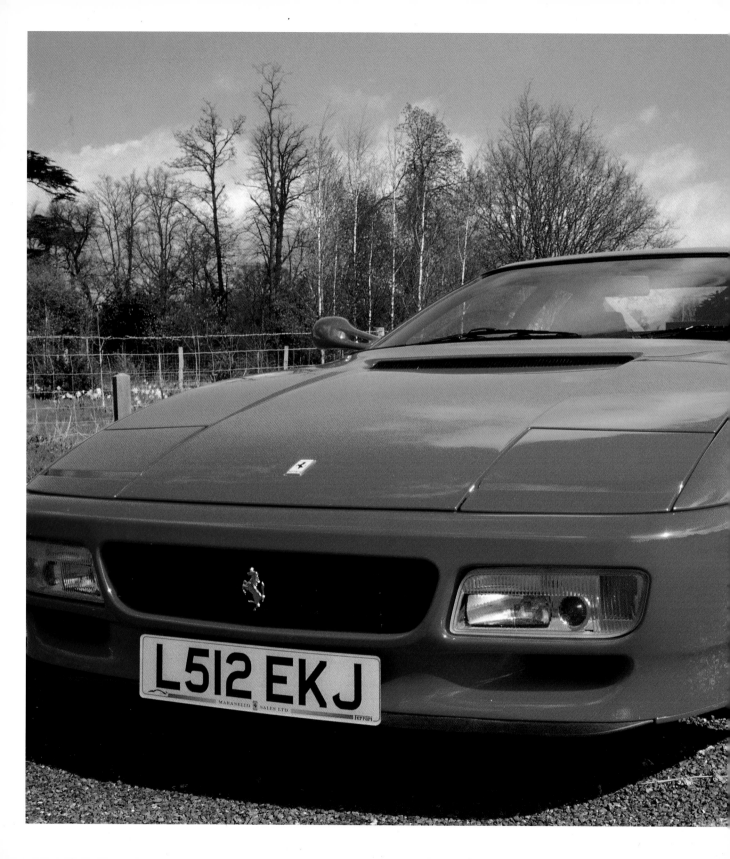

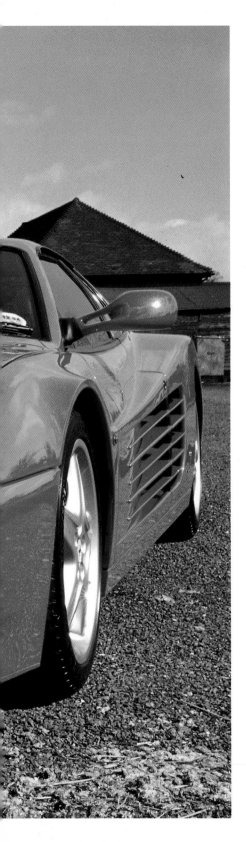

obviously makes a lot of sense. The pedals are offset to some extent, and closer together than the ideal: I would have been in danger of getting my feet mixed up as I had in the SS100 (the pedals were too close together for my liking) if I hadn't been concentrating. However, with a twelve cylinder engine in the back, and decent sized wheels at the front, there's a lot of pressure on the available footroom. This was another little foible that you got used to quite quickly. Just as well, as an injudicious trample on the loud pedal in one of these would have fairly spectacular results.

All too soon it was time to head back to Egham and give the beast back to Maranello, which I would do with some reluctance. Although I'd been reasonably sensible throughout my little spin in the car, I couldn't resist giving it one last boot as I straightened up after a roundabout. A bit of a chirp as the tyres bit, and the same exciting thump as your back hits the seat, and that lovely chord rises howling from behind your shoulder, the steering light and stable and telling you quite a lot of the story.

How did the Ferrari 512TR compare with my favourite rides of the year? Well, when the rear deck hisses up on its rams to reveal the crackly red finish on the cast alloy injection system, and you know that the cam covers buried in the depths of the engine bay are the same Testa Rossa red, you know that the heritage of Ferrari's flagships and the Testarossa name are safe in the hands of this car. Although it's not as rare as the Jaguar SS100, in its own way it's as beautiful, and it is certainly not short of presence.

Does it line up with a Chevy powered seven and a half litre go-kart? In practical terms, the Ferrari is probably faster. It doesn't have the immense torque or the absurd power to weight ratio of a GRP sports car fitted with such a huge engine, but its handling and brakes are state of the art, and its refinement is such that you could drive it at enormously high speeds for hours at a time, confident in the knowledge that if things got a little fraught, you would have the equipment to get yourself out of trouble,.

Fingertip controls like the replica Morgan trike? Not quite. However, the controls on the Ferrari are light, sensitive and user-friendly: apart from keeping an eye on its sheer width, you could drive a 512TR quite happily as an everyday car – it's pretty well as easy to drive as any other road car, but rather more entertaining.

I really only tried this Ferrari out as a road car, but a privileged few have seized the opportunity to take the 512TR out on the track. They found considerable improvements over the Testarossa, partly to do with

An irresistible design, a delicate blend of muscle and sweeping curves. It shouldn't be any colour apart from red, though, should it?

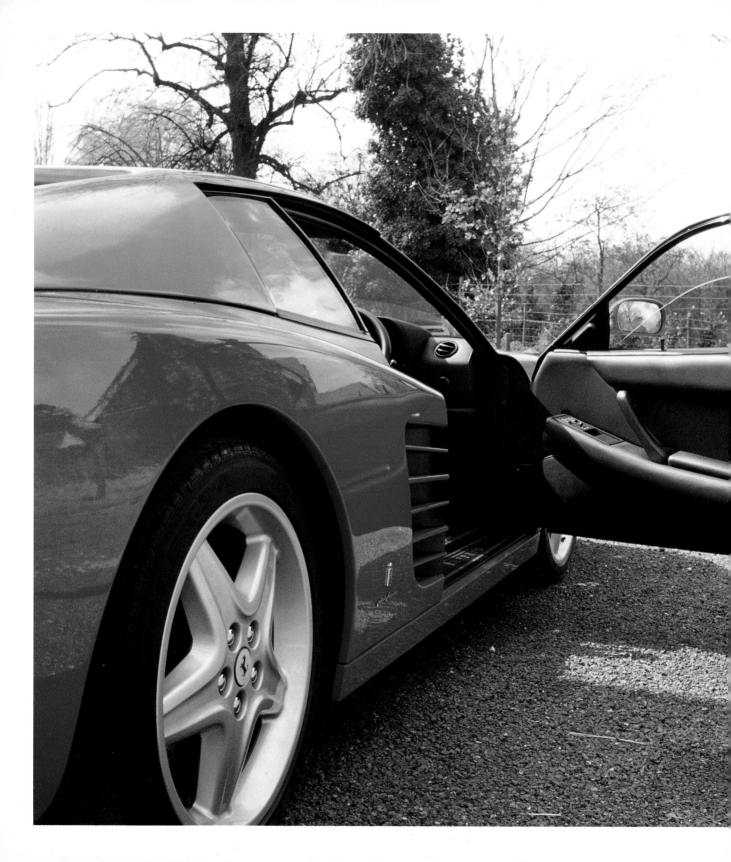

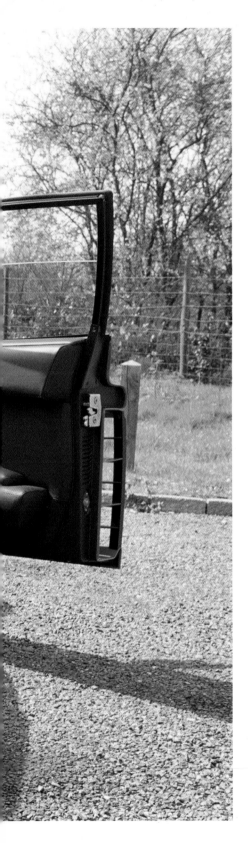

the changes in power delivery, but mostly in the handling. Where the older car used to suffer from roll oversteer, the lowering of the centre of gravity has more or less sorted that out. The word that comes up with telling frequency in the track reviews of the car is control. Although the car could be provoked into a spin by serious abuse, its limits are a lot higher.

The tail can be pushed out by flooring the throttle, but the tyres keep trying to grip, making a tail-out attitude hard to maintain. The general feeling was that the new suspension, wheels and tyres have extended the limits of the car by a considerable margin, but out at the ragged edge there is perhaps less room for manoeuvre than with the softer, less grippy characteristic of the Testarossa. Initially, there seems to be more understeer, but as speeds build up, this becomes more neutral, progressing to oversteer when you push your luck too hard. Achieving the balance between under and oversteer is the secret of getting the best out of the 512TR on the track.

Oh well, perhaps one day I'll get my sticky fingers on one of these monsters on a racetrack. Until then, I would have to admit that driving one even at relatively sensible speeds on the road is quite fun, and I would in fact quite fancy owning one. If the gentlemen at Maranello ever wanted to trade their 512TR demonstrator for one of my XK120 replicas, I must admit I would have to give it serious consideration …

The open door beckons again. Shall I stop fooling with the camera and go off for another play in the car? Yes, that sounds eminently sensible. 0-60 in 4.9 seconds - but can we trust the figures given? Perhaps they should be confirmed …

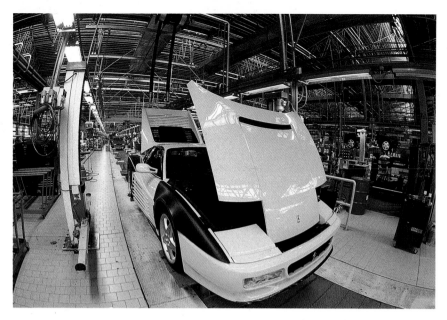

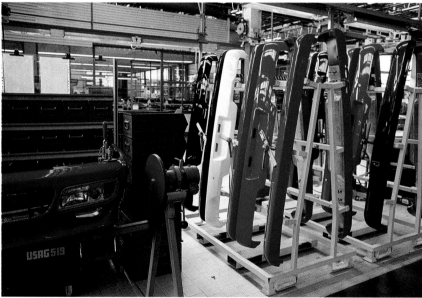

Top
Another Ferrari nears completion, one of the 10% or so that are not red

Above
Finished components awaiting fitment; as for all manufacturers these days, the rule is minimum stock levels

Right
Whatever you do to a Ferrari, you can't hide the basic proportions of one of the prettiest mid-engined cars ever

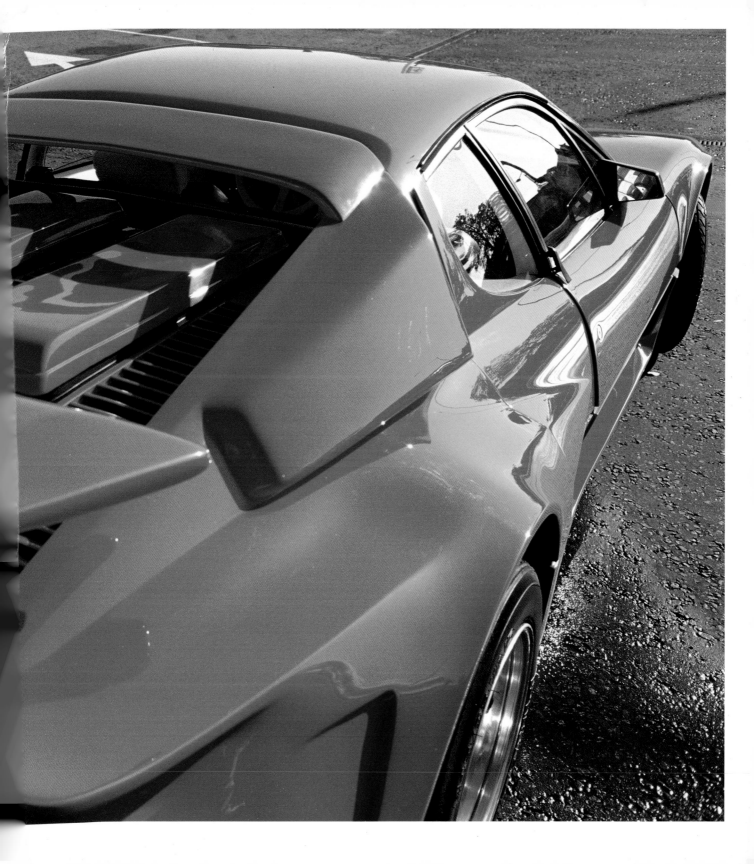

Specifications

CHASSIS

Tubular with rear part integrated with engine housing, two seater Berlinetta designed by Pininfarina. Steel roof and doors, aluminium bonnet, boot, wings

Front track 1532mm
Rear track 1644mm
Length 4480mm
Width 1976mm
Height 1135mm
Wheelbase 2550mm

Turning circle 12.6m
Manual steering rack 3.2 turns lock to lock

Dry weight 1473 kg (US version 1517 kg)

Rear gearbox with 5 synchronised speeds controlled by a central lever

Self locking differential incorporated in gearbox

Independent suspension all round
Four shock absorbers at rear, two at front

Rack and pinion steering with height adjustable steering wheel

Ventilated discs on all four wheels with vacuum assisted hydraulic master cylinder, ABS by Bosch. Mechanical handbrake acting on rear wheels

Twin fuel tanks in light alloy, capacity 100 litres (US gallons 26.5)

Tubeless radial tyres, front 235/40 ZR18 with light alloy cast rims 8J x 18" Rear: 295/35 ZR18 with light alloy cast rims 10.5J x 18" Modular rims also available

Leather upholstery, air conditioning, centralised door locking system, power windows, door mirrors controlled electrically from the passenger compartment

ENGINE

Rear, central, longitudinal
Number and arrangement of cylinders flat twelve at 180 degrees

Bore 82mm and stroke 78mm
Piston displacement 4943 cm sq
Compression ratio 10.1:1
Maximum power 428 bhp at 6750 rpm
US version 421 bhp
Maximum torque 362 lbs per ft
Power to weight ratio 263 bhp per ton

Engine block in light alloy, aluminium cylinder liners with nickel coating

Seven bearing crankshaft with thin wall main and big end bearing shells

4 overhead valves per cylinder inclined at 41°

Camshafts driven by toothed belts with tensioner

Gearpump lubrication dry sump and oil coolers

Bosch Motronic M2.7 integrated ignition/injection

12 volt electrical system with alternator and transistorised regulator

Single plate dry clutch with hydraulic release system

Water cooling with radiator, expansion tank and automatic electric fans

PERFORMANCE

0-60mph 4.9 seconds
0-100mph 10.6 seconds
0-150mph 25.2 seconds

100-140mph 9.9 seconds
30-70mph 3.8 seconds

Standing quarter mile 13.2 seconds at 113mph

Top speed 194mph (revs limited to 7200rpm)